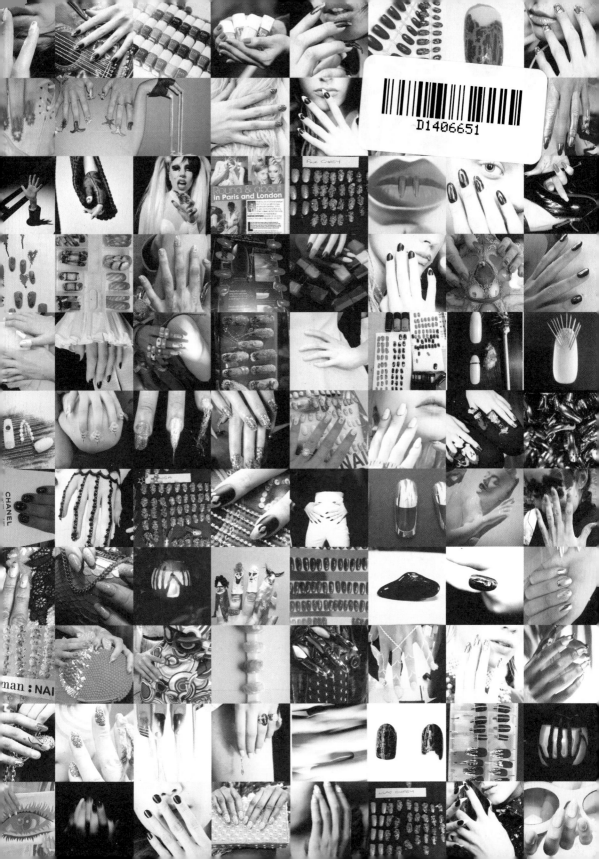

Nailed it.

LAURENCE KING

Published in 2019 by
Laurence King Publishing Ltd
361–373 City Road
London EC1V 1LR
United Kingdom
T +44 (0)20 7841 6900
F + 44 (0)20 7841 6910
enquiries@laurenceking.com
www.laurenceking.com

© 2019 Marian Newman

Marian Newman has asserted her right
under the Copyright, Designs, and Patents
Act 1988, to be identified as the Author of
this Work.

This book was produced by
Laurence King Publishing Ltd, London

A catalogue record for this book is
available from the British Library

ISBN: 978-1-78627-406-9

Interviews and text by Tamasin Doe
Commissioning editor: Camilla Morton
Senior editor: Charlotte Selby
Designer: Nicolas Franck Pauly
Picture researcher: Tory Turk
Production: Kim Wakefield and
Arlene Alexander

Front and back cover:
Photography: Barbara Donninelli,
Makeup: Lucy Bridge, Beauty Director:
Kathy Phillips, courtesy of *Vogue Me*.

Printed in China

Marian Newman

Nailed it.

Nails • Fashion • Technique

Laurence King Publishing

Contents

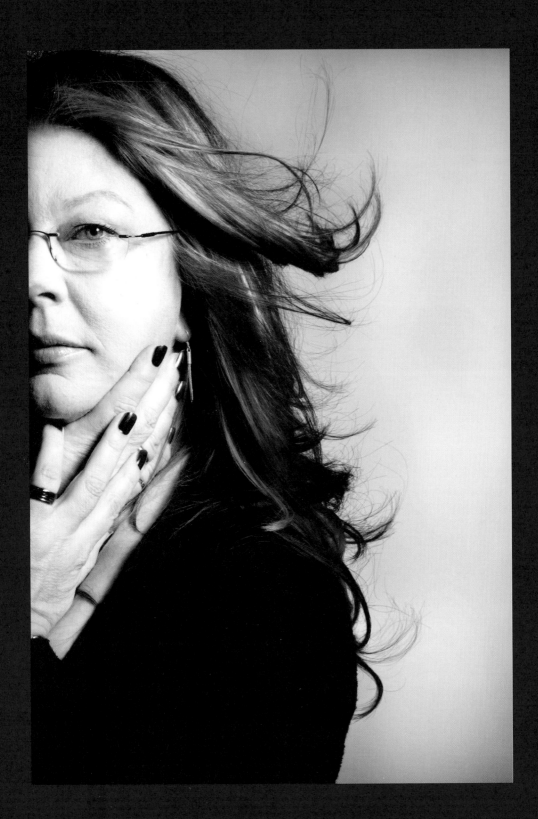

'I'm Marian. I do nails.'

Anyone who has ever worked with me will have heard me say these words as I walk into a photo studio or backstage at a catwalk show. It takes lots of people to create great looks, whether for fashion and beauty photographs or for fashion shows, and the team changes each time. It's likely to include the photographer, designer, model, hair artist, makeup artist, stylist, assistants and – which is where I come in – a nail technician. So we always introduce ourselves and what we do. That way, we can pool our knowledge and thoughts, and hopefully all emerge with relevant and inspiring work.

My career in the fashion and beauty industry began in 1996. I had been running my own nail salon for a little under ten years when I was telephoned and asked if I could help out with some photographs. I knew nothing about the fashion industry and I'd never been in a photographic studio, so I had no idea what to expect. Clutching a small nail kit, I found myself nervously climbing a metal staircase in a seedy backstreet off London's Clerkenwell Road.

In the middle of the small studio stood an unnerving piece of equipment: it looked like it had come from a hospital X-ray department but turned out to be a large-format 10 x 8 camera. A friendly young man introduced himself as the photographer's assistant and together we waited as other people arrived, along with lots of shoes and clothes.

All I knew was that I'd be putting some nails on a model. After a chat around a coffee table, I understood that I needed to make them long, and to match the colour of the polish to each of the pairs of shoes she'd be wearing. Only her legs and hands would be seen, so there was nothing else to prepare. The pressure was on me!

We went into a tiny room with no nail desk to work at, and I simply did what I'd been asked to do. Fortunately I'd brought enough polishes and had a good enough eye to mix the right colours without too much fuss. I had a nice lunch with the team and at the end of the day went home thinking, 'Well, that was good fun. What nice people!' I even got paid.

In those pre-Google years it wasn't possible to search the internet to find out who those 'nice people' were. It turned out that the photographer was Nick Knight; the ſtyliſt was Lucinda Chambers, British *Vogue*'s Fashion Direċtor at the time; and the assiſtant was Sølve Sundsbø. As far as firſt jobs go, mine was as remarkable as they come. I have worked regularly with Nick Knight since that moment. Lucinda booked me for my firſt British *Vogue* cover (with Kate Moss, see page 28) shortly after, and there have been many more since. Sølve and I have worked together on many shoots and he is now a very successful photographer in his own right.

After 20 years, I have a much better idea of what is expeċted of me in a ſtudio, but I sometimes wonder about that day. It was a day that presented me with an entirely new career. I was hired for the job because there were no other dedicated nail technicians working in the induſtry at the time – at leaſt, not in Europe. Lucky me, certainly, but it's also a case of being in the right place at the right time. When I began my journey into the fashion and beauty world, the career path I've since pursued simply didn't exiſt. To make all of this possible required a leap in technology and the new underſtanding that nails are an aspeċt of personal self-expression.

My own journey into the world of nails began in an unlikely place.

As a child I was never especially intereſted in dressing up or playing with makeup. All through school, I chose to focus on science rather than the arts. That said, my firſt Saturday job at age 14 was working in an art shop opposite Hornsey College of Art in Crouch End. There I learned about the materials, paints and papers used by artiſts. Then, as now, I can't draw, but I did buy clay and explored sculpture and the 3D side of art – the firſt things I made were a head and figures.

When I was growing up, it was quite normal to leave school at 16 and take a job that offered a day-release scheme for further education. One of the jobs that intereſted me was a junior position at the Metropolitan Police Forensic Science Laboratory. At the time I was fascinated by *The Expert*, a TV programme about a forensic scientiſt who solved crimes using his scientific expertise, so I knew this was the job for me. It also allowed me to ſtudy human biology, chemiſtry and applied mathematics at college.

The laboratory was an important centre for research into sciences devoted to the inveſtigation of crime. I learned a great deal in that job, sometimes working on infamous murder inveſtigations. I was also lucky enough to work for Margaret Pereira, a highly diſtinguished forensic scientiſt who discovered new ways to identify blood groups long before DNA profiling. Margaret went on to become controller of the Forensic Science Service while I, like so many young women of the time, veered from my career path to have my firſt baby.

Not for long, however. Since my firſt job at the art shop, work has been very important to me. I always need to be moving forwards, so when I was ready to begin work again I decided againſt going back to the Forensic Science Service. My next role was as an assiſtant in a home for adults with learning difficulties. Yet again it was a job that offered me a fresh challenge and new opportunities. It was here that I was sent on a cognitive behavioural therapy course, and I learned about the psychology of learning – something that proved invaluable for my subsequent teaching in the nail induſtry.

After a second baby break, I once again found myself in the mid-1980s wondering which direċtion to take. Despite my years of science and psychology experience, I decided to challenge myself by trying something entirely different. I enrolled on a six-week makeup

course in central London. I had no idea at the time, but it was at this point that my nail career was about to take off properly.

Part of the course was learning how to do a manicure, something I hugely enjoyed. By the end I was sure it was a field I wanted to work in, but I wasn't especially looking for an opening. Fate had other ideas, though. By that time I was living in Hertfordshire, north of London. Located there was a small chain of perfumeries with beauty salons attached to them. I was introduced to a salon owner who was looking for a makeup artist to work on Saturdays. Soon afterwards he mentioned that he wanted to open a nail treatment centre in the biggest salon, an idea that was then entirely ahead of the curve.

So I headed off to a trade show and investigated the various products and treatments available at the time. I was also paid to go on a series of short courses teaching me all about various brands. It was at this moment that I realized I was fascinated by nails. With my scientific background I also wanted to understand how the science worked. There weren't many answers, though, because the techniques were so new – especially nail extensions, which had emerged from products used by US dentists. This piqued my inquisitive nature: I was hooked. It was the California-based company CND, founded by the inspirational Nordstrom family, that gave me those first answers, and continues to do so today. Doug Schoon, a chemist and CND's chief R&D scientist at the time, started me off on a lifetime of learning about the science of nails. The team at CND has enabled me to push technical boundaries, and also shares my attitude that the best can always get better.

After I'd set up the nail treatment centre and it was running well, I decided I wanted to create my own, standalone nail salon. In 1988 I joined forces with Kay Dodd to create

Fingertips in Hertford together. We were friends with children the same age, and when we told the school-gate mums what we were doing, almost all of them thought we were mad. It was the first salon of its kind in the south-east and clients were used to multi-treatment businesses. Before long, however, we'd launched what remains today a successful business for a different owner.

One of the most engaging aspects of running the salon was the social side. We quickly realized that clients booked themselves in for regular slots, so they would end up seeing one another every week or two. Consequently the salon became a hub for all of us. At the time I also became a magistrate, a serious position that gave me both positive and negative insights into the way we connect with one another. The combination of both gave me a deeper understanding of how to build great relationships with anyone who sits on the other side of a nail desk. Touching a person's hands is a very personal act, and I've always thought it's important to create a warm experience for a client or model.

During this time, the nail business was still tiny. There were no proper qualifications to speak of and it felt unregulated, so a few of us got together and formed what we called the International Nail Association. We were nail technicians and distributors, which meant that we covered most of the business between us. One of the most important things we did at the time was to arrange an industry insurance policy available to members who could demonstrate the quality of their work.

By 1991 I was involved in training. Wallace Sharps ran the Health and Beauty Therapy Training Board (HBTTB), then the recognized industry authority, and he approached me to help develop National Occupational Standards (NOS) for manicuring. At the time, manicuring was grouped into a hairdressing qualification.

This was the beginning of National Vocational Qualifications (NVQs) for the beauty industry. The HBTTB was long ago superseded by Habia (Hairdressing and Beauty Industry Authority), but I'm still involved in this area of the business as the industry grows and develops.

Today, there are many technical options that simply didn't exist in my earlier years in the industry. I am always looking for fresh ideas, especially if they call on the scientific side of my brain. One that has been important to the fashion side of my work is airbrushing. When I first came across it in 1998, it was mostly used by model-crafters. KaSaRa, a small company that specialized in airbrushing and nail art, offered to show me how it could be used as a creative technique.

At the time I was working a lot with Sharon Dowsett, a top makeup artist. We were both interested in the potential of airbrushing, not only for nails but also for makeup. Sharon also had a very cool loft in Farringdon. It was there that the KaSaRa expert taught us both how to airbrush – Sharon for face and body and me for nails. It gave me a lot more control and different options for nail design, while Sharon became one of the early adopters of airbrushing for makeup.

Great relationships are at the heart of the best pictures, which are almost always acts of collaboration. Since my first shoot over 20 years ago I have developed a wonderful working relationship with Nick Knight. He has many talents as a photographer, one of which is his attention to detail. For him, the nails are an important element.

When he first booked me, very little attention was paid to nails. If anything, nails were an annoyance. Some models would turn up with theirs in a shocking state and it was the job of the makeup artist to make everything better.

Nick had a different approach. His critical eye can evaluate every detail, every attitude in a moment. He sees the hands as an essential part of the sitter's 'expression'. Nick has said: 'Nails in an image are like the last note of a melody that you always remember. Nails are such an important part of it – they finish the line.' For him, the nails become a focus, which is why he took the trouble to find a nail technician; he didn't want that detail to be an afterthought. It could be argued that Nick is at least partly responsible for creating the successful fashion nail industry we're a part of today.

Alongside Nick and the hairdresser Sam McKnight and makeup artist Val Garland, I have been lucky enough to help create some groundbreaking images since 1998.

Having their personal friendships has also made my working life so much easier. At the start of my career, models were reluctant to allow anyone near their nails for more than polish because poor practice at previous shoots or shows had damaged their nails. Sam was very good at reassuring them that their precious nails would be safe in my hands.

After so many years together, we can work quickly and easily to create whatever simple or spectacular look is required of us. It helps that we have a similar, sometimes naughty, sense of humour and at the end of the day we're all just friends doing our creative jobs. Over the years, I have spent hours and hours laughing (and singing old music hall songs!), particularly with Sam.

Of course, without models the rest of the team would be redundant. The nature of our work means that the backstage beauty crew will be booked together for many shoots, some back to back, but the model will always be changing. That said, I have been lucky enough to work with a few women regularly, starting with Kate Moss, who

Right: My first experience in the fashion industry: the Casadei photoshoot, photograph by Nick Knight.

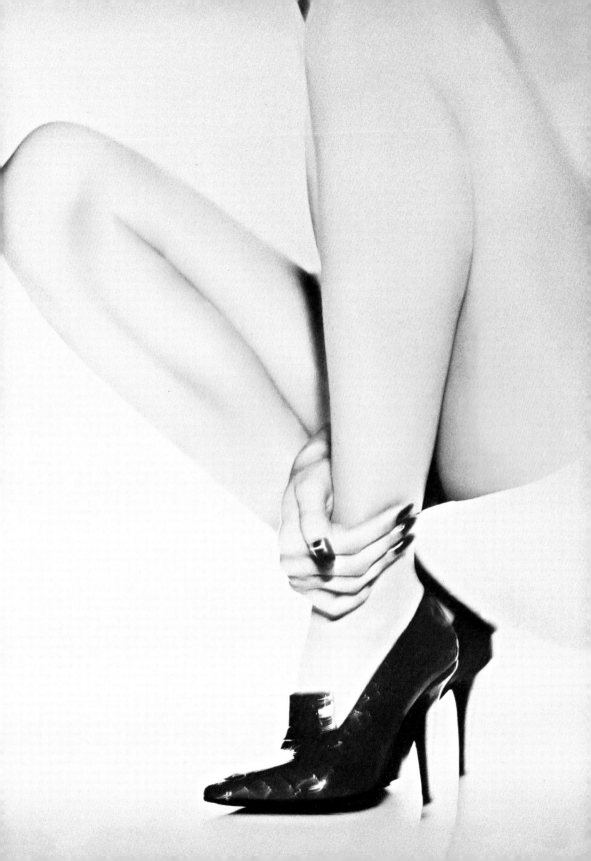

was the model for my first *Vogue* cover. Our long and friendly working relationship has included campaigns for Dior and Rimmel, shows for Alexander McQueen and various SHOWstudio projects.

Kate is one of my favourite models, not least because she is always such fun to be with. Her entry into the studio in the morning is always 'Morrrrrrning!' shouted at the top of her very familiar voice. She always takes the time to go around to say hello to everyone – great manners on her part and something that always puts everyone at ease.

I can't say Kate enjoys having her nails done on shoots, especially if there need to be 'attachments'. She has never complained, though, and she is certainly partial to dark nail polish. When Kate is on holiday she likes to paint her toes on the beach, and at times I've put together a little kit of fun nail bits for her and her daughter to take on their summer holiday.

Beyond the studio we all form relationships with brands and companies, not necessarily for financial reasons. The scientific nature of the beauty industry means that nail and makeup artists forge these links to explore the technological advances and their creative potential.

One important and enjoyable collaboration has been with MAC Cosmetics, specifically with James Gager, the former senior vice president and group creative director. It's very satisfying when a client rebooks you for their advertising campaigns: it means you've done a good job the first time around. It is truly amazing when that client asks you to collaborate with them to create a retail line for the brand. This is what happened with MAC Cosmetics.

> **I stay true to my own style of creative curiosity. Thankfully it's one that chimes with the most innovative designers and photographers.**

Val was already working for MAC when she recommended me for a shoot in New York. It called for 'interesting' nails, which I created using string. It also meant I'd be working in London with Miles Aldridge, the photographer who has shot many iconic beauty images for MAC over the years.

From the outset it was clear that James didn't like 'pretty'. He mostly responded to an 'off' colour, one that is less obvious. One of the things he liked about my work was my ability to mix colour to achieve the unusual. I had always mixed colour in my salon but not thought a great deal about it. It was this knowledge, however, that meant James would ask for a *very* specific colour – to match a lipstick, say, or part of the set – and I would be able to find it.

I was eventually asked to create a unique line for the brand (see page 140) – a huge privilege. I expected to receive quite a tight brief, as was usual at the shoots, but this time there were no parameters. I was being given the keys to the MAC treasure chest with no creative direction. Once again, it was a challenge that would test my ingenuity.

I began by looking at MAC's brand vision. It had always encouraged its customers to make their own stories and to be true to their own sense of beauty. Part of that vision was to encourage experimentation. I had long used powder pigments to create different polish colours and effects, an idea buried in MAC's DNA. So I used that idea as my starting point. I decided to create a polish range that could be used alone for a beautiful and surprising effect or, when used on top of another colour, would transform it. The

layering idea included a highlighter to make colours pop and a shader to give them depth.

The process included a day at MAC's polish labs creating the exact colours and effects I wanted. This synthesis of science and art is what has made my job such a pleasure for so many years, and buoyed by the experience of that day I was ready for my next first: attending an impromptu meeting at the company's HQ to explain my concept.

I was expecting a couple of people in a meeting room but ended up in their impressive boardroom presenting to MAC executives. I explained the concept and was met with … silence. Had I pitched badly? Had I messed up my open brief? No! It turned out they were so impressed they needed a few moments to process the idea. James, who was sitting next to me, leaned over and whispered in my ear, 'I knew you could do it!'

It was a defining moment in my career, another test passed. The range was titled Transformations and I went on to take part in a presentation to 150 global beauty press and makeup artists at the Teatro Sociale in Como, Italy. The occasion also included a James Bond-style boat ride to dinner in a spectacular villa, with waiting staff who looked like they had come from central casting. Yet another of my pinch-me moments!

My work with Minx Nail Inc. has been another important tie-up. Launched in 2007 by Dawn Lynch-Goodwin and Janice Jordan, it has been the market innovator of nail stickers and wraps. We have worked together many times since, including the show for *Plato's Atlantis*, Alexander McQueen's last collection (see page 199). Minx brought to the market unique, printed nail coverings that included metallic and holographic finishes. The result is endless creativity that can be achieved quickly – very important for both photographic work and the catwalk.

Teaching has been important to me throughout my working life. Lately I have extended that work to include Mastered, a global online programme for professionals across the fashion fields to extend their skills and collaborate. Nick Knight, Sam McKnight and Val Garland also contributed to the pool of knowledge during its first year. The aim of Mastered is to inspire and help younger creators from a constellation of backgrounds to gather their abilities and hone their own areas of expertise.

There are no entirely straight career paths in fashion, but when I left school and started my working career as a forensic scientist for the Metropolitan Police I could never have guessed that I'd end up making 'extreme' nails for the world's media or creating nails for some of the most famous women in the world.

So many times in my long career, I've stood back and witnessed fashion magic happen before my eyes. In the studio I've watched Naomi Campbell put the full force of her powerful persona into a character. I've seen Erin O'Connor work every part of her body right down to her little toe until she achieves the perfect line. I've heard Björk and Lady Gaga sing their hearts out to an audience of less than ten.

I have to say, I'm proud of my front-row seat. As lucky as my introduction to the highest echelons of fashion was over two decades ago, I have to earn my place there each and every time I'm asked to do a job. I am older than most of those I work alongside, but I will only be invited if my work remains current and relevant. I never stop questioning techniques or researching new ones. I never lose sight of fashion's horizon and am on the look out for those who are emerging into view. Most of all, I stay true to my own style of creative curiosity. Thankfully it's one that chimes with the most innovative designers and photographers.

Weird? Right up my street!

Marian Newman, 2019

Helping Hands

As a way of honouring their enormous contribution to my own creative portfolio, I approached some of my fashion collaborators to create an image of their own hands. Each of their responses were, just like their personalities and work, unique!

1

2

3

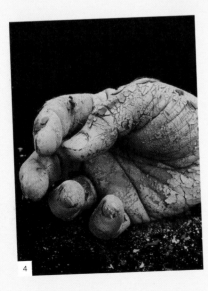

4

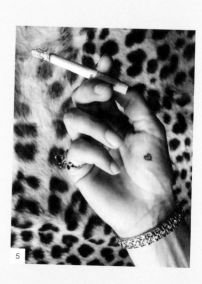

5

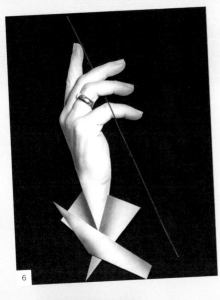

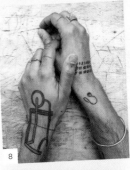

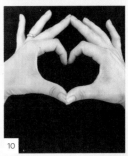

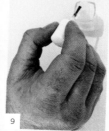

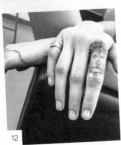

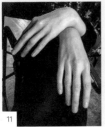

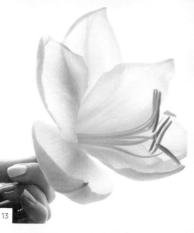

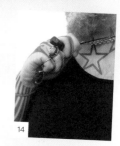

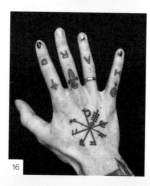

1. **Val Garland**
 Makeup artist

2. **Sam McKnight**
 Hair artist

3. **Nick Knight**
 Photographer and
 director of
 SHOWstudio.com

4. **Sølve Sundsbø**
 Photographer

5. **Kate Moss**
 Model and businesswoman

6. **Justine Laeufer**
 Photographer

7. **Eugene Souleiman**
 Hair artist

8. **Ryan Lanji**
 Fashion and art curator

9. **Adam Slee**
 Nail artist

10. **Aimee Mullins**
 Athlete, actor and model

11. **Erin O'Connor**
 Model

12. **Cara Delevingne**
 Model and actor

13. **Kathy Phillips**
 Former International
 Beauty Director of Condé
 Nast Asia Pacific and
 the founder and creative
 director of This Works

14. **Malcom Edwards**
 Hair artist

15. **Janice Jordan**
 President and CEO of
 Minx, Inc.

16. **Tom Eerebout**
 Stylist

Iconic Editorials

PHOTOGRAPHY BY

Nick Knight

——

'White Heat'

PUBLISHED IN

British *Vogue*

——

JUNE 1997

It was early in my fashion career when I got a call asking me to leave my salon and hotfoot it to London to help urgently on a shoot for *Vogue*. The model, Sara Morrison, needed some remedial work on her bitten fingernails, so I hopped on a train with a small nail kit. By the time I arrived it was lunchtime and, although the team were patient, I needed to work very quickly. It was an important moment for me because I was able to create believable nails using a technique that the team hadn't seen before. It was still a time when nail technicians were rarely used on shoots, so in a way I proved myself that day. It felt important for people to see my value to the team beyond decorating nails.

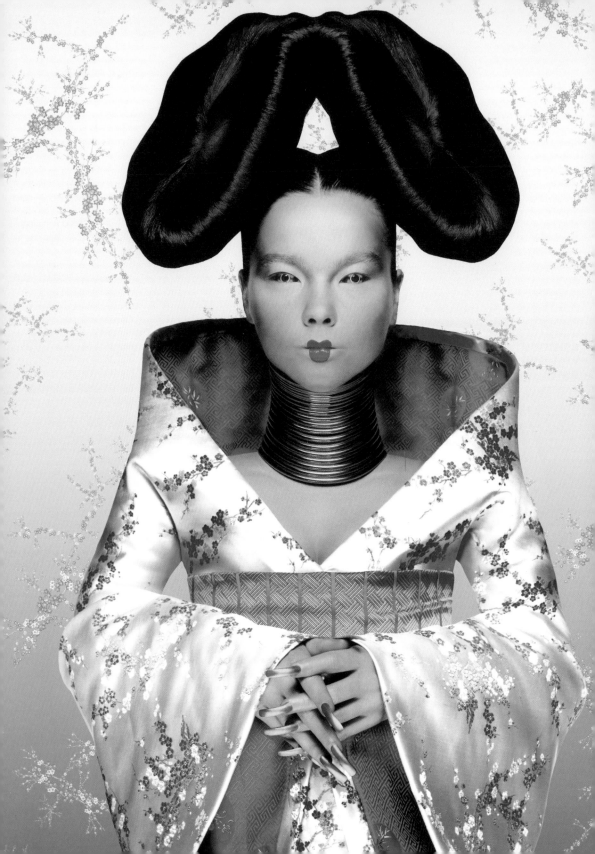

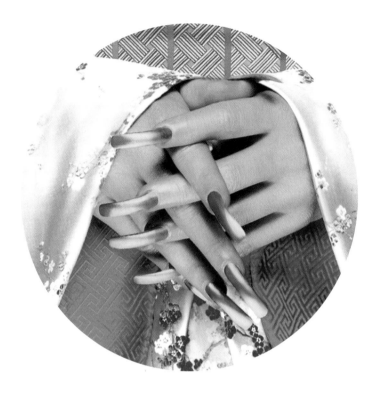

PHOTOGRAPHY BY

Nick Knight

——

APPEARED ON

Homogenic,

by Björk

——

22 SEPTEMBER 1997

Nick Knight was asked to create Björk's *Homogenic* album cover, and Alexander McQueen was commissioned to make the dress. The brief was 'alien' – possibly with fish scales thrown into the mix! After a discussion to finalize the concept, I started to experiment with various ideas to complement the Chinese-inspired fabric of Björk's dress. I used a layering and dry brushing technique so that the colour seemed to move under the studio lights. It's rarely appropriate to make nails with any type of acrylic on shoots, because it takes too long to apply them – and far too long to remove them safely afterwards – but on this occasion, session and salon techniques had to be merged to achieve these extreme oriental talons.

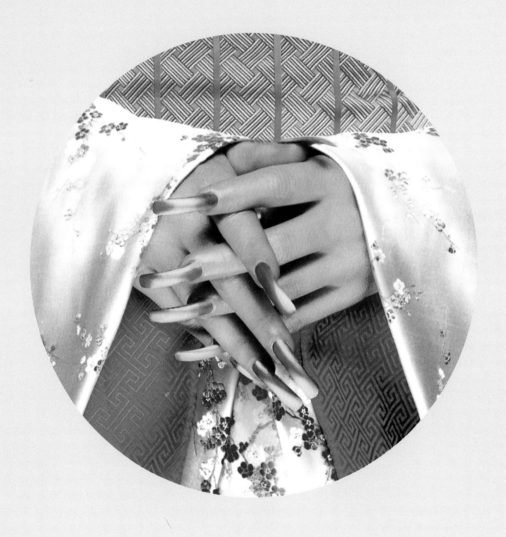

How to create unique colour effects with dry brushing

This was a technique I discovered when I was trying to achieve a specific look for Björk's album cover. Since then, I've used it many, many times to create different effects. Used alone, it can look painterly and abstract. Over a wet polish, it can blend two colours beautifully. Over a dry polish, it will give a sharper blend or a very easy bit of decoration. For this image I used it over dry polish; the base colour was blue and the top was silver.

1. Clean the nails with a conditioner-free polish remover.

2. Apply a thin layer of clear base coat to each nail.

3. Apply the base colour coat, I used blue for Björk.

4. Choose a contrasting colour. I used silver for Björk. (By the time all ten nails have been painted, the first one should be sufficiently dry for the brushed top effect.)

5. Wipe the brush on the neck of the bottle until there is very little polish left on it. Before applying to the nails you can test the technique on nail tips by using different amounts of polish on the brush, and different pressures, as each will give a different effect.

6. Apply the contrasting polish using lots of short strokes, almost as if you are wiping the polish back off. The base colour should show through the top colour. In Björk's case, the metallic effect of the silver gives a very pleasing effect in direct light.

7. Use a top coat if you want the nails to be glossy, or leave if you would like them to remain slightly matte.

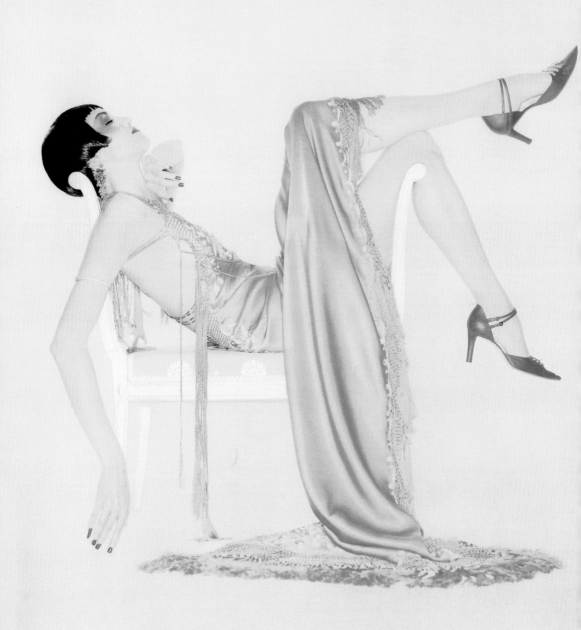

PHOTOGRAPHY BY

Nick Knight

———

CAMPAIGN FOR

Dior

———

AUTUMN/WINTER 1997

The devil, and sometimes an angel, is in the detail when it comes to nails. John Galliano's first shoot for Dior in 1997 called on the services of Linda Evangelista, Yasmeen Ghauri (seen here) and Shalom Harlow, three of the most lissome models we've ever seen. Their sinuous, Chinese-inspired gowns evoked the heady, Bohemian haze of the 1920s. Towards the end of the shoot, Yasmeen was shot with a single long pinky on her right hand. I had created short red nails, but left one long to symbolize the cocaine nail her character might have worn. The team kept my creative statement in, producing one of my pinch-me moments.

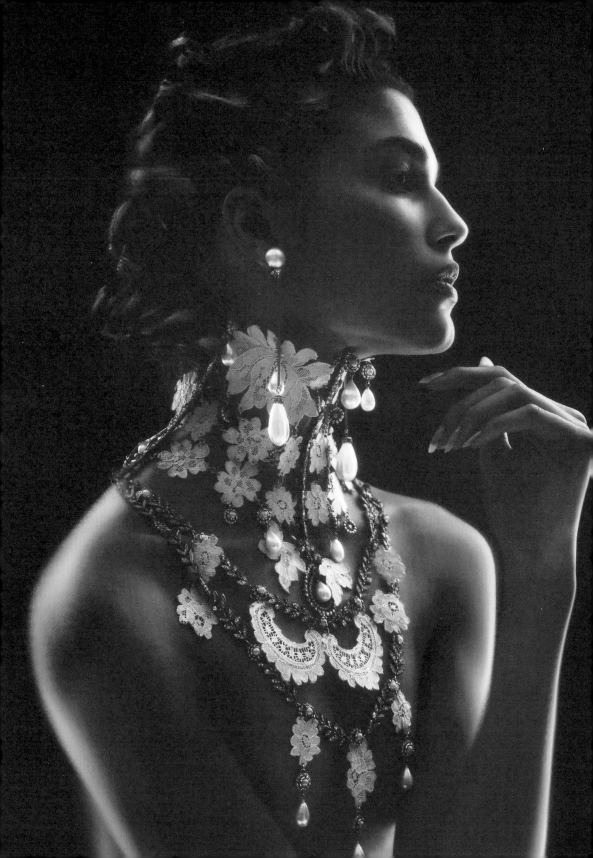

PHOTOGRAPHY BY

Nick Knight

——

CAMPAIGN FOR

Dior

——

SPRING/SUMMER 1998

Sometimes an image exemplifies the craft I'm so proud of – and that's certainly the case here, an image from John Galliano's second Dior campaign. The collection was a synthesis of a sort of Edwardian European and tribal African glamour. There was no brief; the team simply came together in the morning and the shoot evolved. For my part, this was the time before stick-on nails could be made to look halfway real, so I used my own technique to achieve a near-perfect 'natural' nail.

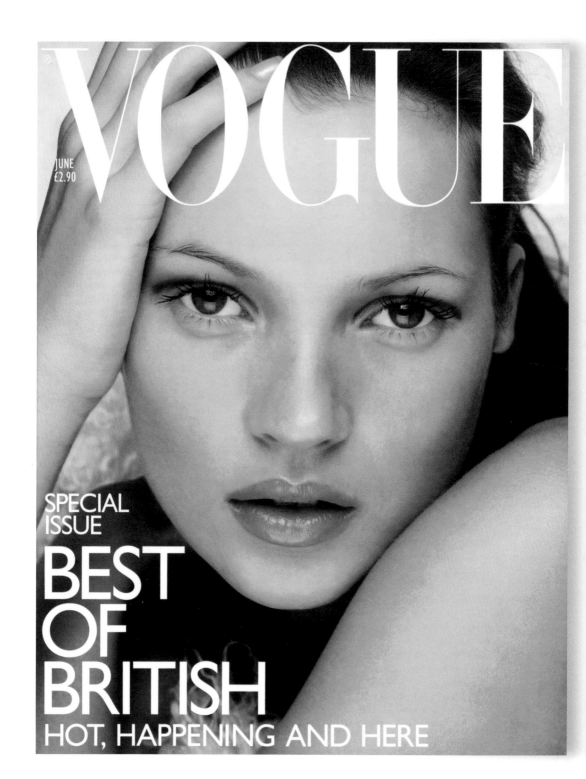

VOGUE

JUNE
£2.90

SPECIAL
ISSUE

BEST
OF
BRITISH
HOT, HAPPENING AND HERE

PHOTOGRAPHY BY

Nick Knight

———

'Best of British'
PUBLISHED IN
British *Vogue*

———

JUNE 1998

This was my second shoot and my first *Vogue* cover. I was booked because I'd recently worked on my first ever shoot with Nick Knight and Lucinda Chambers, the photographer and stylist. I think it's the first time a dedicated nail person was ever used on a fashion shoot in this way and it certainly consolidated my reputation from the outset. Robin Derrick was the art director at *Vogue* and he joked he'd made me famous with the fingernail that pokes out between the O and the G on the cover. I remember that the team talked about a 'cover try' on the day, but I had no idea at the time that it meant a speculative shot at creating a *Vogue* cover.

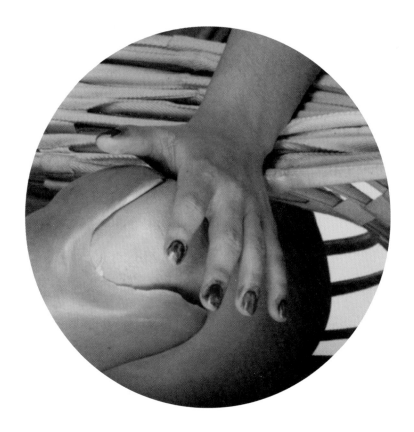

PHOTOGRAPHY BY
Nick Knight
——
'Access-Able'
PUBLISHED IN
Dazed & Confused
——
SEPTEMBER 1998

This image was part of a fashion story created for *Dazed & Confused* magazine and art-directed by Alexander McQueen. Groundbreaking in many ways, it featured the athlete and model Aimee Mullins, who uses prosthetic legs, as a way of challenging the prevailing ideals of physical perfection. Val Garland and I created a beauty narrative that cast Aimee as a beautiful broken doll. The nails on her fingers and on her prosthetic toes were made to look as though they'd been painted and rubbed off by generations of little girls who had loved her and passed her on. An image such as this is created with many visual messages, so I also attacked the legs with lash glue and brown eye shadow to make sure they had the same 'used' look.

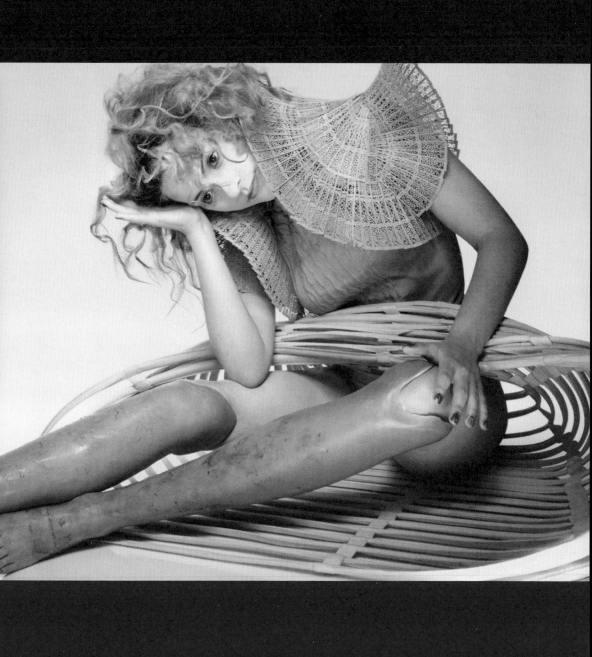

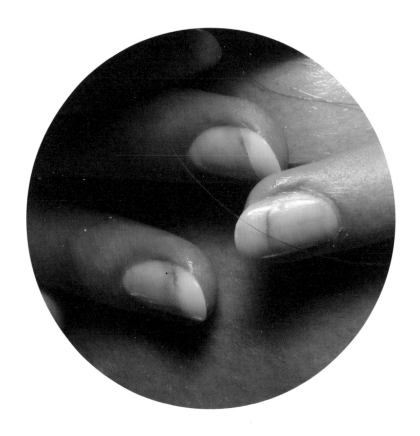

PHOTOGRAPHY BY

Nick Knight

——

CAMPAIGN FOR

Dior

——

SPRING/SUMMER 2000

This steamy Dior campaign features Gisele's neck but not her hands. Those belong to Rhea Durham, another gorgeous woman but one with short nails! For this shoot, they needed to be natural-looking but longer. It is easy to lengthen nails if they are going to be painted, but achieving a perfect 'natural' nail when they're going to be photographed so minutely is much harder. I have always used a technique that adds just a tiny sliver of tip to the very edge of the nail, so that the main part is real. Products have changed since this time and, unfortunately for me, I can see faults in the nails in this shot, although the overall effect is stunning.

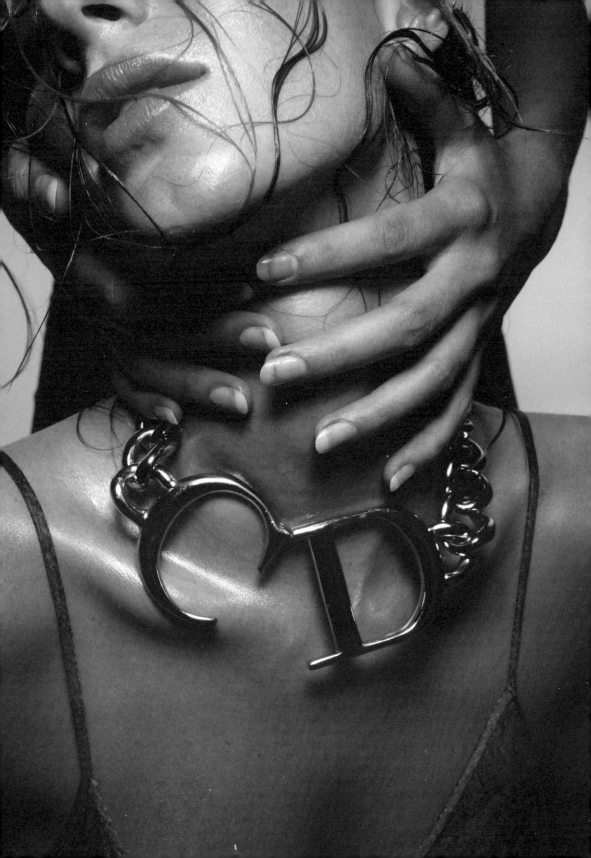

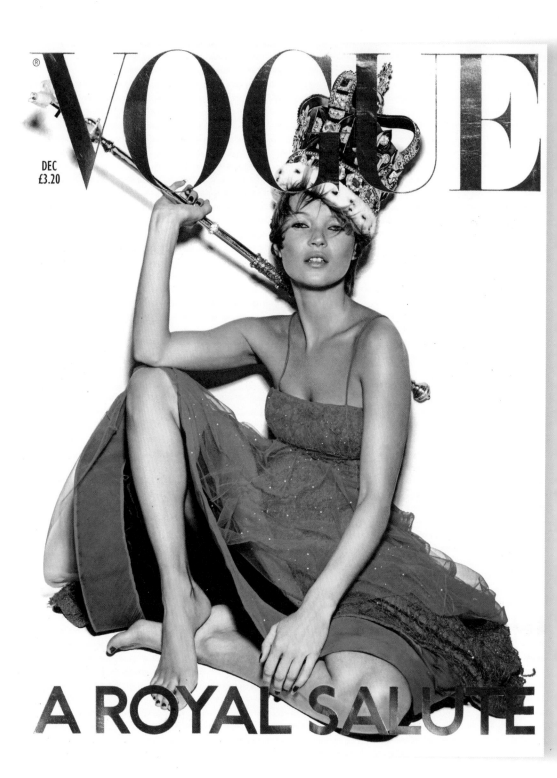

PHOTOGRAPHY BY

Nick Knight

———

'A Royal Salute'

PUBLISHED IN

British *Vogue*

———

DECEMBER 2001

This cover shoot and fashion story was for the royal issue of British *Vogue*. It was an interesting story from beginning to end – especially seeing the replica coronation crown, which was as heavy as it was beautiful. For Kate's fingers and toes, dark red was chosen, but for such an important cover I wanted to add some detail. With a crown as a reference, I applied little pieces of gold-coloured wire to the end of each nail. I knew that a close-up was out of the question, but when they were held together they looked like a little crown!

PHOTOGRAPHY BY

Vincent Peters

——

'Princess purr-fect!'

PUBLISHED IN

The Face

——

SEPTEMBER 2002

This cover always surprises people because the designer Phoebe Philo has caſt herself as a cat. She also wanted an element of bling on her long, feline nails, which I created with cryſtals and diamantes around the smile line. The moſt creative people in fashion very often extend their artiſtry into their personal ſtyle and that's certainly true of Phoebe.

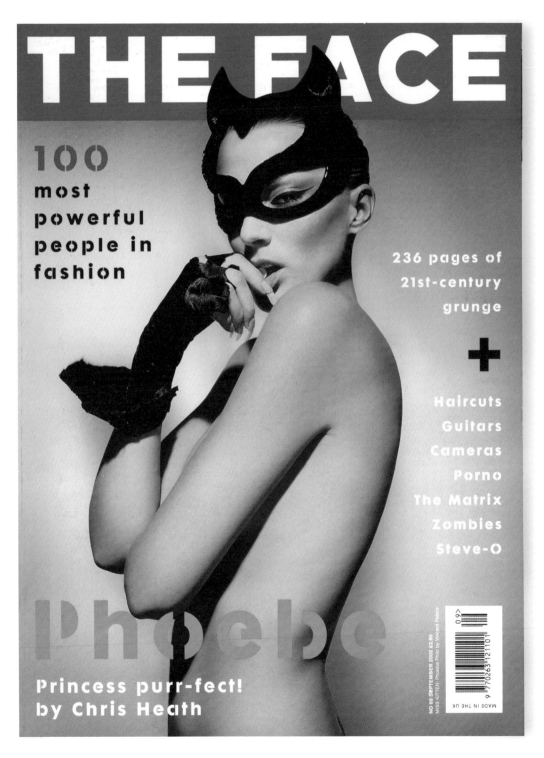

THE FACE

100
most
powerful
people in
fashion

236 pages of
21st-century
grunge

+

Haircuts
Guitars
Cameras
Porno
The Matrix
Zombies
Steve-O

Phoebe

Princess purr-fect!
by Chris Heath

NO 60 SEPTEMBER 2002 £2.90
MISS KITTEN: Phoebe Photo by Vincent Peters

MADE IN THE UK

9 770263 121101

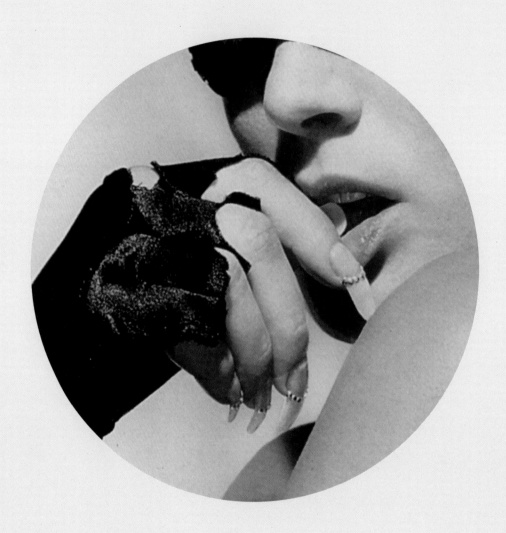

How to use embellishments to create subtle glamour

With nails, sometimes less is more. This image was created long before any type of nail art or embellishments became mainstream. Lots of things can be used to decorate the nail – many years ago they used to be called 'polish secures', which describes the technique perfectly. Often just one or two strategically placed embellishments can elevate a simple polish to create a chic statement. Here I've used crystals and diamantes.

1. Clean the nails with a conditioner-free polish remover.

2. Apply a thin layer of clear base coat to each nail.

3. Apply two layers of the chosen colour coat. Once dry, apply a clear top coat over the colour. A gel effect polish is good to use, because it is usually thicker.

4. While the polish is still wet, pick up the embellishment using a wet orange stick and place onto the wet polish. For this look I applied crystals and diamantes along the smile line.

5. Gently push into the wet polish so that the polish 'grips' the sides.

6. A top coat of polish can be used to seal in some embellishments. Don't do this if using crystals, because they will become dull. Just make sure the sides are 'gripped' by the polish.

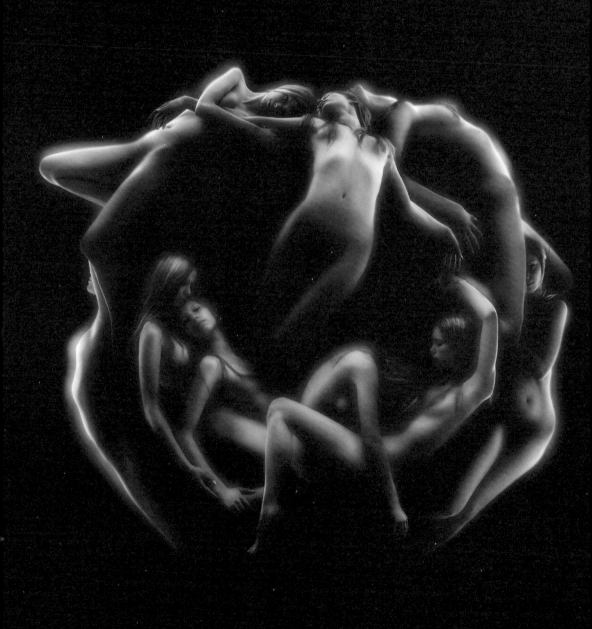

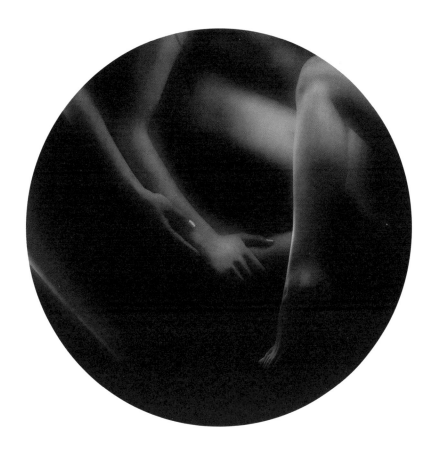

PHOTOGRAPHY BY
Nick Knight

———

CAMPAIGN FOR
Alexander McQueen
Kingdom perfume

———

2003

Sometimes my contribution is a small detail that won't be picked up on the final image. For Alexander McQueen's first fragrance campaign for Kingdom, Nick created an ethereal wreath of bodies. The nails were simply naked and as good as they could be. For me, this picture embodies the brilliance of the teams I've been lucky enough to work with. Every detail, shape, tone and colour is achieved because a team has brought its collective abilities to the studio that day.

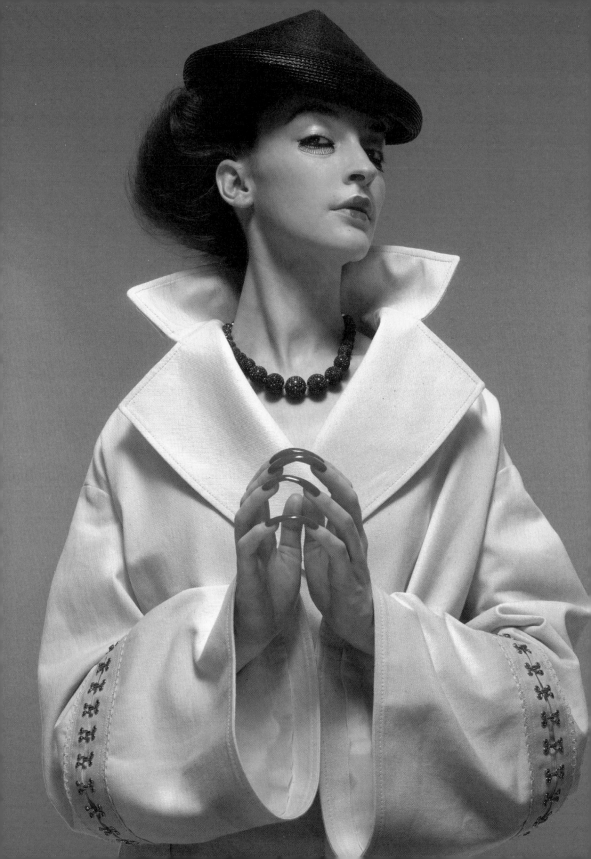

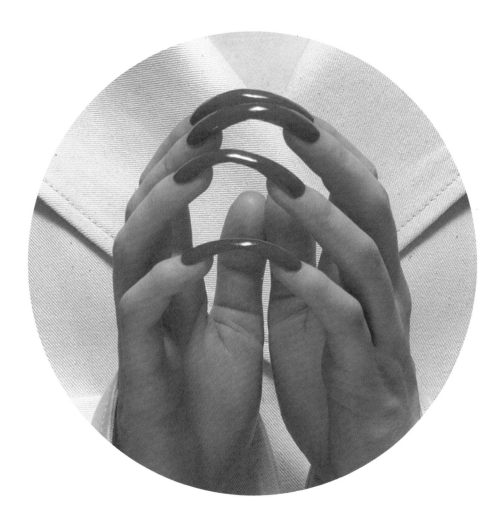

PHOTOGRAPHY BY
Justine Laeufer

———

PUBLISHED IN
Vogue Gioiello

———

JANUARY/FEBRUARY 2003

Sometimes, the most creative results come about because the whole team is willing to take risks together. On this occasion we were each bringing something fresh to the picture – as you can see from the styling, makeup and the image itself. I had the idea of joining nails together to create a slightly claustrophobic and surreal effect. I have since repeated the idea. The result has been different each time, but always a little disturbing!

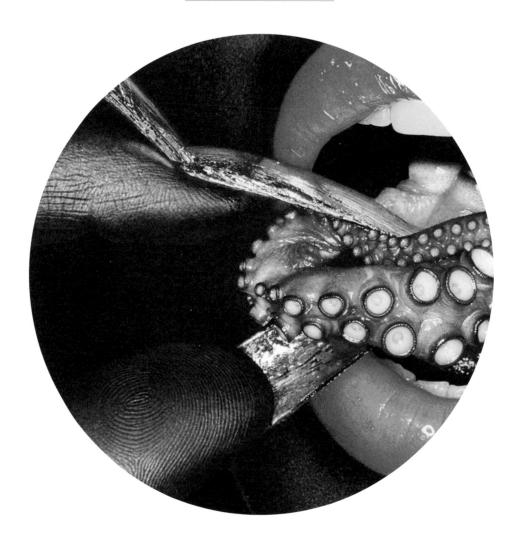

PHOTOGRAPHY BY
Darren S. Feist

——

PUBLISHED IN
The *Sunday Times Style*

——

20 APRIL 2003

I'm known for my creativity, but often I will come up with an extreme concept without having any idea how I'm going to execute it. This shoot was about seafood and I decided I wanted the nails to look and act like Japanese chopsticks. Not content with this challenge, I also wanted them to look as though they were made from real gold, rather than painted. This could only be achieved with gold leaf, which gives the nails their depth and richness.

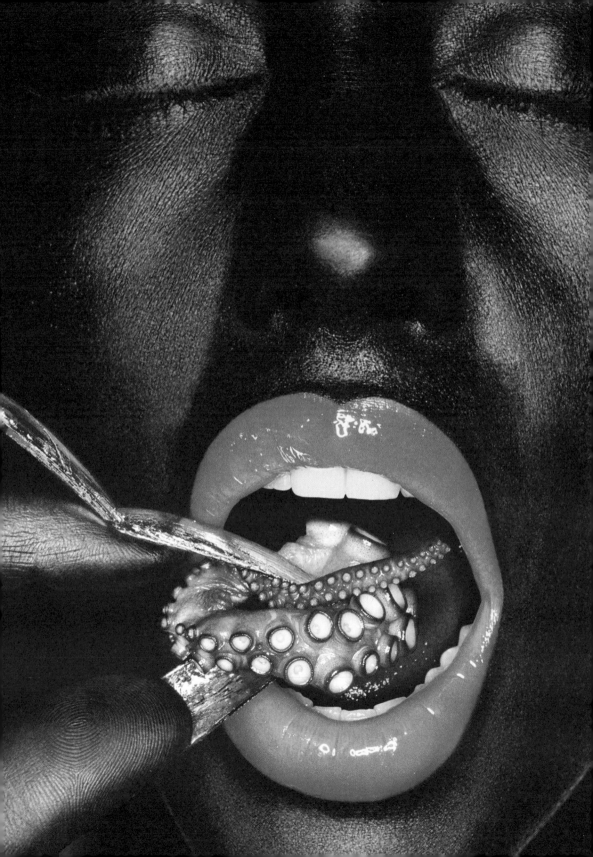

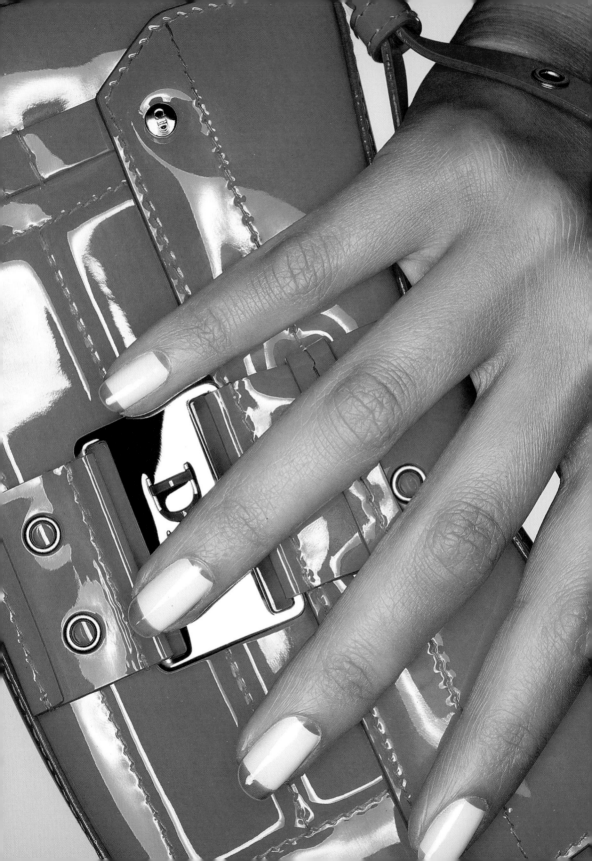

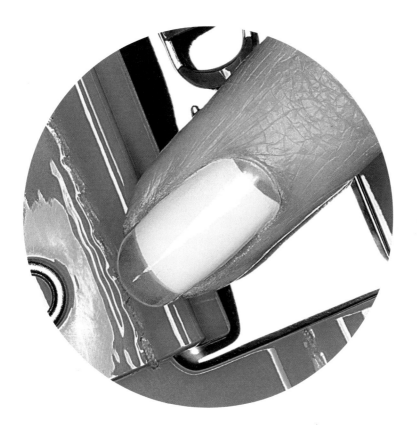

PHOTOGRAPHY BY
Robin Derrick

——

'Neon Signs'
PUBLISHED IN
British *Vogue*

——

JUNE 2003

This image for a *Vogue* beauty feature was really at the start of neon nail polish. My brief was 'neon', although at the time a neon pigment wasn't cosmetically approved, so we pushed the colour and offered good advice to the reader.

This particular style of nail was tricky to achieve. Getting straight lines that are good enough for a close-up is always a challenge. For this image I chose to use airbrushing, a versatile technique that has been popular in the nail industry. It's something I love to do, although I rarely use it because it requires a very heavy compressor for continuous and accurate 'painting'.

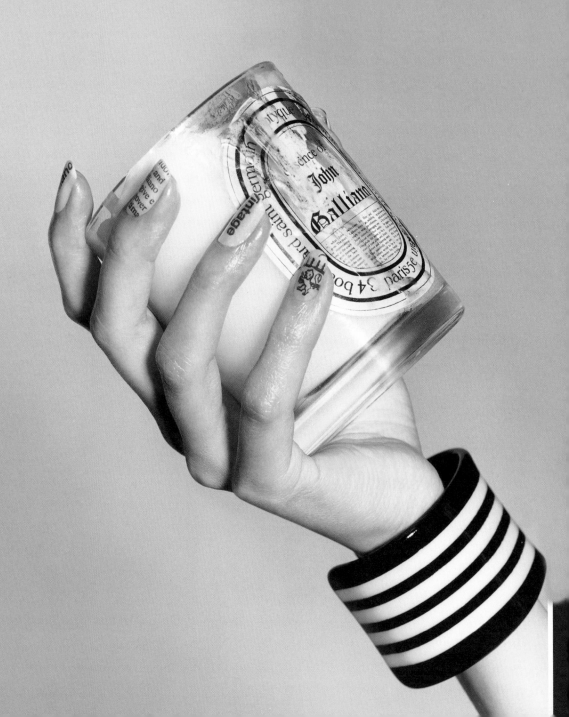

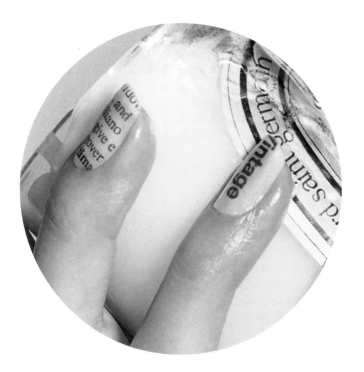

PHOTOGRAPHY BY

Metz+Racine

———

PUBLISHED IN

British *Vogue*

———

SEPTEMBER 2003

In 2003, John Galliano collaborated with the French candle company Diptyque to create his own unique candle. He told me that the scent was connected to incense, as he'd been researching into Russian churches and intense spiritual experiences. On a shoot for *Vogue* with the Beauty Director, Anna-Marie Solowij, we experimented with lots of ideas, including using airbrushing to create the impression of burnt carbon along the fingers (it looked amazing, but wasn't right). (I was using airbrushing again to create the effect of carbon up the fingers.) Part of the John Galliano brand packaging was tissue printed with his fictional *Galliano Gazette* newspaper. I had the idea of applying the tissue paper to the nails as a sort of découpage. It worked perfectly and I even placed a caricature of John bang in the middle of the thumbnail, although sadly it can't be seen in the photograph!

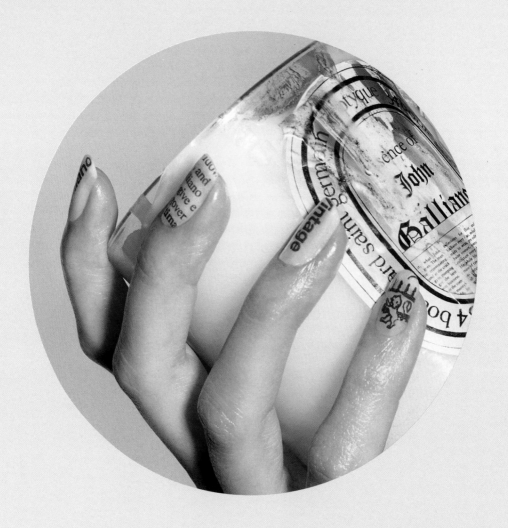

How to create découpage nails

There are lots of materials not specifically created for use on nails, but which are fun and perfectly safe to use. One of these is tissue paper or similar decorative papers. Cellophane is also a good material: it doesn't mould to the curves of the nail, but it can be cut up into small pieces and placed under polish.

This nail was created to tell a story about the stunning Dyptique candle created by John Galliano. For it, I repurposed his brand packaging – tissue paper printed with his make-believe newspaper, the *Galliano Gazette*. There was even a cartoon of John in the print!

1. Clean the nails with a conditioner-free polish remover.

2. Apply a thin layer of clear base coat to each nail.

3. Prepare the newspaper or tissue paper by roughly cutting it into small pieces. For cellophane, cut into your preferred shape.

4. Apply a colour coat that will complement or enhance the paper to be used – i.e., for coloured tissue paper, use a pale hue that features in the paper. (A darker colour works very well for shimmery cellophane.) Here I've used a cream colour to match the newspaper.

5. While the polish layer is still very wet, pick up the tissue paper with tweezers and lightly place it on the nail.

6. Gently press the edges of the tissue paper into the sides of the nail, to achieve complete coverage. Don't worry if it doesn't fit perfectly, it can be trimmed later.

7. When you're happy with the placement of the paper, trim any excess paper using small scissors. Then apply a layer of clear or sheer polish, making sure to seal the edges of the paper.

8. Reapply the top coat once or twice to seal and smooth. If the surface feels rough, once the top surface is dry, use a very gentle buffer to file smooth and apply another top coat. A gel effect top coat is good for this.

PHOTOGRAPHY BY
Corinne Day
——
'Wallflower'
PUBLISHED IN
British *Vogue*
——
AUGUST 2003

I've been privileged to work with some wonderful photographers. Corinne Day was certainly one of those. She had a very specific ſtyle, almoſt raw and very honeſt. For moſt fashion or beauty shoots the nails need to be perfeƈt, whether natural or painted. But sometimes a different approach is right, and Corinne's ſtyle often called for real imperfeƈtions. The almoſt childlike feel to this ſtory recreated the way a child gets hold of her mother's polish and plays with it. The results needed to look haphazard, but creating a convincing chipped nail is surprisingly difficult to do!

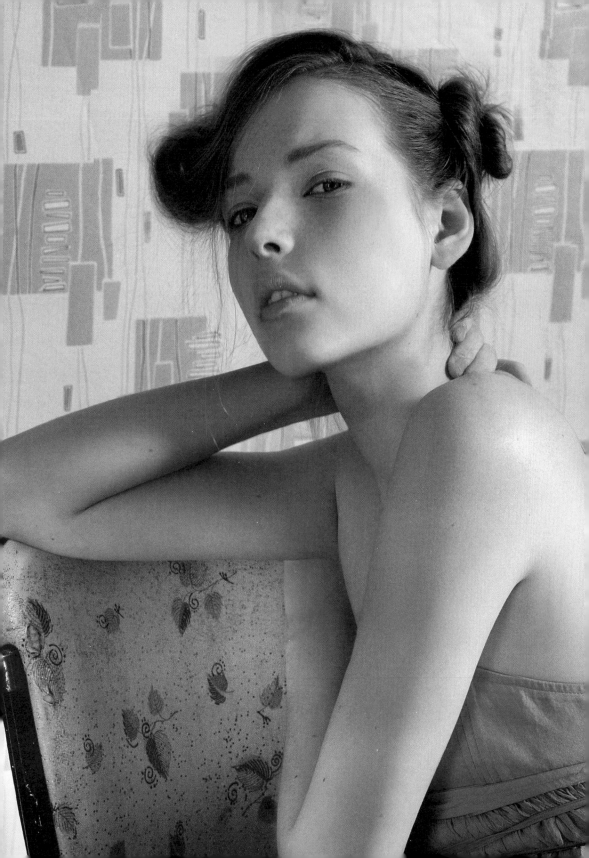

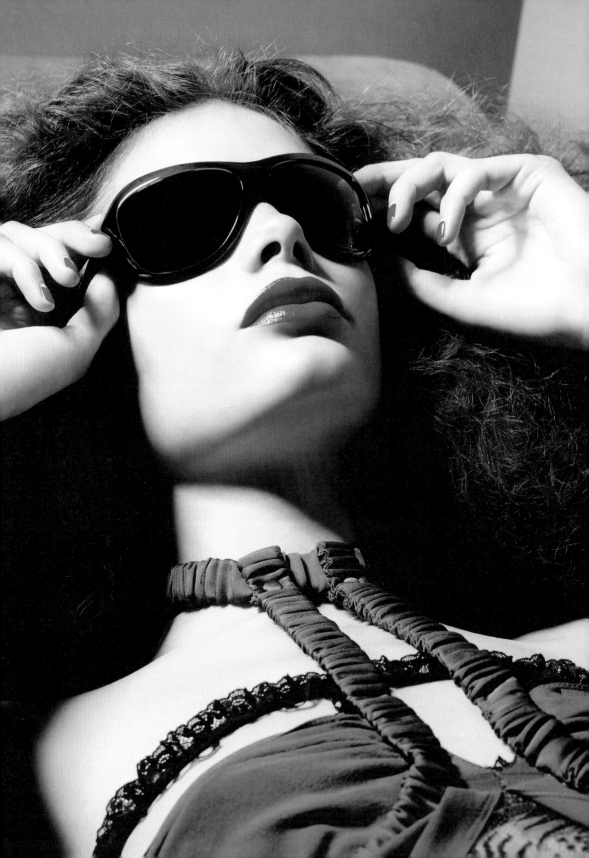

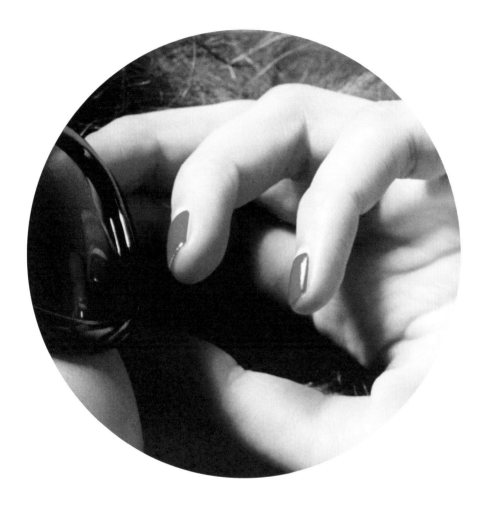

PHOTOGRAPHY BY
Craig McDean

———

CAMPAIGN FOR
YSL

———

AUTUMN/WINTER 2003

On an advertising shoot, the client will always have a very specific idea about how an image will look and will be there to help you to achieve it. On this occasion it was Tom Ford himself, who at the time was the Creative Director at YSL. The shot called for a moon manicure – a 1930s, highly polished technique that leaves the cuticle bare. The focus here is on the accessories (I repeated the technique for the handbag collection that year), but the nails give piquancy to the image and help to define the mood of the campaign.

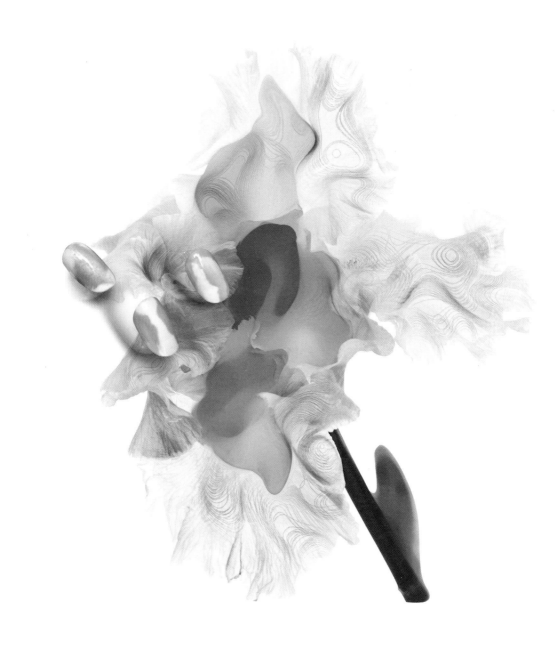

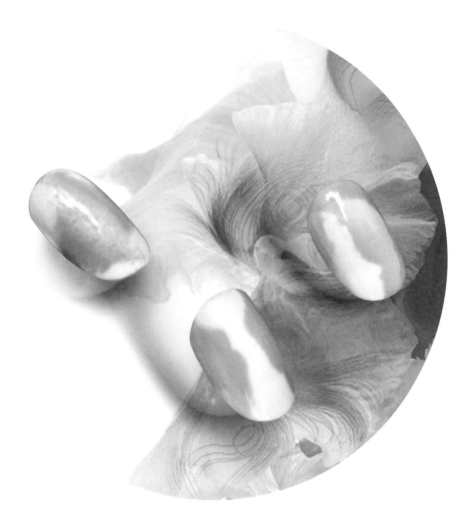

PHOTOGRAPHY BY
Nick Knight

———

PUBLISHED IN
Pirelli Calendar

———

2004

The shoot for Pirelli's 2004 calendar took an entire week and two studios working simultaneously. The nails for this shot were based on Georgia O'Keeffe's celebrated flower paintings (which she always denied were representations of women's genitalia). The subtlety and powerful softness Nick gave to his interpretation of the iconic calendar made it one of the best. This image ended up being on the cover of the calendar, a huge privilege for me.

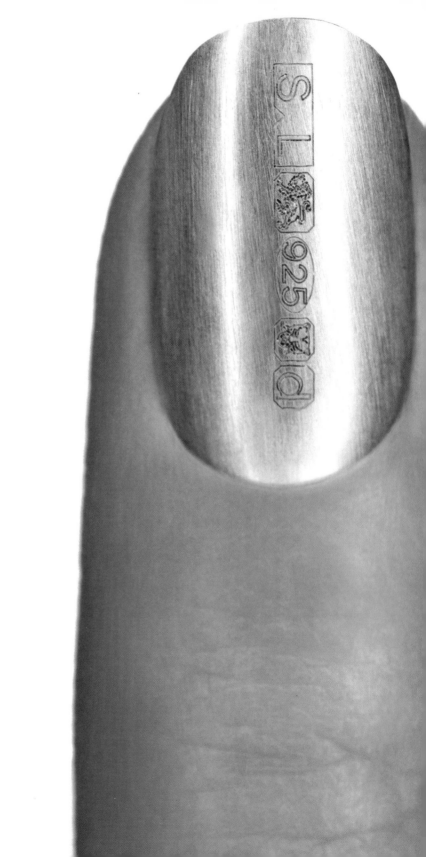

PHOTOGRAPHY BY

Carlton Davis

——

PUBLISHED IN

*Wallpaper**

——

SEPTEMBER 2003

Sometimes, a concept will arrive as a fully formed brief. I was approached because the editorial team was looking to create a solid silver nail with a hallmark etched into it. I created the template using a plastic form, and it was made by Shaun Leane, who was responsible for some of Alexander McQueen's iconic body jewellery. On the shoot I applied the nail and perfected the skin around it to give this hyperreal effect.

PHOTOGRAPHY BY

Tesh

——

'And God Created Kylie'

PUBLISHED IN

i-D

——

NOVEMBER 2003

Remarkably, this was the firſt time that Kylie had ever worn false nails. Everything about her is beautiful and perfeċtly executed, including her natural nails. But it was decided that for the shoot we'd create something longer and more vampy. Kylie's personal ſtyle is a part of her unique hallmark and the nails here extend that vision. They, like her, are womanly but always on the right side of sexy.

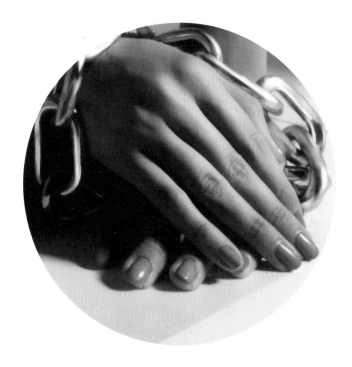

PHOTOGRAPHY BY

Nick Knight

——

'The Model'

PUBLISHED IN

British *Vogue*

——

DECEMBER 2003

For most great shoots, the creative team will work with references given to them by the photographer or stylist. One of the most invaluable skills to learn is making sure you've done your homework in the first place. This may involve hours searching on the internet or in a library. The shoot itself will then require you to interpret the references as they are intended. This beautiful shoot refers to the painter Tamara Łempika's highly stylized nudes. It directly references a painting from 1929 called *Andromeda*, so the nails, as in the original work, are given a tonal colour – in this instance, an intriguing 'off' orange.

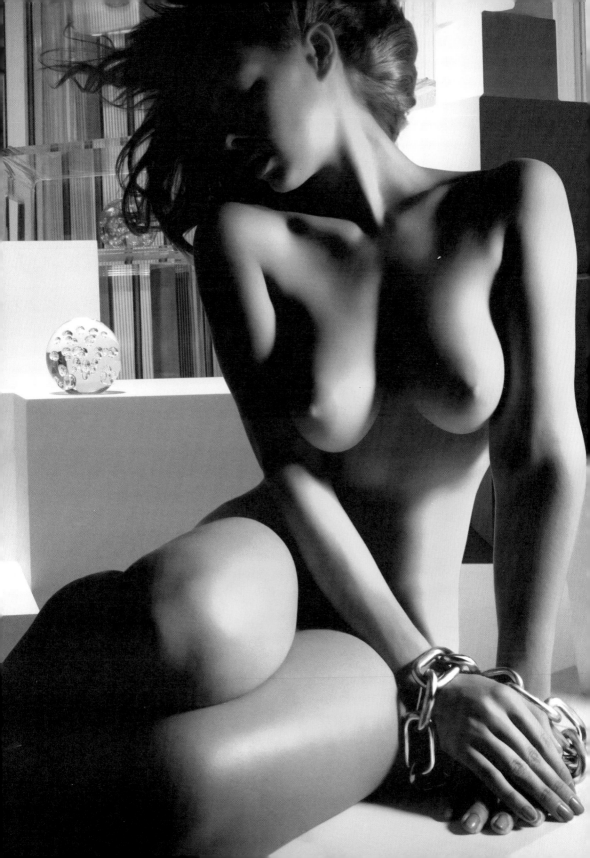

PHOTOGRAPHY BY

Nick Knight

———

CAMPAIGN FOR

Dior

———

SPRING/SUMMER 2004

This image of Gisele Bündchen represents the pinnacle of my career. After several very long days shooting this campaign, I was chilling on a sofa at 2 a.m. when I received a text from Val Garland calling me back to the studio. My heart sank. Had Gisele broken a nail? I sprang up with my nail glue and file and rushed to the studio. There I found Gisele, John Galliano, Steven Robinson, Nick and Val standing around a Polaroid of this image. This, they explained, was my shot – and they were right. The light had fallen to create the perfect image for me. It is an astounding picture, but what mattered as much was the pleasure the team felt for me. John has always called it my 'visitation from above'!

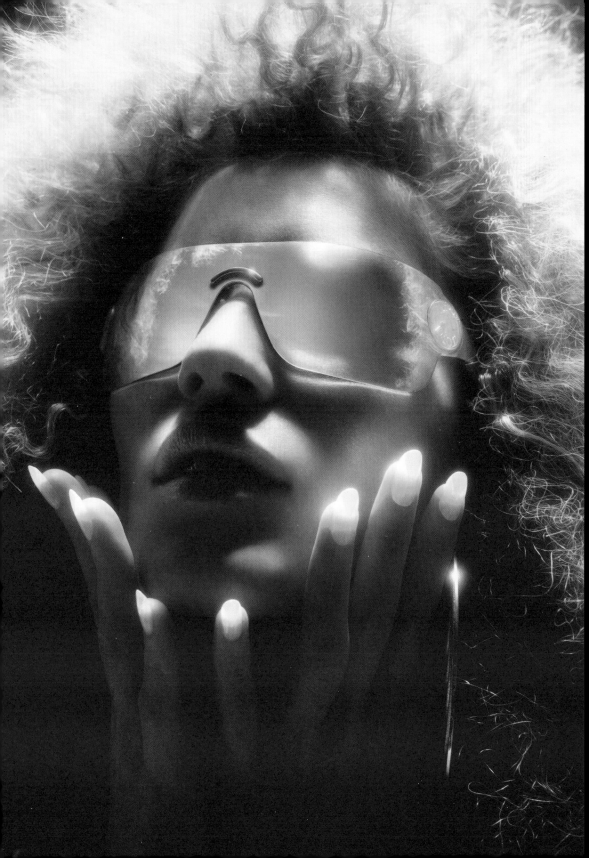

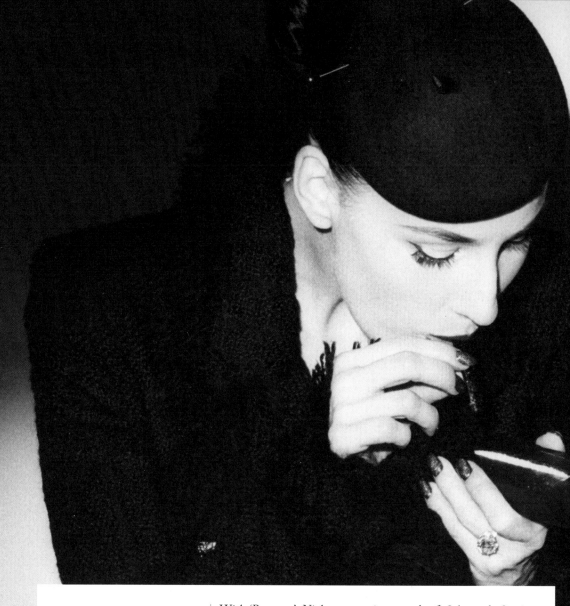

PHOTOGRAPHY BY
Nick Knight

———

'Banquet'
PUBLISHED IN
W magazine

———

MAY 2004

With 'Banquet', Nick once again created a first by orchestrating a multi-channel fashion moment. Mystery guests, including Dita Von Teese and Aimee Mullins, were invited to a living fashion shoot in the form of a dinner cooked by Heston Blumenthal. Together they entered a closed set to eat and interact for the event, which was live-streamed on SHOWstudio. The still images were also a fashion shoot for *W* magazine. Cameras were positioned above every setting, so the nails became a focus for viewers – who also got to eavesdrop on the conversations being held beyond the range of the lenses.

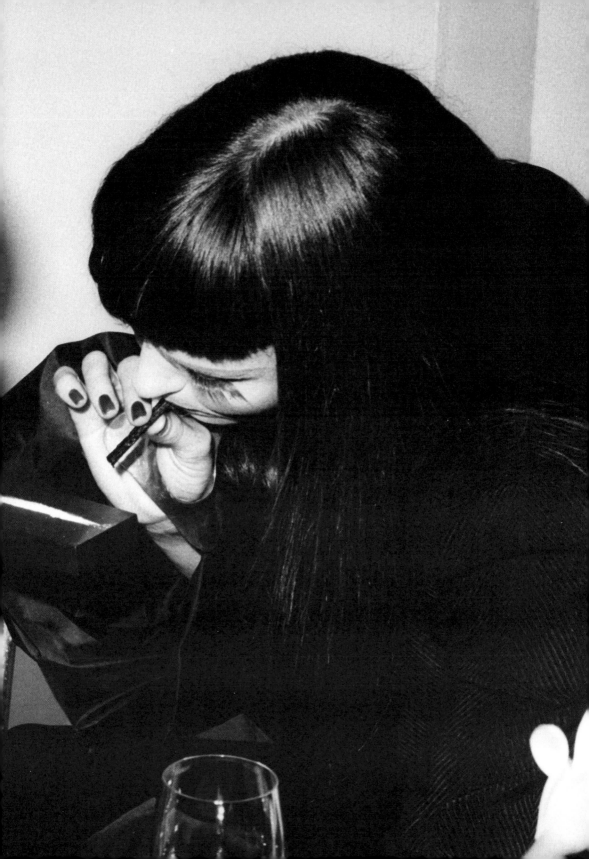

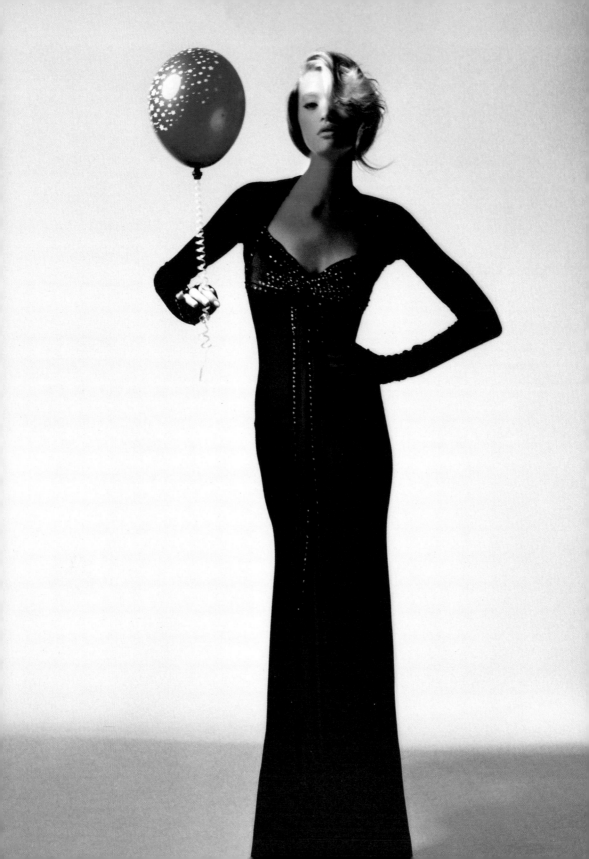

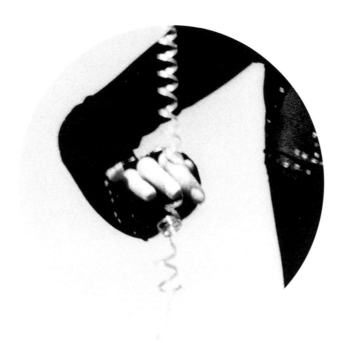

PHOTOGRAPHY BY

Nick Knight

———

'Banquet'

PUBLISHED IN

W magazine

———

MAY 2004

The simple elegance of this picture makes it one of my favourites. There are many wonderful models, and Gemma Ward is one of the best. Her beauty is both youthful and statuesque, which enables her to convey the charm school poise of a 1950s model in an entirely modern way.

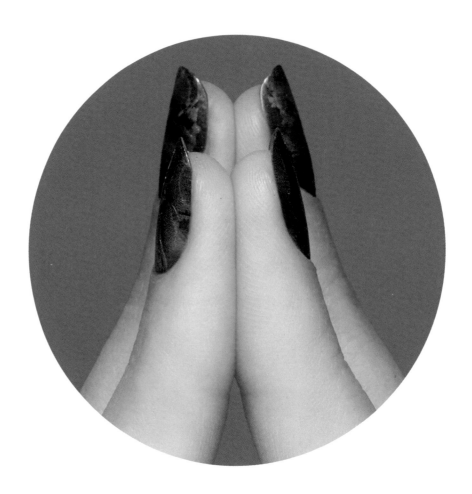

PHOTOGRAPHY BY

Matthew Shave

——

PUBLISHED IN

British *Vogue*

——

DECEMBER 2004

Shoots are dynamic and sometimes unpredictable, but that suits my personality: I relish a challenge and nothing pleases me more than to come up with a creative solution. When I turned up to this jewellery shoot, we realized that a stylist hadn't been booked. Instead of this being a problem, I was incredibly pleased to be able to style the pictures myself. I created a dark, marbled nail design so that the fingers could frame the design top and bottom without detracting from the jewellery.

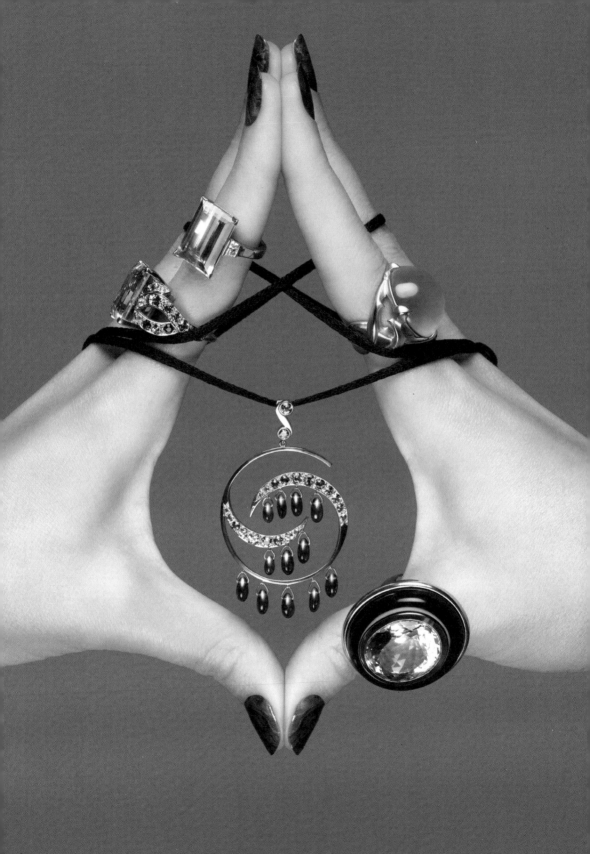

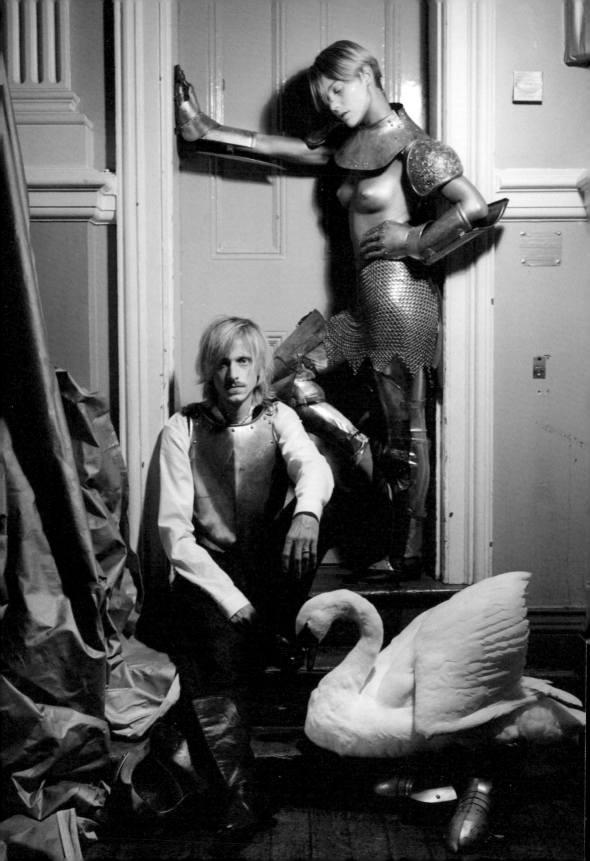

PHOTOGRAPHY BY
Tim Walker

———

'The Greatest
Show on Earth'
PUBLISHED IN
British *Vogue*

———

DECEMBER 2004

The photographer Tim Walker is known for his huge productions and this extravaganza, created for British *Vogue* with the stylist Kate Phelan, is no exception. The story covered page after page with remarkable personalities and models. MacKenzie Crook (photographed here with the model Fanny Gentle), Nigella Lawson, Alan Rickman and Bill Nighy were just a few of those photographed – it was a cast of thousands and took several days to create. Kate had the greatest number of clothes racks I've ever seen on a shoot. For me, the job was a never-ending procession of stars to manicure and the pleasing feeling at the end of the last day that every one of them was as charming as you would have wanted them to be.

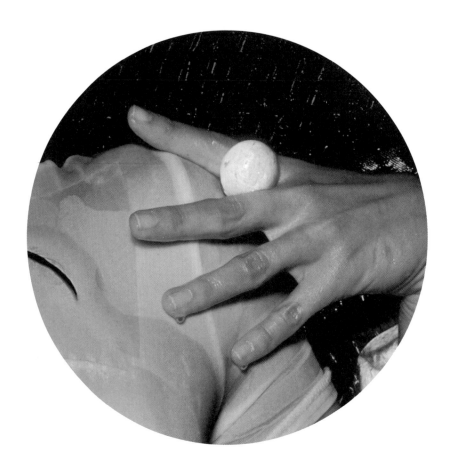

PHOTOGRAPHY BY
Nick Knight

——

'Centrefold'
PUBLISHED IN
British *Vogue*

——

FEBRUARY 2005

This is Cindy Crawford as you will probably never have seen her before. I missed the core supermodel years, so it was a joy to work with one of the originals. There was something special about the entire day and Cindy, despite the way the image comes across, was entirely calm and professional. Nick Knight is able to ask people to push themselves to places they may not have been, because the sitter knows that the result is always going to be sophisticated. Here the nail is simply manicured to be an extension of her beautiful skin.

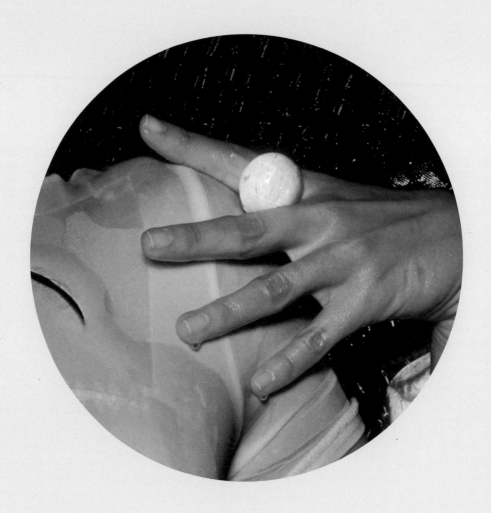

How to achieve the best natural nails with a mini manicure

This is a quick and effective mini manicure I use when a natural nail is required on a shoot. Do this every week at home and your nails will improve enormously – guaranteed!

1. Remove all polish.

2. Use a good nail or cuticle oil around the frame of skin of each nail. (This should be done daily anyway.)

3. With a very gentle nail file, shape the nails or, at the very least, smooth the edge because this will help prevent peeling.

4. An orange wood stick can gently and effectively remove the cuticle from the nail plate. Don't push or dig, though. If you have a lot of cuticle, simply use a cuticle remover – this type of product can be alkaline, so it will need washing off. For toes, cuticle can be removed easily after a bath or shower with just your thumb inside a towel.

5. Once a month – and no more often – use a three-way buffer on your nails. Do not try to buff away any ridges as this will make nails weak.

6. Every week, use the three-way buffer to smooth the edge. This will help keep polish on and help prevent peeling (promise!).

7. Use a conditioner-free polish remover to remove all oils from the nail plate (not the skin).

8. Apply polish, if required.

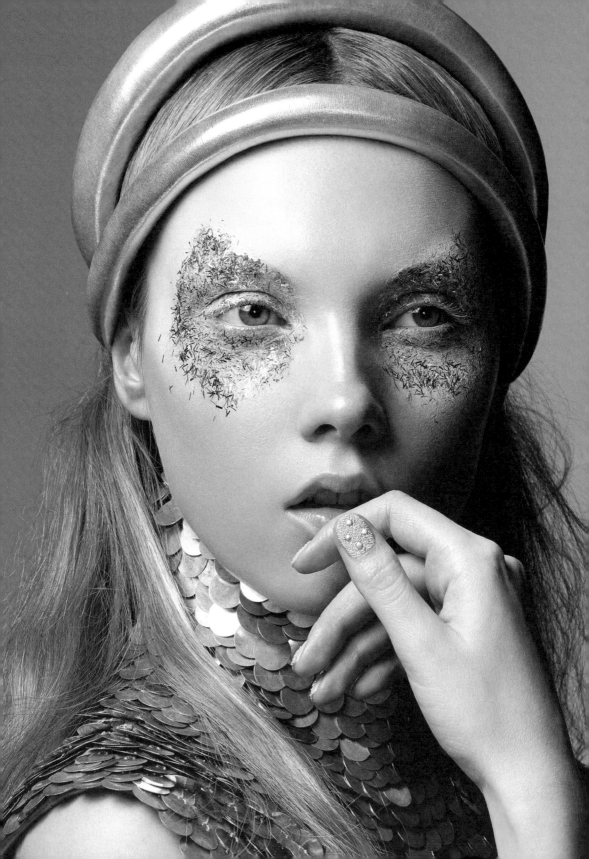

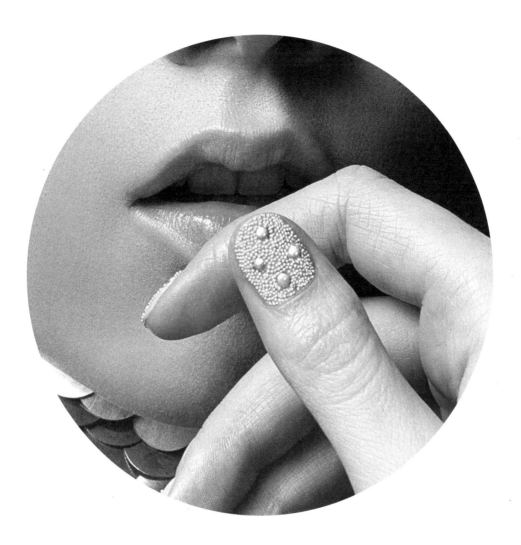

PHOTOGRAPHY BY
Lachlan Bailey

———

PUBLISHED IN
Vogue Japan

———

MARCH 2005

There's usually nothing new in the world, but sometimes it's possible to push boundaries in unlikely ways. A few years before the fashion for caviar nails (a beaded, three-dimensional finish), I was experimenting around the idea of textured nails using bullion beads embedded into varnish. Here they are used to complement the textured and abstract glitter design around the eyes.

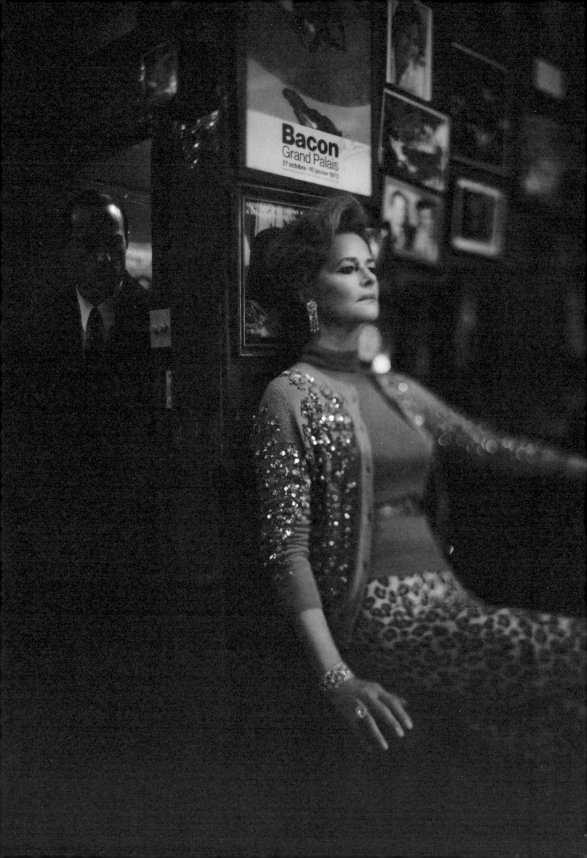

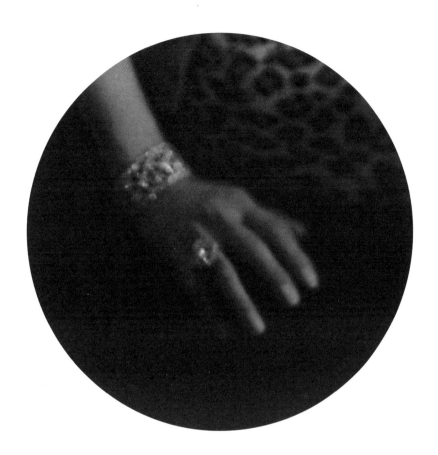

PHOTOGRAPHY BY
Paolo Roversi

——

'Heroine, Murder in Mind'
PUBLISHED IN
British *Vogue*

——

DECEMBER 2005

A photographic subject will always fall into one of three categories: a model, a 'real' person or, as in the case of Charlotte Rampling here, a 'real' person who is an actor playing a character. For this story, Charlotte was photographed by Paolo Roversi in one of Soho's dark, historic drinking clubs. She created a fictional persona who was entirely believable, yet beautiful in a way that is rare to behold. It's a bewitching combination, and in some ways slightly unsettling because her characterization is so powerful.

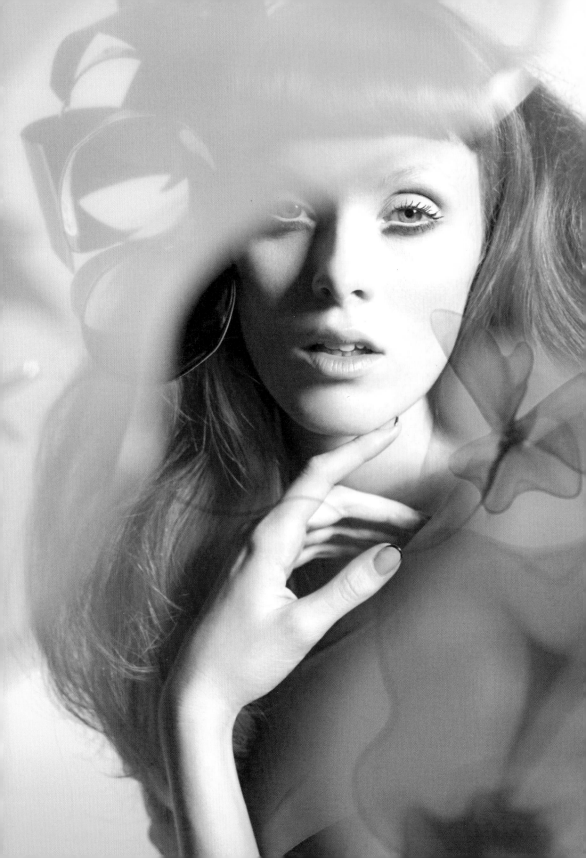

PHOTOGRAPHY BY

Nick Knight

———

'Sculpture Class'

PUBLISHED IN

British *Vogue*

———

OCTOBER 2008

Karen Elson has a unique, exciting beauty. In this picture the use of a tonal, painted nail allows her hair to be the star, even though the hand is placed centrally so it points our gaze up along her nails to her face. Nevertheless, the 'off' colour used on the nail has a creative strength to it, something that's needed when the model, makeup and styling are telling such an interesting story.

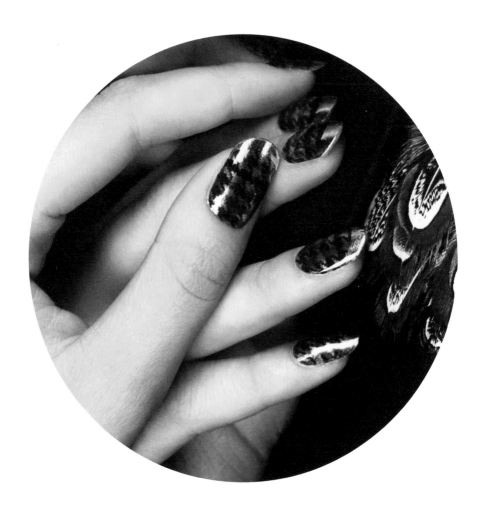

PHOTOGRAPHY BY

Kai Z Feng

——

'Forward March'

PUBLISHED IN

British *Vogue* supplement

——

SEPTEMBER 2009

Nails can sometimes be an accessory in their own right. The gilded, feathered epaulettes on this jacket are a very strong statement. It was one of those times when the stylist had the choice either to knock back the makeup and nails, making them less prominent, or to accentuate them so that they became part of the outfit itself. The latter can be a very difficult trick to pull off but when, as here, the three work together they can create a stunning image.

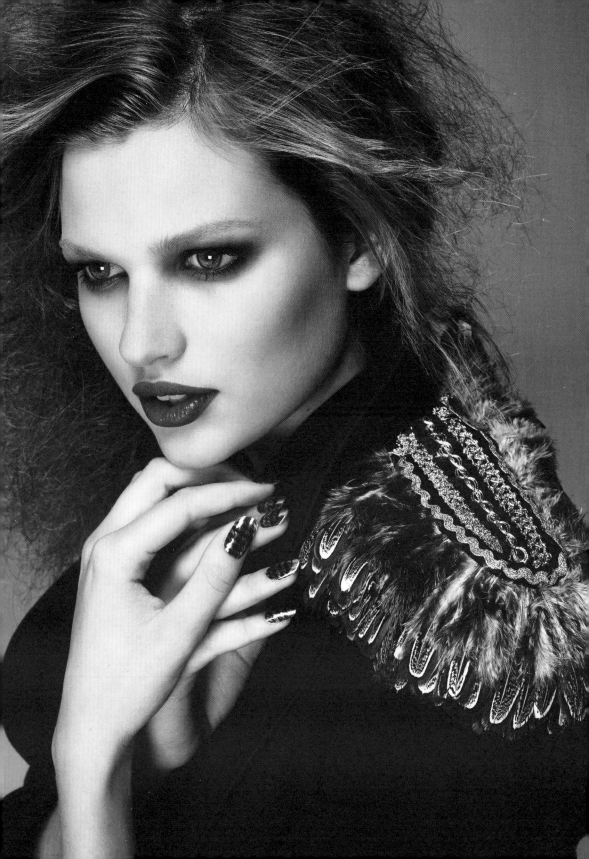

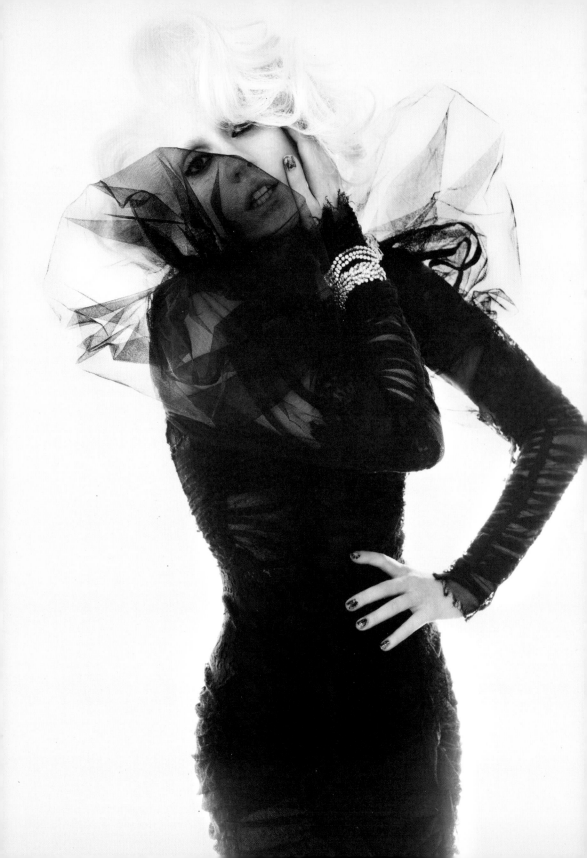

PHOTOGRAPHY BY

Josh Olins

——

'Go Gaga'

PUBLISHED IN

British *Vogue*

——

OCTOBER 2009

Meeting Lady Gaga for the first time was an unforgettable experience. She arrived fully dressed with her bodyguard, with all her wigs on named blocks and locked away in their own boxes. The only time available to work on her nails was as she was being interviewed, but Lady Gaga is someone who speaks with her hands, so hers were a constantly moving target! At one point I chased her hand to the other side of the makeup chair she was reclining in, and ended up lying across her. I've worked with Lady Gaga many times since this picture was taken and it's always a booking that I look forward to.

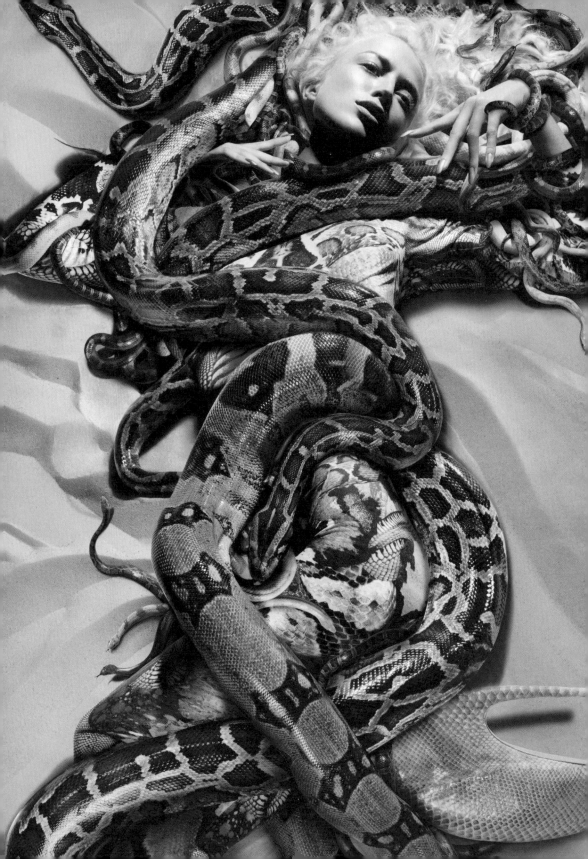

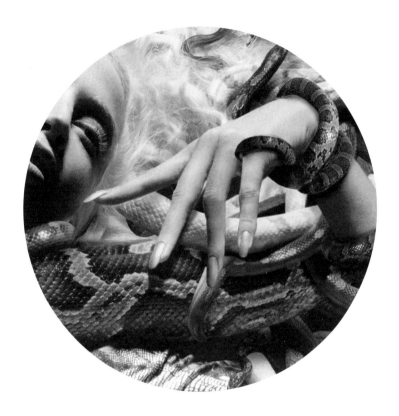

PHOTOGRAPHY BY
Nick Knight

⸻

CAMPAIGN FOR
Alexander McQueen

⸻

SPRING/SUMMER 2010

Plato's Atlantis, Alexander McQueen's final full collection, is now regarded as one of the most important creative collections. It was based on the concept of reverse evolution and for the season's brand image, the model, Raquel Zimmermann, was covered with live snakes. The nails created for this remarkable shoot were long but simple – in contrast to the highly technical ones created for the catwalk. The shoot for this image also created the film that was the backdrop for the collection.

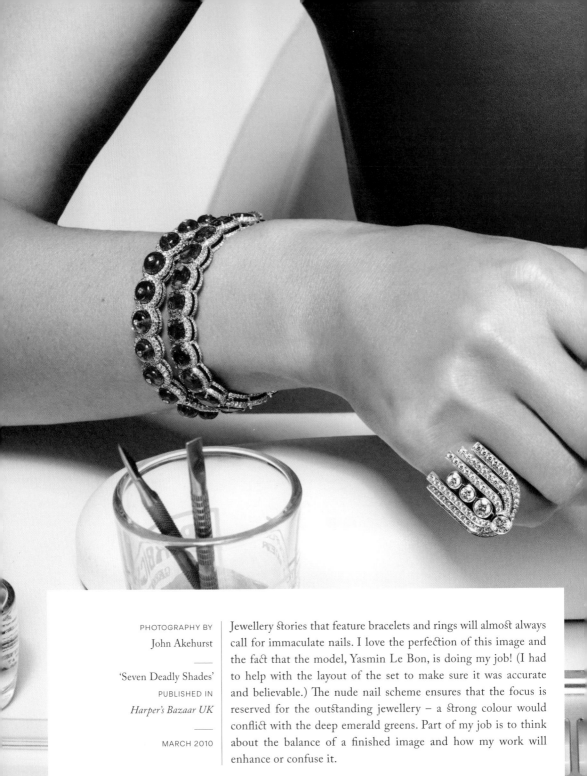

PHOTOGRAPHY BY

John Akehurst

———

'Seven Deadly Shades'
PUBLISHED IN

Harper's Bazaar UK

———

MARCH 2010

Jewellery stories that feature bracelets and rings will almost always call for immaculate nails. I love the perfection of this image and the fact that the model, Yasmin Le Bon, is doing my job! (I had to help with the layout of the set to make sure it was accurate and believable.) The nude nail scheme ensures that the focus is reserved for the outstanding jewellery – a strong colour would conflict with the deep emerald greens. Part of my job is to think about the balance of a finished image and how my work will enhance or confuse it.

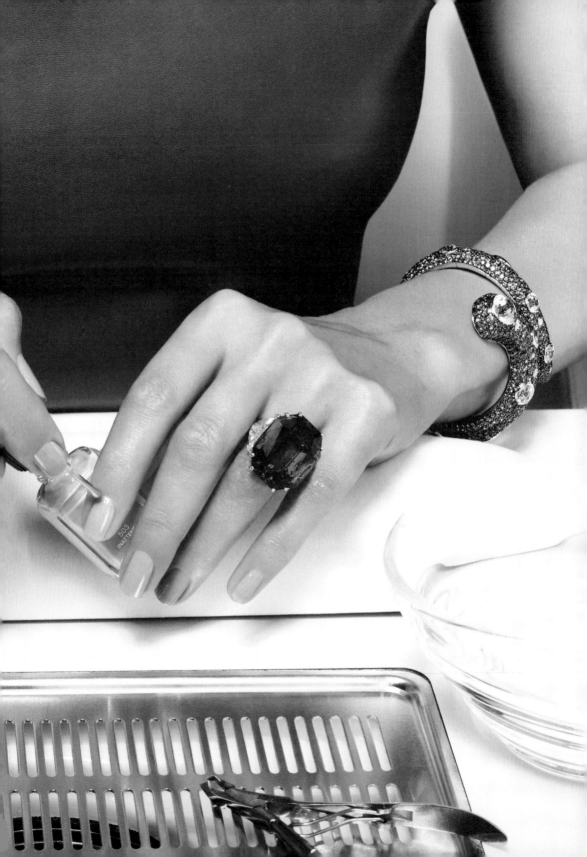

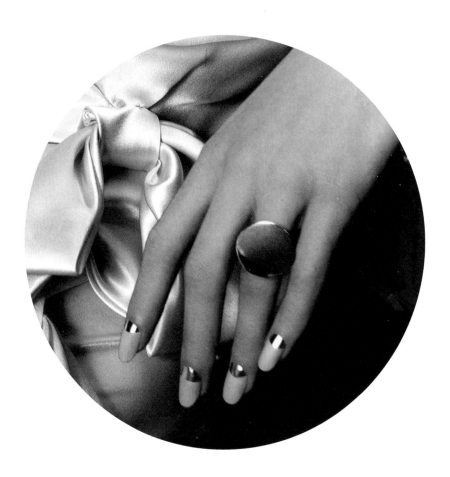

PHOTOGRAPHY BY
Emma Summerton

——

'Love is in the Hair'
PUBLISHED IN
Italian *Vogue*

——

MAY 2010

The photographer Emma Summerton creates worlds that are both familiar and unsettlingly otherworldly, but each of the elements always remains fabulous. This story brought together metallic themes in a unique way. The long, nude mannequin nails have a moon created with shiny paper – they are designed to complement the scheme without becoming matchy-matchy. The overall effect is polished without presenting a cliché of glamour.

PHOTOGRAPHY BY
Emma Summerton

———

'Love is in the Hair'
PUBLISHED IN
Italian *Vogue*

———

MAY 2010

I love dark stories: they can evoke a disturbing weirdness that nevertheless carries with it great beauty. Sam McKnight created the hair for this intriguing story. This dramatic, slightly occult, gothic theme needs every detail to tell the right story for the viewer to believe it. The nails are a part of that powerful story, not the focus, but they are an important detail for this character.

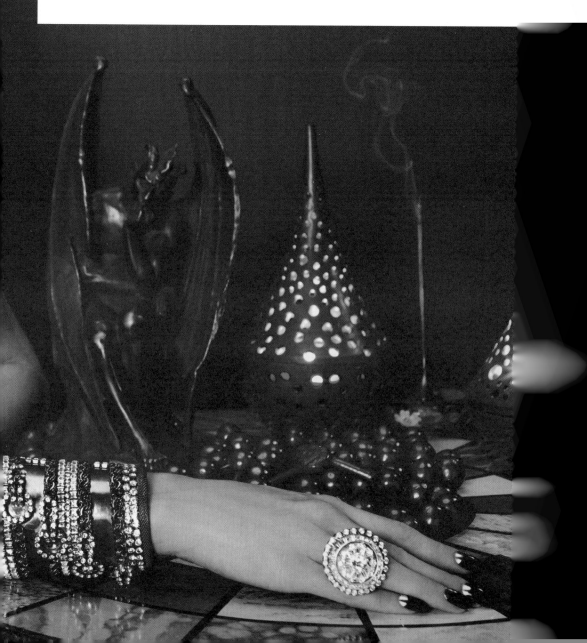

PHOTOGRAPHY BY

Catherine Servel

——

'Eyes Wide Open'

PUBLISHED IN

Vogue China

——

SEPTEMBER 2010

Nails aren't always the main focus of a beauty story, but if they're on show they need to express the same perfection. Here they match the colour of the model's coat, which is effectively a neutral background, allowing the lips to pop out of the picture. It's a subtle detail, but it's what makes the picture work so well.

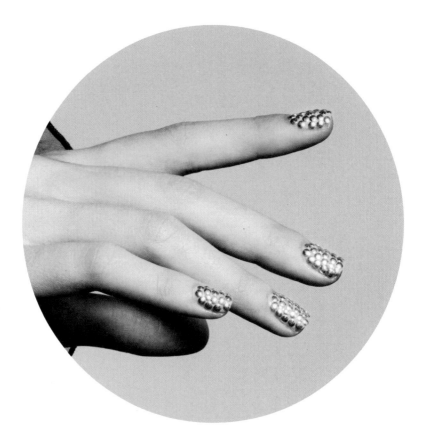

PHOTOGRAPHY BY
Nick Knight

———

'Refined Rebel'
PUBLISHED IN
British *Vogue*

———

NOVEMBER 2010

I used this image for the cover of the third edition of my handbook, *The Complete Nail Technician*, because it's representative of both the creative and technical sides of my work. Raquel Zimmermann is one of my favourite models. She's a chameleon who brings the skills of an actress to every shoot. Another aspect to her talent is that she's aware of every part of her body and seems to know how it looks from every angle. Here the expressive placement of her hands has an almost balletic feel and, of course, creates a marvellous display of her tonal, textured nails. These ones are studded to give an edge that contrasts with the romantic softness of her ribboned bracelet cuff.

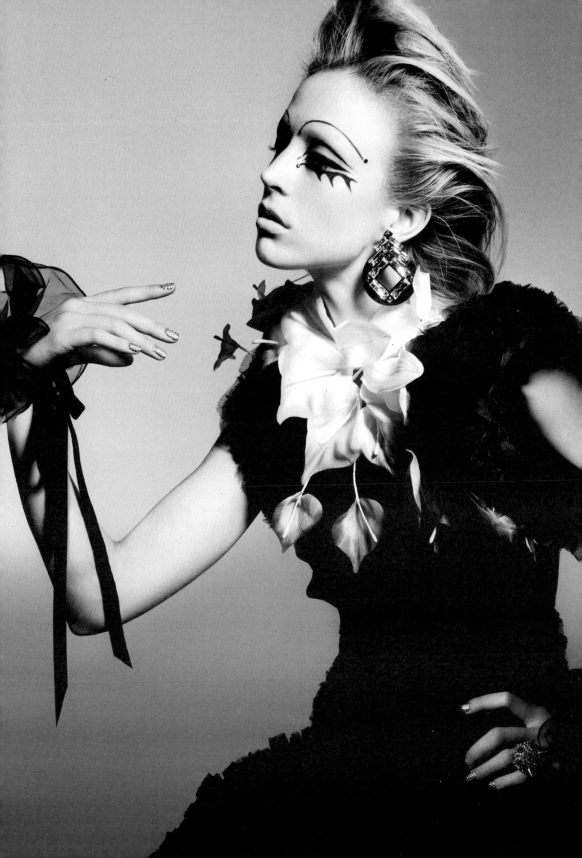

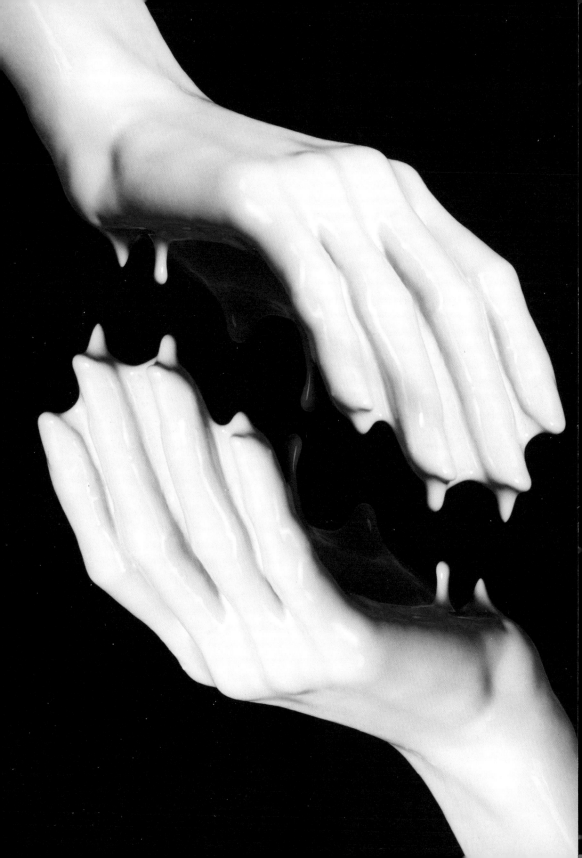

PHOTOGRAPHY BY

Pawel Pysz

———

[Test shot]

———

2011

This image is a test for a shoot I went on to develop for *Vogue* China. I wanted the hands to look as though they were emerging from marble. Alex Cunningham, the set designer, created the liquid from a special type of cosmetic clay. It managed to coat the hand perfectly and at the same time allow the nails to be clearly defined. Pawel, the photographer, gave me a print, and it sits proudly on my office wall.

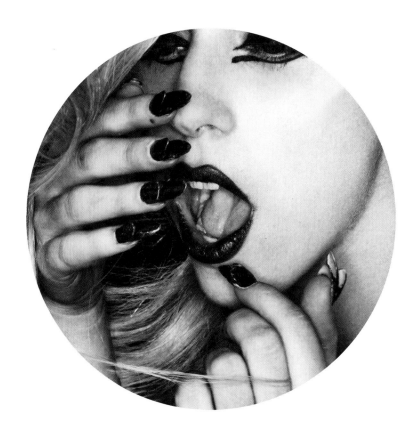

PHOTOGRAPHY BY

Nick Knight

——

APPEARED IN

'Born This Way' video, Lady Gaga

——

9 MAY 2011

Lady Gaga was looking to change and challenge her own form and proportions for the 'Born This Way' video. Val Garland used her makeup skills and prosthetics to give the singer her dramatic protuberances. My nails mirrored the body-morphing idea with three nails appearing to be emerge from a single nail bed. The effect was both disturbing and very beautiful.

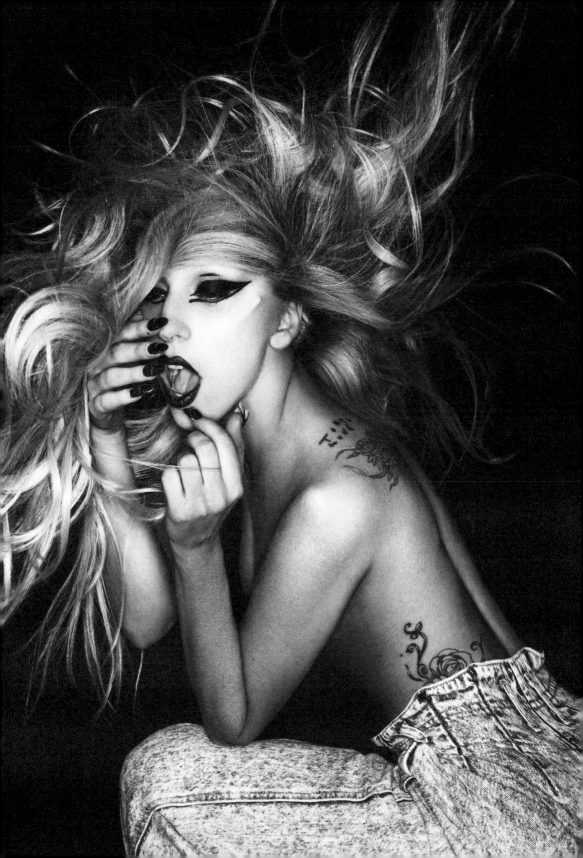

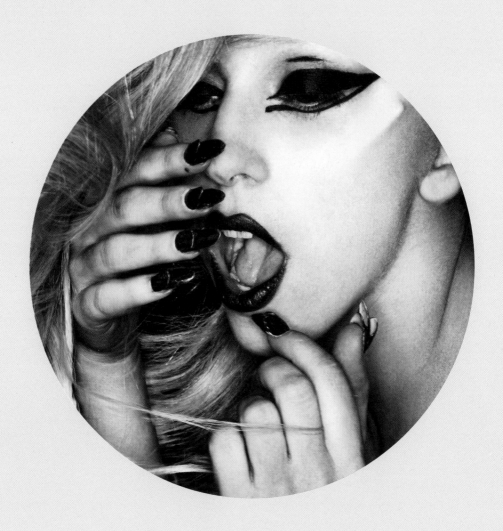

How to create a theatrical nail sculpture

Lady Gaga was making an album and video called *Born This Way*. She wanted prosthetics and makeup techniques to morph the shape of her face and shoulders. As part of the scheme, she chose an effect that made it seem as though three nails were growing from each nail bed. I created these in a few colourways, although the construction was the same each time. The instructions below are for *one* complete nail – simply repeat steps 1–6 ten times. These instructions are for stick-on nails.

1. Choose a long stick-on nail sized to fit the natural nail perfectly at the base and sides. Select two more the same size. Shape the bottom nail.

2. Take the second nail and cut it to about two-thirds of the length of the bottom nail, leaving the base of the nail untouched. Shape.

3. Take the third nail and cut it to about one-third of the length of the bottom nail. Shape.

4. Once all three nails are shaped, paint the bottom one on top and underneath. This can be with the same colour or with a contrasting one. Here I've used black polish on top and a nude colour on the bottom of the nail.

5. When all are dry, place a small bead of L&P (the liquid monomer and powder combination known as acrylic) at the base of the longest nail. Gently hold the second nail onto it, angled slightly upwards. Hold for a few seconds until the L&P starts to set.

6. Once the second nail is secured, place another small bead of L&P on it and apply the third nail in the same way.

7. Repeat until you have completed your amazing nails – dubbed 'armadillo' and 'Sydney Opera House' nails by the press at the time!

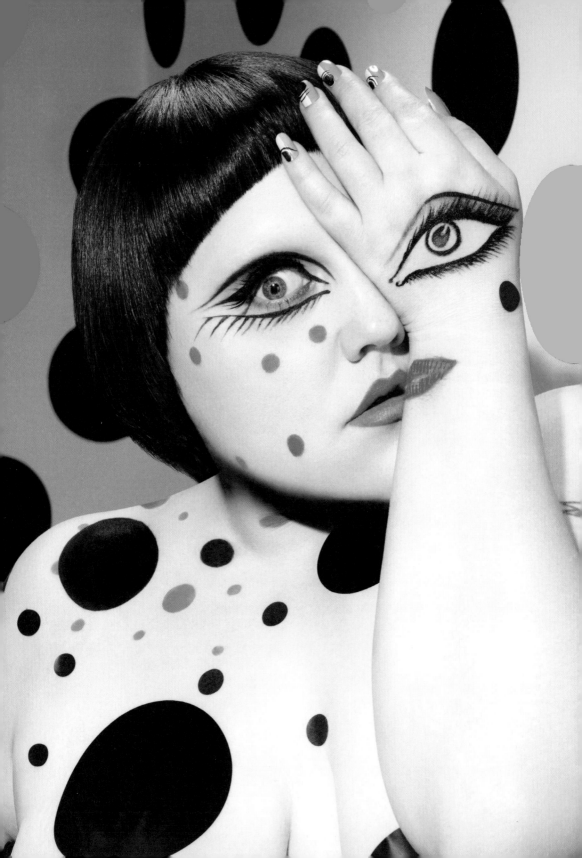

PHOTOGRAPHY BY

Miles Aldridge

——

CAMPAIGN FOR

Beth Ditto x MAC

——

JANUARY 2012

For the photographs to accompany this limited-edition MAC collaboration in 2012, I was asked to create nails to complement Val Garland's makeup design for Beth Ditto. The makeup and nails were inspired by Beth's own clothes, with the theme of spots and eyelashes used throughout. Expressing a person's personality through nails is something I always enjoy, especially when that personality is so bold.

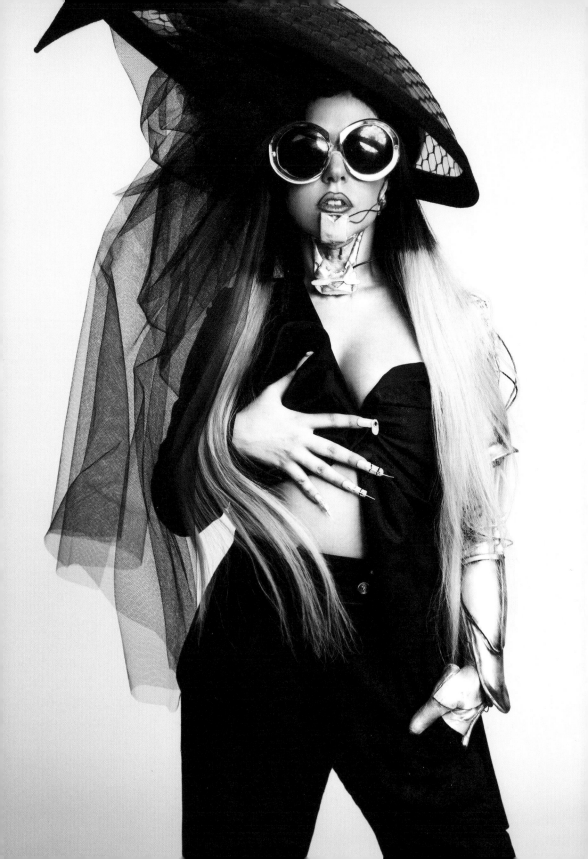

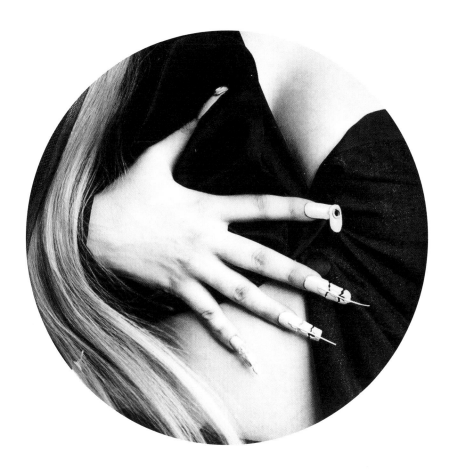

PHOTOGRAPHY BY
Inez & Vinoodh

———

APPEARED IN
'Yoü & I' video, Lady Gaga
L'Uomo Vogue

———

JANUARY 2012

Lady Gaga always presents me with artistic challenges. For her 'Yoü and I' video, these included making nails that were wired, pinned or riveted together. The production for the film was a challenge (see next page) but the results were, as they always are with Lady Gaga, exciting and unexpected. When I'm working I always travel with boxes of interesting craft tools and findings, and very often I end up using them to create something unique for her.

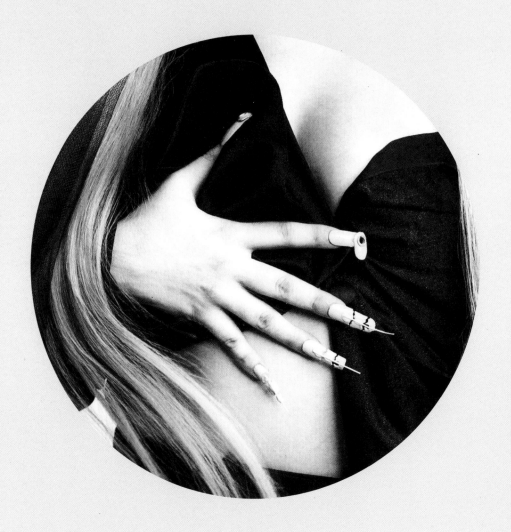

How to create unique physical effects with nails

I have often been asked about the inspiration for these nails and why they turned out the way they did. The video explains it. Lady Gaga is walking from the couture fashion of New York City all the way back to her character's home town in Nebraska. Along the way, things break (including her) and she uses anything she finds along the way to fix them. Of course, her long, chic nude nails keep on breaking, so wire and rivets are used to mend them. During the shoot, her 'disconnected' nails were repaired over and over because bits were flying off when she tried to fix her shoe in a scene for the video! This technique is definitely one that is more visual than practical, but it is a lesson in creating maximum impact.

1. Select very long stick-on tips.

2. Paint with an opaque nude UV gel polish.

3. Cure under a UV lamp.

4. Cut each nail into three of four pieces (I used children's paper scissors with blades of various shapes).

5. Line up the 'broken' pieces of nail with a long piece of wire laid lengthways along them. Apply a thick layer of clear UV gel to embed the wire, and then cure under a UV lamp.

6. Vary the style of each nail to create the same look as Lady Gaga. To create a second type of nail, use the base piece of cut up tips to create a jagged nail.

7. To create a third type of nail, the swivel nail, take two new tips and repeat steps 1–3. Use a hole puncher to make a hole in both tips: one at the top of the tip and the other at the base of the tip. Use a craft riveter (used to apply rivets in fabric or leather and available in craft stores) to rivet the two nail tips together. This should allow the two nails to swivel.

8. Apply each 'disconnected' nail to the natural nail.

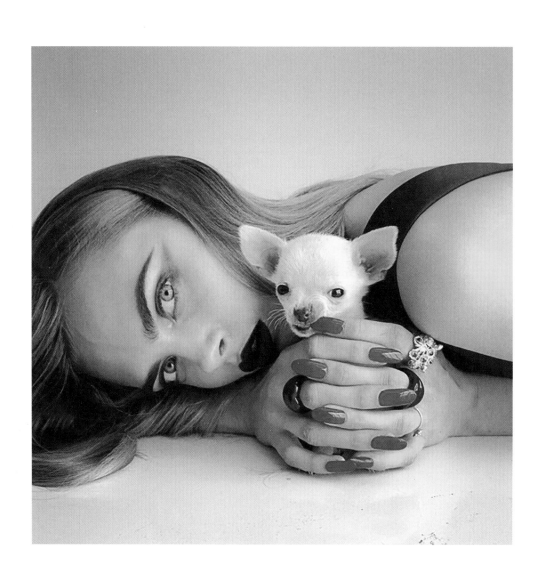

PHOTOGRAPHY BY

Nick Knight

———

'Pussycat, Pussycat'

PUBLISHED ON

@SHOWstudio Instagram

———

20 APRIL 2012

Cara Delevingne is well known for her love of animals, which must be why she is often photographed with them! On this occasion it was for a nail story – a cute pup turned out to be the perfect way to draw attention to a manicure. Styled by Alexander Fury, the shoot featured a whole farmyard of baby animals, including kittens and ducklings as well as puppies. This shoot was the first time that Nick had taken all his photographs on an iPhone (for Instagram). It was also live-streamed on Nick's website, SHOWstudio. This was a day of firsts, as well as being a fun shoot. It was also great to get a top nail shot, with this puppy taking a liking to Cara's long red nails.

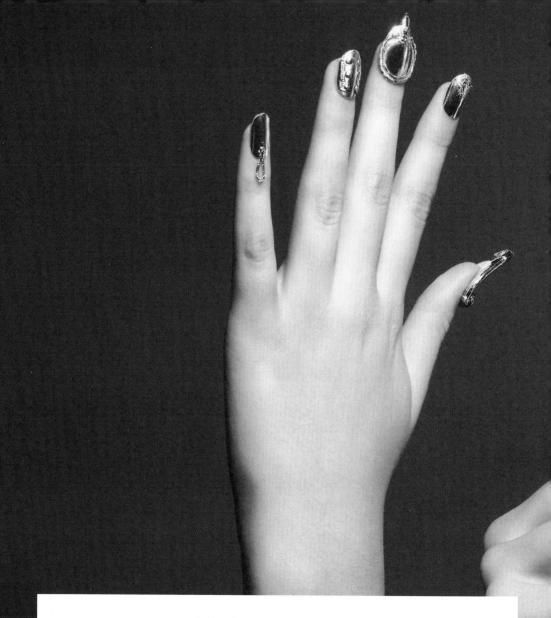

PHOTOGRAPHY BY

Rankin

———

PUBLISHED IN

Hunger magazine

———

10 MAY 2012

For this image, I was asked to come up with a concept under the title 'Vanity'. Being given an open brief can sometimes be daunting, but I created for myself a character whose sense of personal perfection is beyond comparison. In fact she's so vain that each of her nails is a different, tiny mirror. I made them beforehand – along with plenty of spares, because you never know how an idea will work until you see it in front of you. If the concept hasn't been tried before, it's even more important to do your homework.

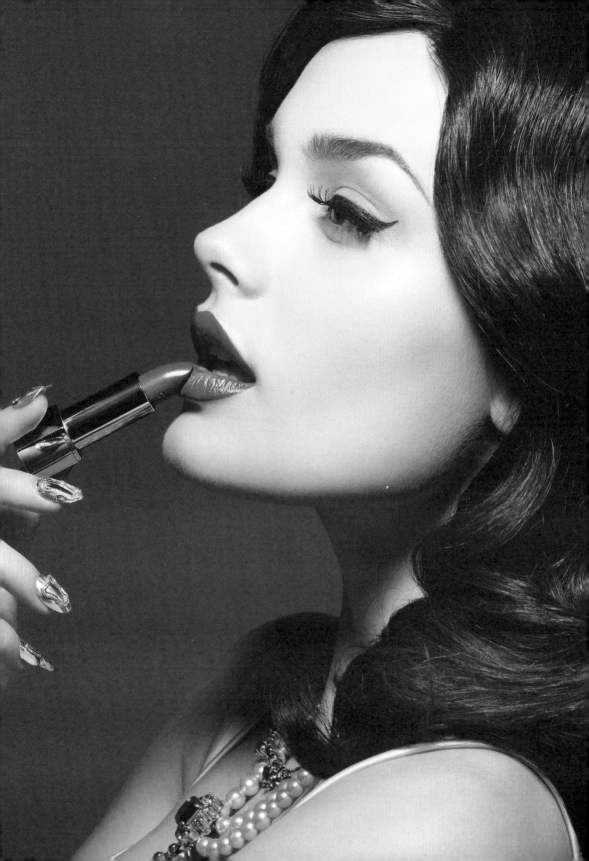

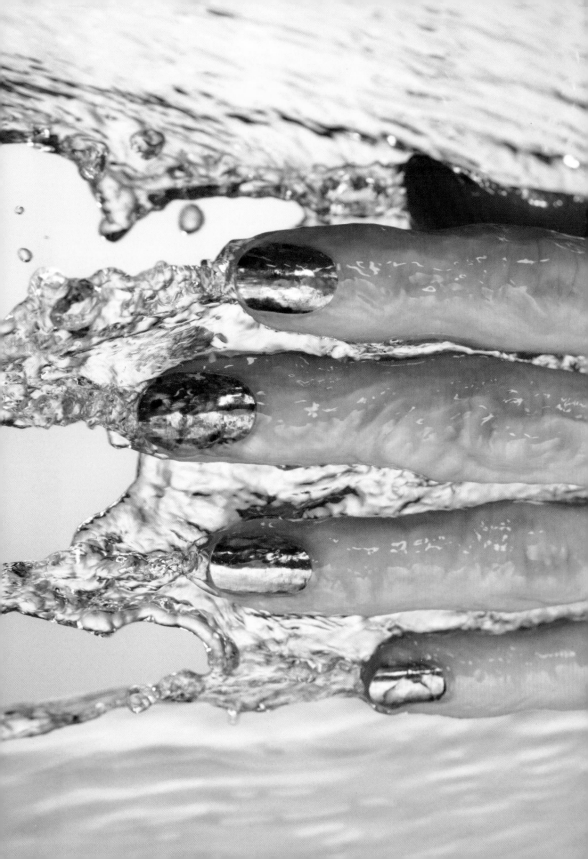

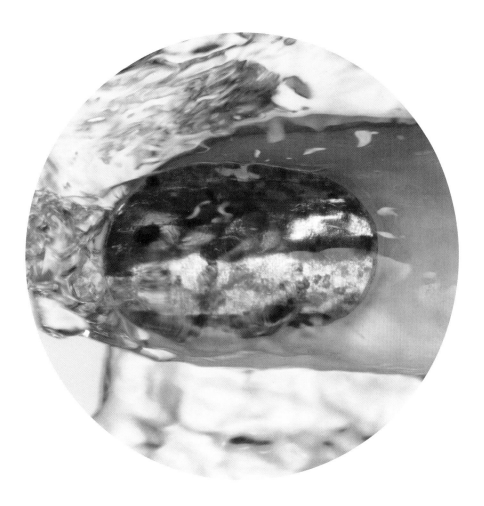

PHOTOGRAPHY BY
Graeme Montgomery

———

'Cool Tips'
PUBLISHED IN
Vogue Japan

———

MAY 2012

Since I began working in fashion and beauty, digital technologies have given us creative options that wouldn't have been available to us before they emerged. Digitally printed nail stickers, in this case created by Minx, allow us to create a very precise effect that would have been almost impossible to achieve. Here, Graeme has managed to capture the magical metallic colours printed on the nails in the water that surrounds them.

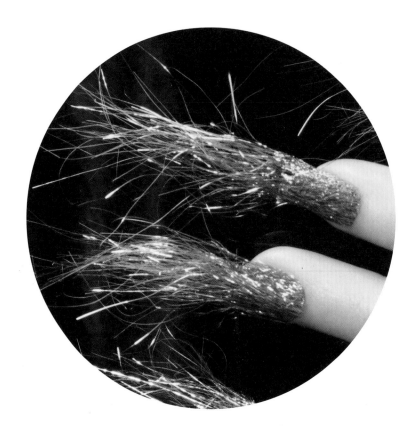

PHOTOGRAPHY BY
Graeme Montgomery

———

'Come the Shades of Fall'
PUBLISHED IN
Vogue Japan

———

NOVEMBER 2012

I'm always collecting materials that I think might come in handy for nail projects. Angelina is a fine, heat-bondable fibre that comes in lots of exciting colours. It's normally used for crafting, but when I first saw it I knew I could use it to create something interesting. During a shoot it's sometimes possible to experiment with ideas while a picture is being taken, so I created these nails between shots. The idea was to imitate fireworks. At the end of the day I showed them to the photographer Graeme and Kathy Phillips, the stylist on this story. They agreed to shoot them, and with one click of the camera we had this picture. It became a beauty cover and shows that going with your gut instinct really can pay off.

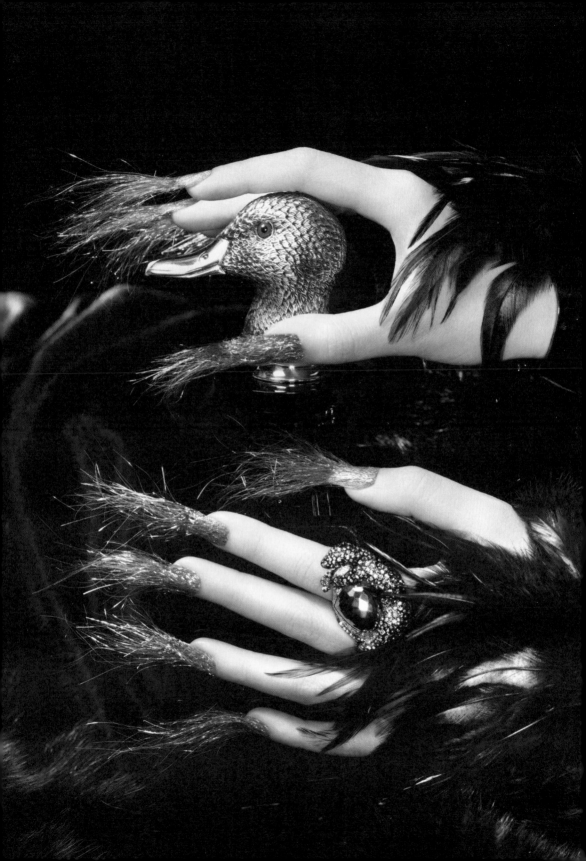

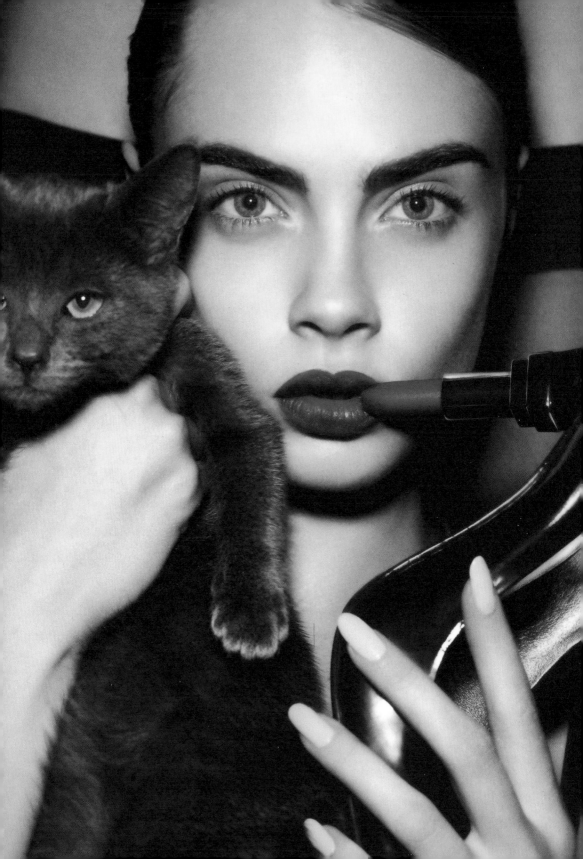

PHOTOGRAPHY BY
Liz Collins

——

'Cat'
PUBLISHED IN
LOVE magazine

——

SPRING/SUMMER 2013

The photographer Liz Collins and model Cara Delevingne are a great combination and the results they achieve are always spot-on. During this shoot, Cara once again proved how good she is at handling animals (see page 112) – and how equally good she is at keeping false nails on at the same time! This image is also an example of 'natural' nails that are far from anything nature might have created. Over the years I've developed many different ways of lengthening nails to look real without harming the model's natural nail. There's nowhere to hide, but it's always satisfying to create them.

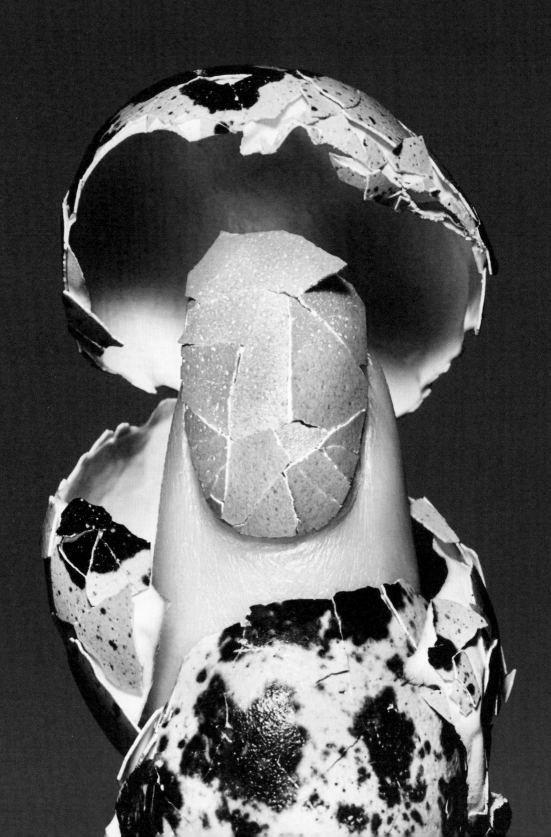

PHOTOGRAPHY BY
Pawel Pysz

———

'Easter Nails'
PUBLISHED IN
AnOther Magazine

———

MARCH 2013

A great idea will often come from a happy accident. *AnOther Magazine* commissioned the photographer Pawel Pysz and me to come up with some nails for an online Easter story. Pawel asked Stevie Stewart, set designer and formerly one half of BodyMap, to join us. Stevie brought lots of interesting materials such as eggs and eggshells. I took one nice-looking shell, cut it with nail scissors, and applied it to the hand model's fingernail. WOW! It broke exactly as it needed to and fitted perfectly. This is still one of my favourite images, and it was very much a case of 'Let's see what happens if …'

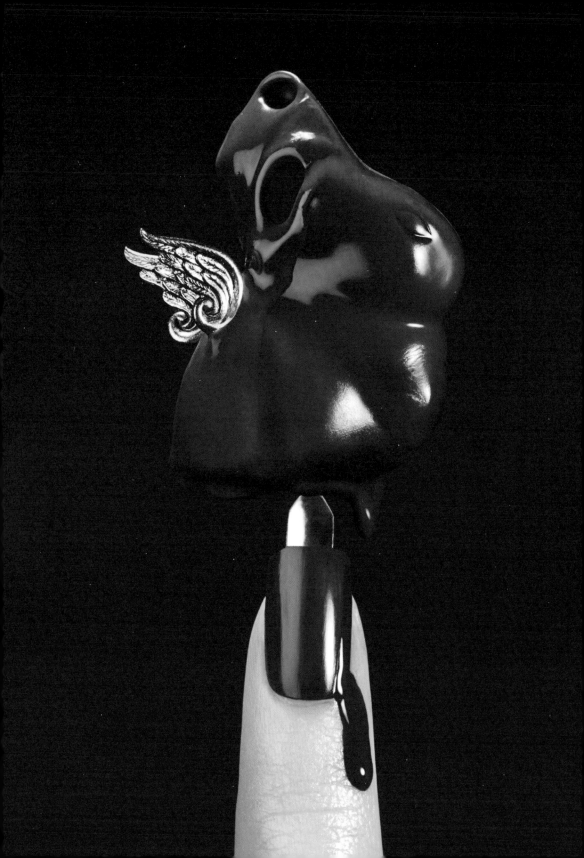

PHOTOGRAPHY BY
Pawel Pysz

———

'Easter Nails'

PUBLISHED IN
AnOther Magazine

———

MARCH 2013

This image is about the darkness of the Easter story — something we tend to overlook. The poor bunny is being speared by a weaponized nail and heated until it melts. For good measure, the varnish has been used to suggest chocolate melting down the nail. I created the nail to have shoulders and made a 'blade' from a Minx nail sticker. Like one of James Bond's hidden weapons, it emerges from the end of the nail. On the day, we melted the bunny with a cigarette lighter – and I felt so sorry for it, I then applied the silver angel wings!

PHOTOGRAPHY BY
Pawel Pysz

———

PUBLISHED IN
Vogue China

———

SEPTEMBER 2013

Creating a set of images or a full picture story usually requires a central brief. This nail story, created for *Vogue* China, is a collection of subjects that have symbolic value in Chinese culture. Each picture is my impression of one symbol, achieved with a variety of techniques. For the scales of koi carp, the symbol of abundance, I used lavish layers of fish scales created from nail stickers by Minx.

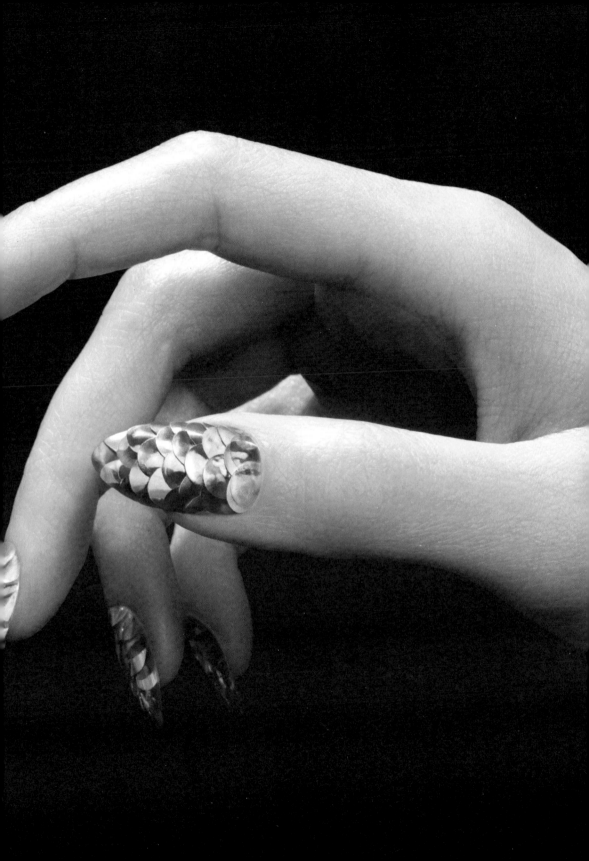

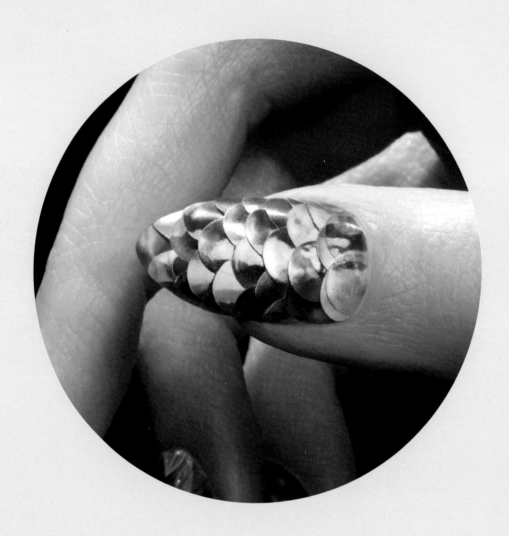

How to use nail stickers for dramatic 3D textures

This image was for a nail story that was all about Chinese symbolism and fish, specifically koi carp, which are an important motif in Chinese mythology. Holographic effects look beautiful on the nail, so my fiddly and time-consuming idea to create fish scales with nail stickers was worth the time and effort! I used nail tips because it enabled me to prepare the nails carefully and they are easier to work on than the natural nail.

1. Choose tips that fit the nail perfectly.

2. Choose your stickers. (In this case I used a holographic sticker from my favourite company, Minx.)

3. Using a hole punch, cut lots of circles from the stickers.

4. Cut half of them in two to create half-moon shapes.

5. Apply a half sticker to the back of a full circle, to ensure the back has an exposed sticky area.

6. Starting at the tip of the nail, place circles so that they overlap. Continue adding the circles until the nail is completely covered.

7. A 3D scale effect is created because half of the scales aren't sticky. To make this effect slightly more pronounced, lift the scales and sprinkle holographic pigment under them.

8. Trim the tips to neaten the edges and apply the tips to the natural nail with a temporary double-sided sticker.

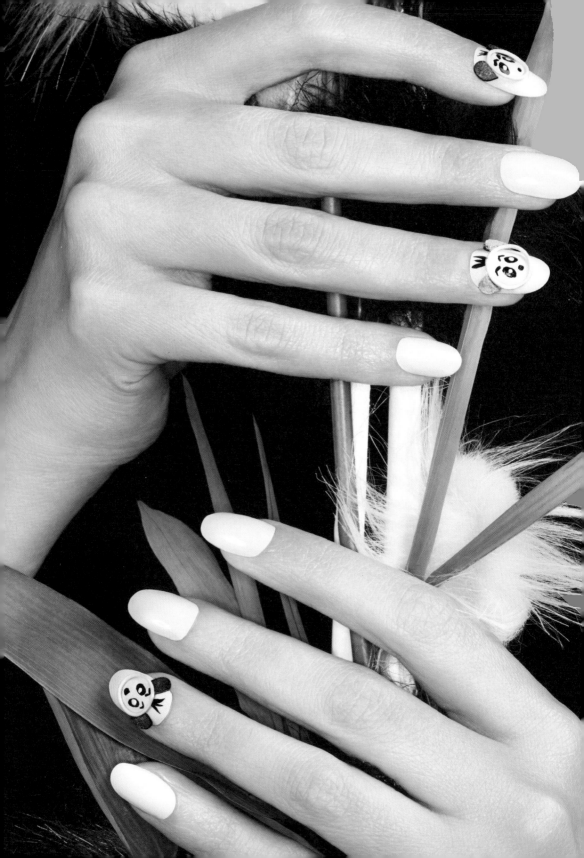

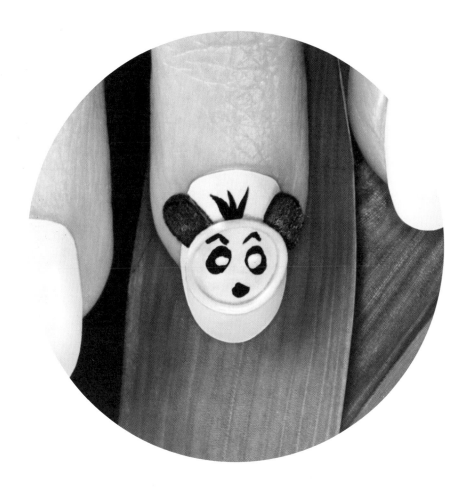

PHOTOGRAPHY BY

Pawel Pysz

——

PUBLISHED IN

Vogue China

——

SEPTEMBER 2013

To create the impression of a cute creature emerging from the nails, I made the panda and his bamboo with a little 3D modelling. I chose a simple background of white varnish and applied felt ears, which I painted black to accentuate the contrast. I then sat a metal ring on the top to give it the 3D effect. As with the other images in this set, the designs are impressionistic rather than literal. This gives them a unique dimension.

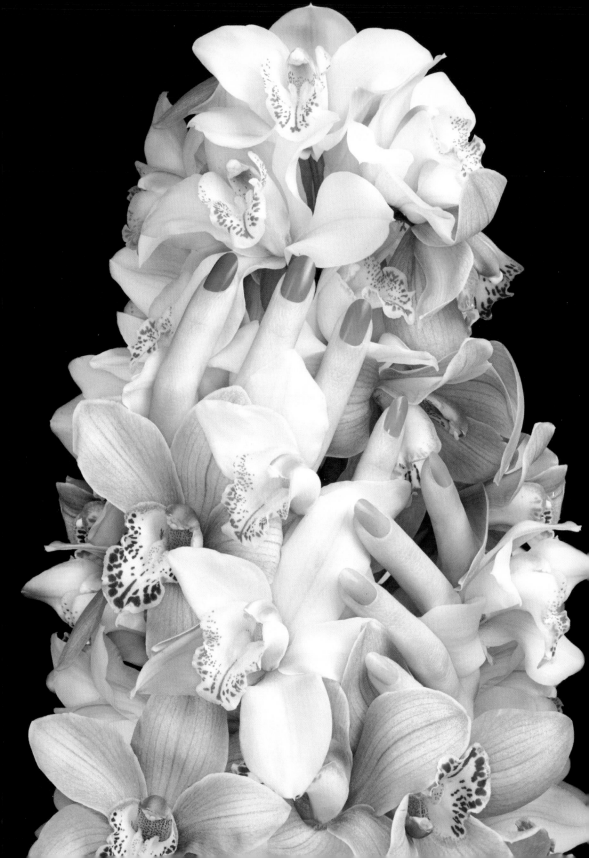

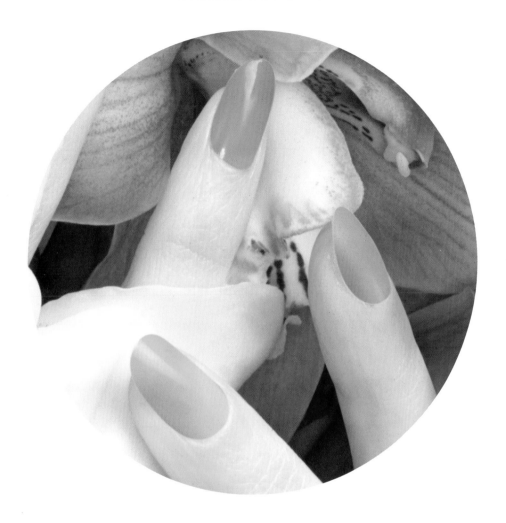

PHOTOGRAPHY BY

Pawel Pysz

———

PUBLISHED IN

Vogue China

———

SEPTEMBER 2013

This array produces a super-pretty gradient of pinks, from dark to pale. They perfectly reflect the shades found naturally in the flowers around them – one reason I always travel with an entire colour wheel of nail varnish shades. I love doing colour gradients like this – and our picture has since been referenced many times. Organizing the flowers and hand to create exactly the right balance was harder than it appears here – simplicity is sometimes the hardest illusion to capture!

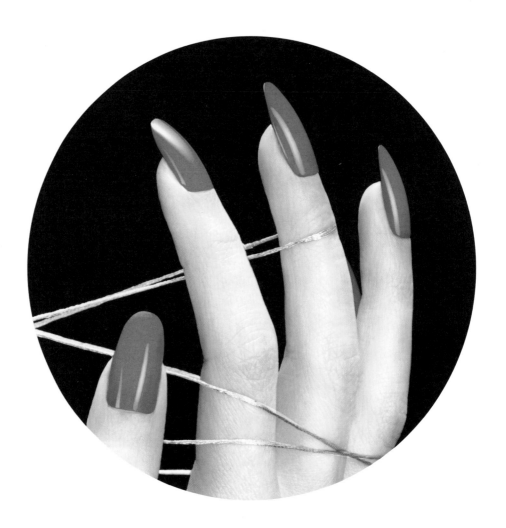

PHOTOGRAPHY BY
Pawel Pysz
——
PUBLISHED IN
Vogue China
——
SEPTEMBER 2013

The rich, beautiful true red here is a reference to Chinese lacquer, one of the art world's most enduring techniques. The shape of the hands creates a beautiful bow for the cat's cradle, inspired by the folk art of Chinese knotting. For nail art, sometimes less is more and here the Chinese-inspired aesthetic and a simple but perfect lacquered nail combine for a strong impact.

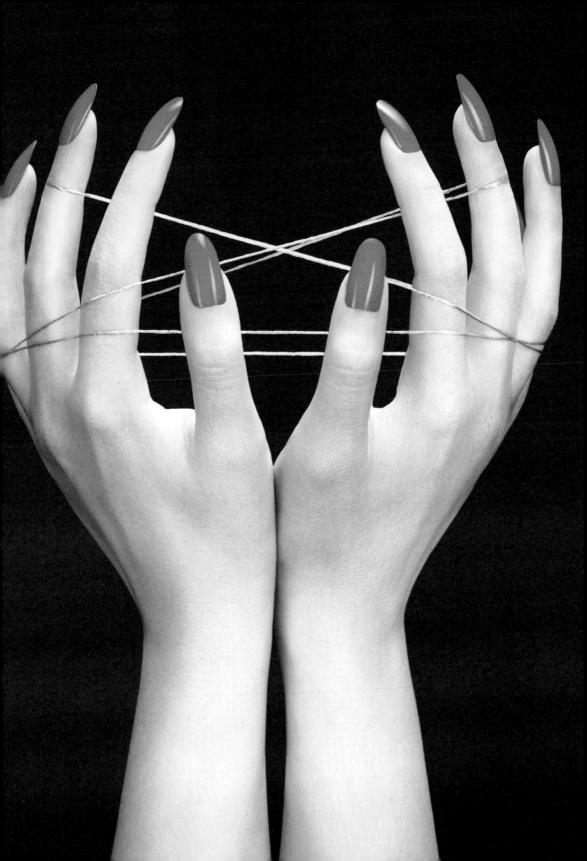

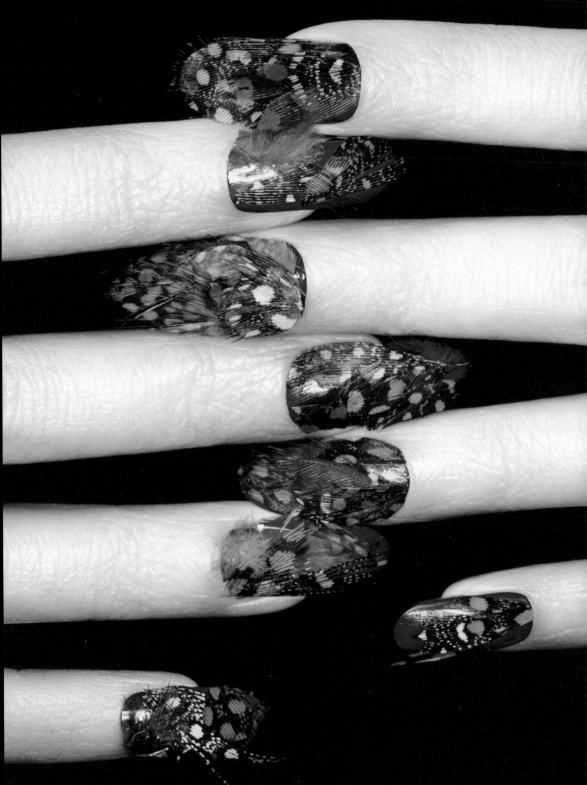

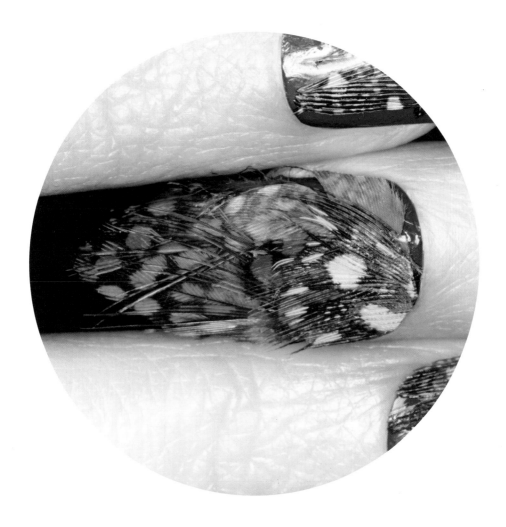

PHOTOGRAPHY BY
Pawel Pysz

———

PUBLISHED IN
Vogue China

———

SEPTEMBER 2013

Male mandarin ducks are colourful symbols in Chinese culture. They represent marital love and fidelity – a great deal to reflect within a nail picture. Here I chose to celebrate their colour, and created these dramatic textured nails by applying beautiful feathers to wet nails. The iridescent natural pigments explode from the nails beautifully. It may not be a real-world concept, but it is a fabulous photographic one.

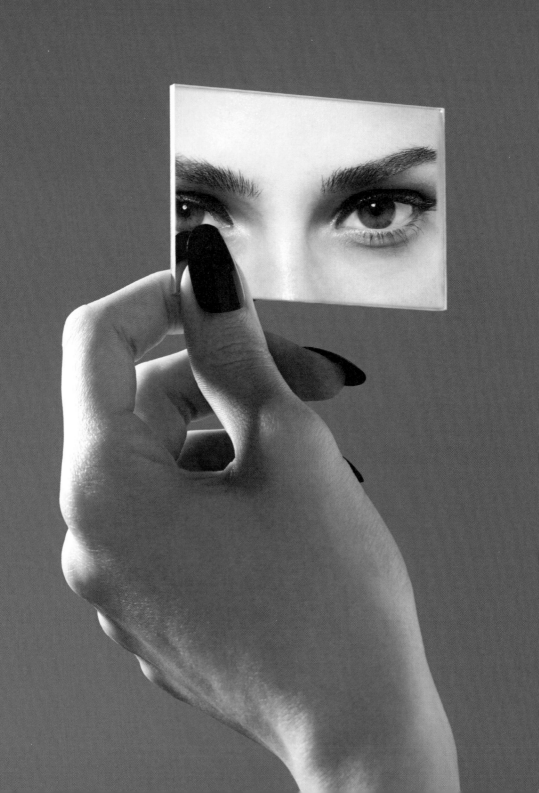

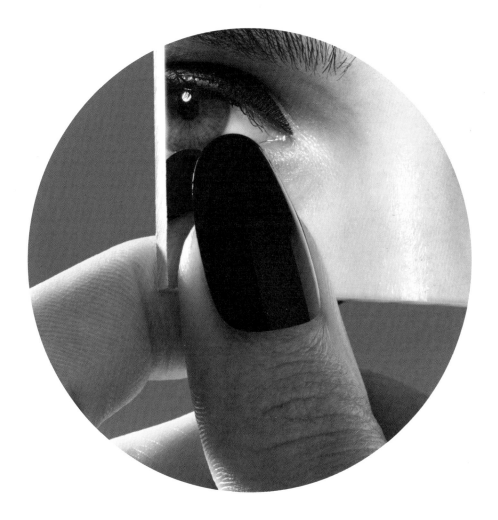

PHOTOGRAPHY BY
Liz Collins

——

PUBLISHED IN
PORTER

——

2014

Sometimes, even in a makeup story where they are not the focus, nails can play an important part. It goes without saying that perfection is still required, and this is an example where nails both support and amplify the makeup story without confusing the message. A simple, clean sharp idea is perfectly executed and the nails remain dramatic but unobtrusive. It's all about balance, and here the photographer Liz Collins has managed to place the eye makeup at the centre of the picture in an entirely unexpected way.

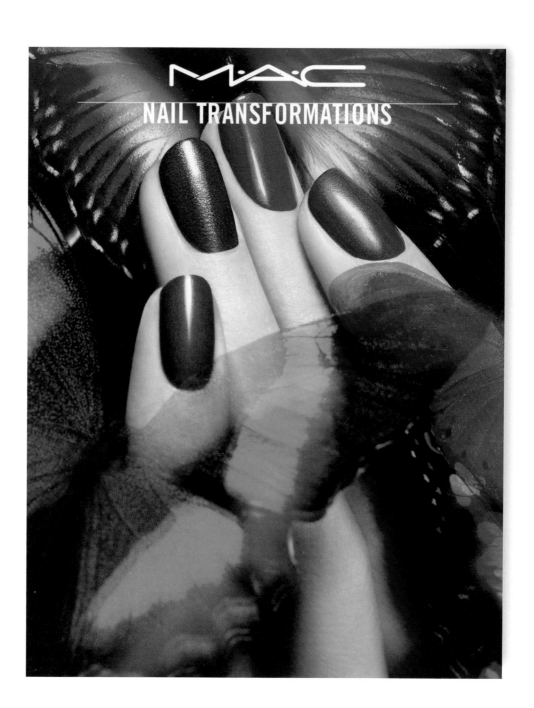

CAMPAIGN FOR

MAC

———

2014

This is the brand image used to represent the collection I created for MAC (see page 12). I based the idea on butterfly wings, which the photographer, Richard Burbridge, layered over the model's hand. The collection comprised six sheer colours that each contained different pigments to create iridescence. They were designed to be worn on their own, or layered for a stronger effect, or over a coloured nail polish to create a whole new shade that changed in the light. My starting point was MAC's heritage as a professional range. Key to it is the idea that a wearer can adapt a product depending on the effect they want, as if creating their own unique session nails.

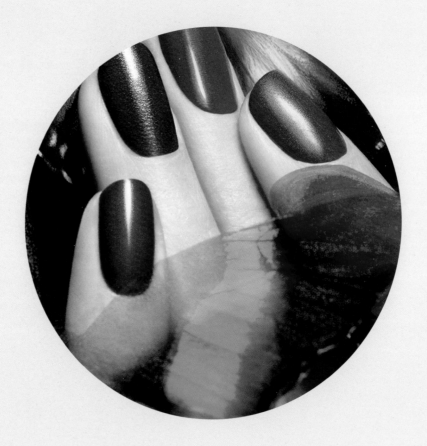

How to use pigments to achieve unusual effects

When I created my first metallic nails 20 years ago, products were far more limited than they are today. The ideas remain the same, though, and this can be a beautiful and dramatic effect when done well.

1. Clean the nails with a conditioner-free polish remover.

2. Apply a thin layer of clear base coat to each nail.

3. Choose a base colour such as red and apply to each nail. Dark polish colours work better than light.

4. Choose a shimmery or metallic pigment – this can be a powder eye shadow or even loose pigment (available in many makeup ranges). Lighter colours work better.

5. Once the base colour is slightly sticky but not wet, press the pigment onto it using an eyeshadow sponge. (It will take a bit of practice and patience to recognize the right moment to press the pigment without smudging the polish.)

6. Apply a glossy top coat to each nail.

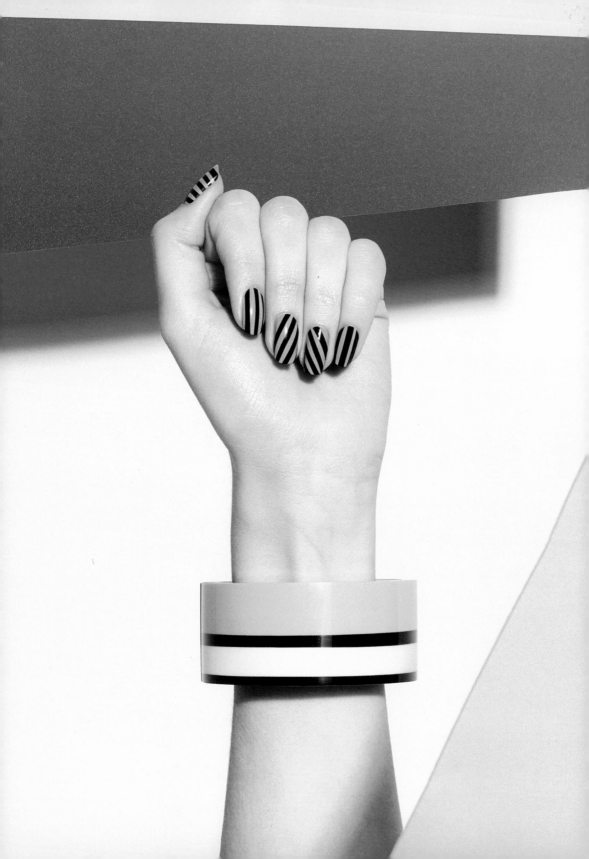

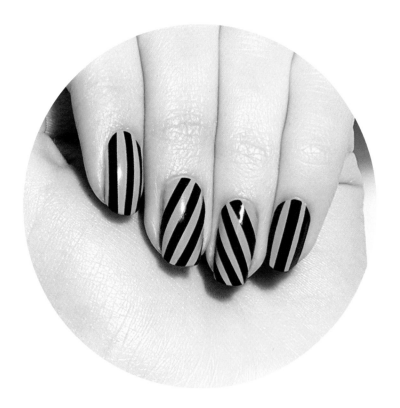

PHOTOGRAPHY BY

David Ralph

———

'Power Tools'

PUBLISHED IN

The *Sunday Times Style*

———

5 APRIL 2015

Sometimes a client will send a brief based on an artist's work. For this shoot it was Wassily Kandinsky, a Russian painter best known for his abstract paintings. I researched Kandinsky's work and had a good idea about what I wanted to achieve. Features like stripes have to be completely precise, so this perfect, graphic finish was achieved with a little help from my trusty USB microscope, which I use to examine my work minutely. It enables a hyperexact finish when graphic perfection is required.

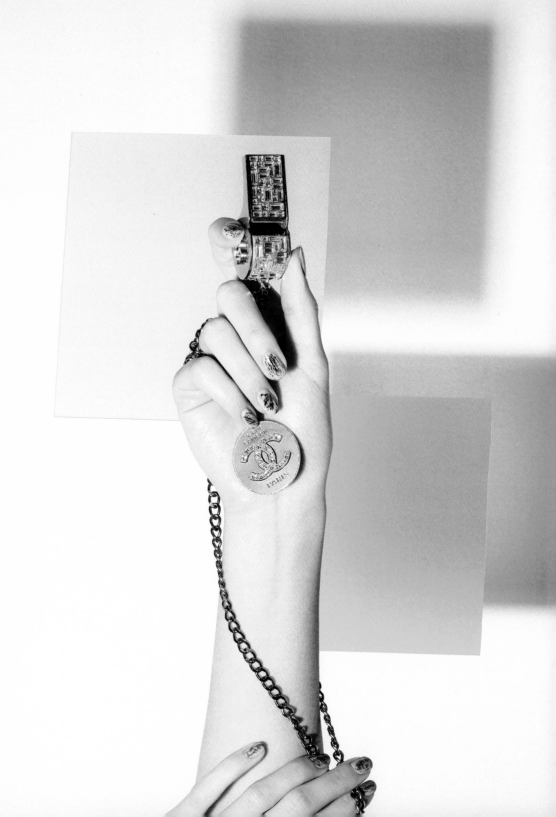

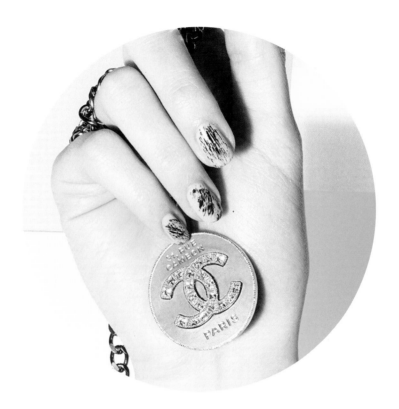

PHOTOGRAPHY BY

David Ralph

——

'Power Tools'

PUBLISHED IN

The *Sunday Times Style*

——

5 APRIL 2015

Dry brushing (see pages 22–23) is a particularly effective technique. I have perfected it over many years. The method starts with a base coat, which is then overpainted, either with a contrasting colour or with the same colour, to create a textured effect similar to brushed metal. Before the upper coat is added, the brush is wiped again and again until very little varnish remains. This enables the nail artist to create defined strokes. Here, the strokes of Kandinsky's own painting are mimicked using a deep royal blue over nude.

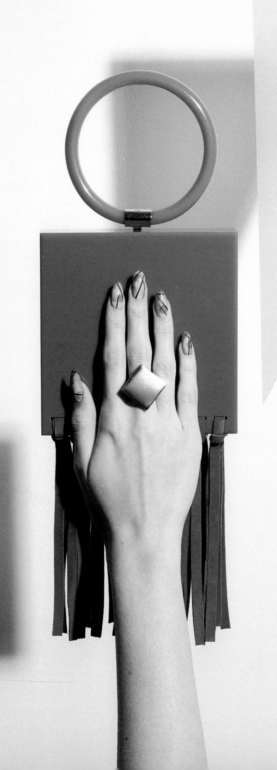

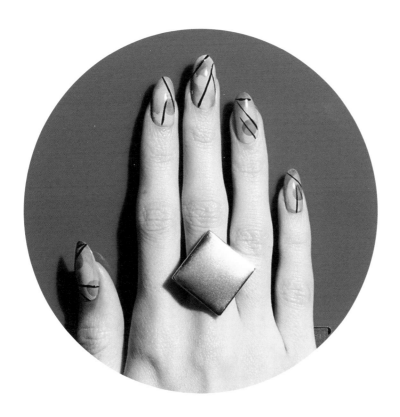

PHOTOGRAPHY BY

David Ralph

———

'Power Tools'

PUBLISHED IN

The *Sunday Times Style*

———

5 APRIL 2015

This is the most literal interpretation of Kandindsky's work in this series created for The *Sunday Times Style* magazine. I used an orange often associated with his work, along with a very interesting, if murky, green. The technique features random strokes of colour created with airbrushing, and layered over with strokes and circles – an abstract, painterly effect that mirrors his own. Choosing unusual colours and using them together can create a powerful and unique look. These take a historical reference and turn them into a fresh, contemporary idea.

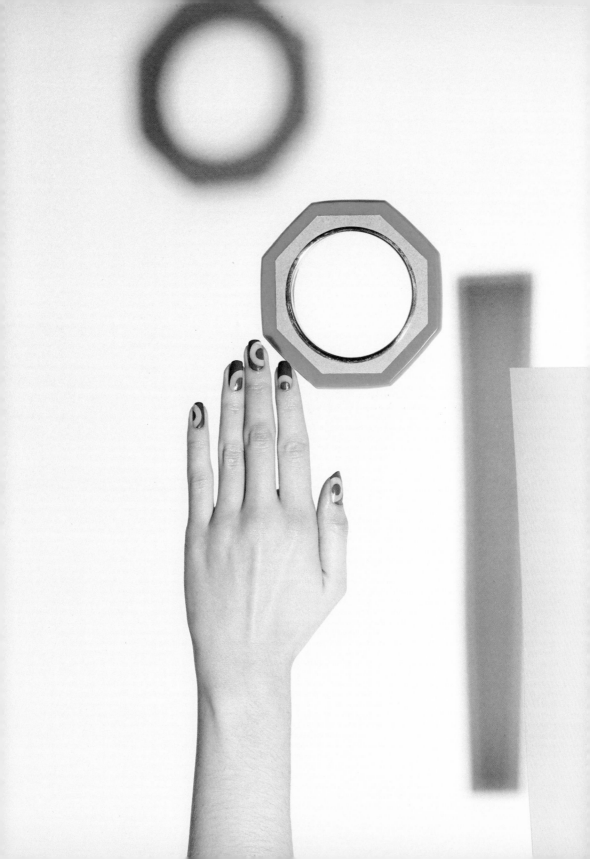

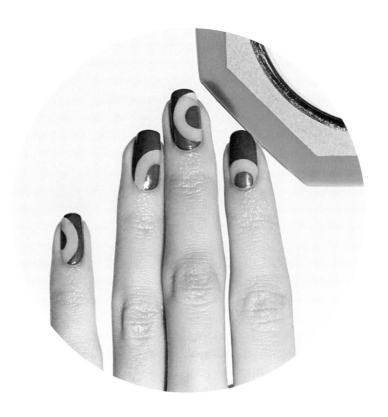

PHOTOGRAPHY BY
David Ralph

——

'Power Tools'
PUBLISHED IN
The *Sunday Times Style*

——

5 APRIL 2015

Kandinsky used circles and negative space in his paintings and we've reflected them here using binder-file reinforcement rings. These make very effective masking stickers, for creating perfect circles. The process works best if you keep the layers of nail polish thin and know exactly when to remove the mask to prevent it dragging or tearing. (Around two minutes is best, but it will take a few practice runs to get it right!)

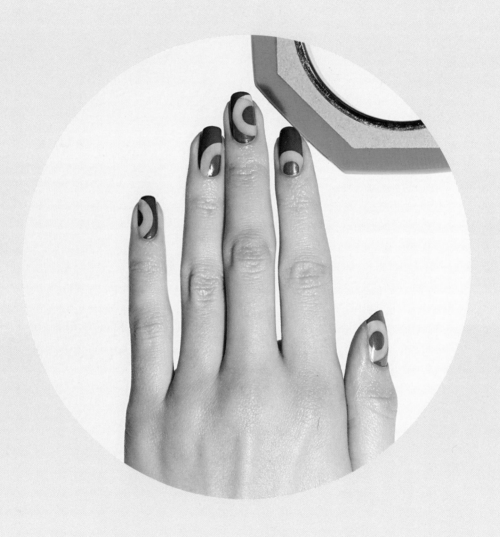

How to create striking nails using negative space

Using blank areas on nails can be a very effective, graphic technique. The example here used binder reinforcement stickers to achieve circular negative spaces. Used as a mask, regular sticky tape will produce sharp, straight lines wherever you want to create perfectly linear areas of colour – without any wobbles!

1. Clean the nails with a conditioner-free polish remover.

2. Apply a thin layer of clear base coat to each nail.

3. Apply a binder reinforcement sticker to the first nail.

4. Using your chosen colour polish, apply a thin coat. Ensure that you paint over the sides of the sticker, to create clean lines. Dark colours such as the metallic grey-green I used here work well.

5. Wait for approximately two minutes and then carefully remove the sticker with tweezers, to reveal the negative space.

6. Repeat the process for each nail.

7. Apply a clear top coat.

PHOTOGRAPHY BY
Graeme Montgomery

——

'Tattoo'
PUBLISHED IN
Vogue China

——

SEPTEMBER 2015

This story was all about Chinese characters, and brought together a variety of creative talents. We had a remarkable 80-year-old Chinese calligrapher with us that day as well as Pavan, the henna artist who created this particular hand painting. At the time Pavan was recognized by Guinness World Records as the fastest henna artist, and I was looking for someone who could work within the time constraints of a photographic shoot. She has gone on to create many remarkable shoots and to open henna bars in Selfridges and NYC. For my part, I like that nails can become part of a bigger hand story.

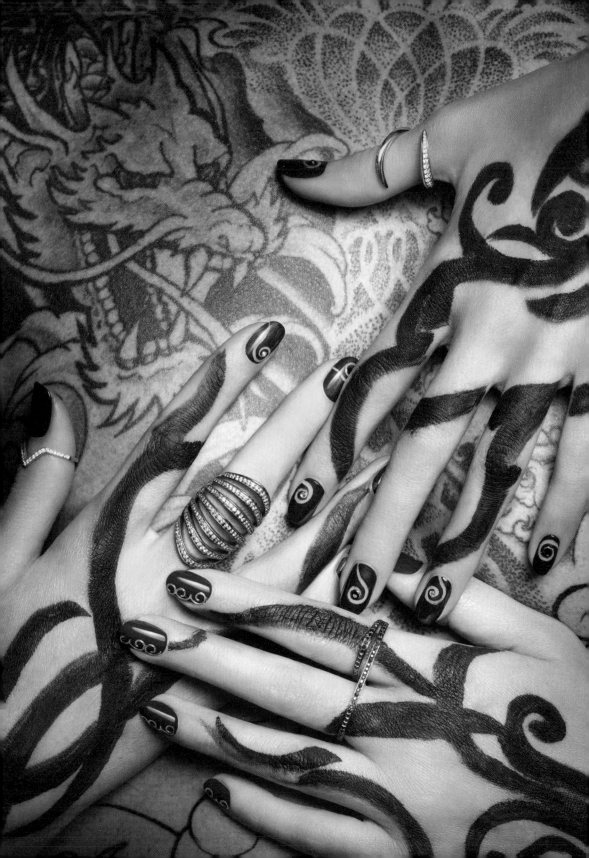

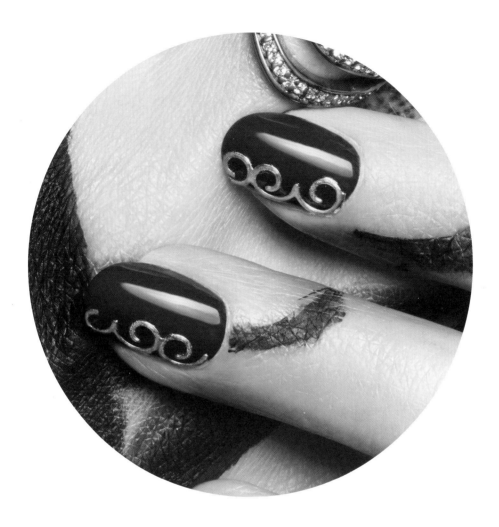

PHOTOGRAPHY BY
Graeme Montgomery

——

'Tattoo'
PUBLISHED IN
Vogue China

——

SEPTEMBER 2015

I worked with the henna artist Pavan to create these Art Nouveau-inspired designs. The hands have been painted and arranged to appear organically entwined. It's an effective and complementary use of very different inspirations. For my part, the designs on the nails were achieved by placing crafting stickers on the nails as masks. As complicated and artistic as the image is, the nails are practical and decorative.

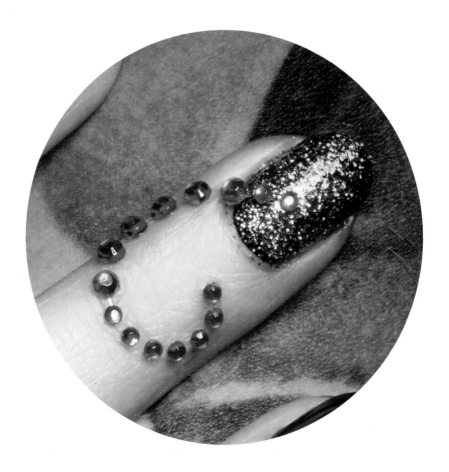

PHOTOGRAPHY BY
Graeme Montgomery

———

'Tattoo'
PUBLISHED IN
Vogue China

———

SEPTEMBER 2015

Sometimes I include an element that comes from my enormous box of creative tricks. For this picture I applied a crystal design bought from a hobby shop. It appears to grow down the hand and extend over the nail. I love being able to bring nail design onto the hands in this way, and to grow the connection between the two. The flower sits in the right place on the hand to balance the design and point the eye to the end of the finger. It's a satisfying combination of techniques and gives me the opportunity to explore unusual creative ideas.

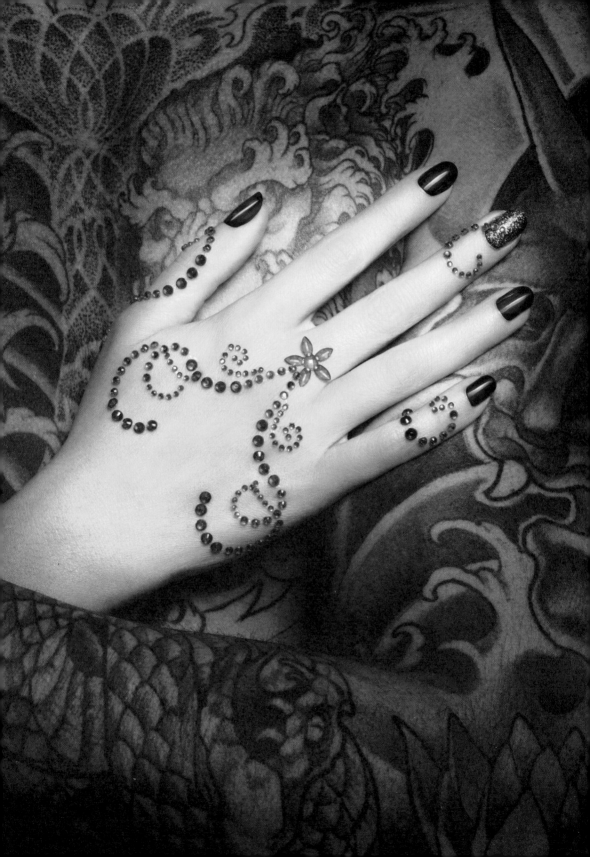

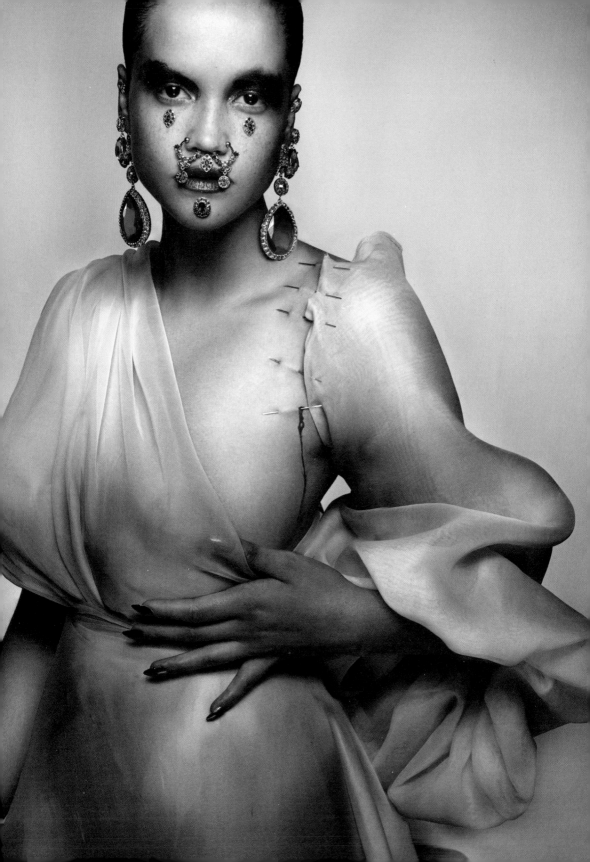

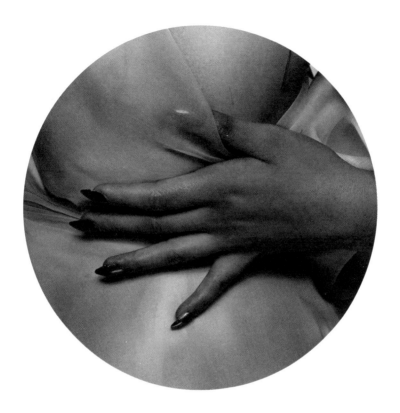

PHOTOGRAPHY BY

Nick Knight

———

PUBLISHED IN

AnOther Magazine

———

AUTUMN/WINTER 2015

The model and fetish artist Tessa Kuragi is known for her exploration of BDSM (Bondage and Discipline, Sadism and Masochism) and shibari, a Japanese artistic form of rope bondage. For her story with Nick Knight, the extreme theme included this image of Tessa with a sleeve physically sewn onto her body by a body piercer. Because of my scientific background I have always been fascinated by the physical nature of photographing bodies. No matter how dark it gets, I am always to be found running towards a scenario that tests where the boundaries lie, not away from it.

PHOTOGRAPHY BY

Aleksandra Kingo

———

'Ouch!'

PUBLISHED IN

Hunger magazine

———

AUTUMN/WINTER 2015

I love being involved in creating an image that has a strong narrative but one the viewer can make their own. I'd worked with Kim Howells, the stylist, on a number of shows and we'd always managed to create some pretty unusual nails one way or another. She asked me to collaborate on a story titled 'Ouch!' for *Hunger* magazine. Using the title as a starting point, the team met to discuss our thoughts, some of which were more disturbing than others. We had so many ideas! The result was a series of thought-provoking pictures, each of which had a strong story attached to it and asked the viewer to question the whole idea of what beauty really means.

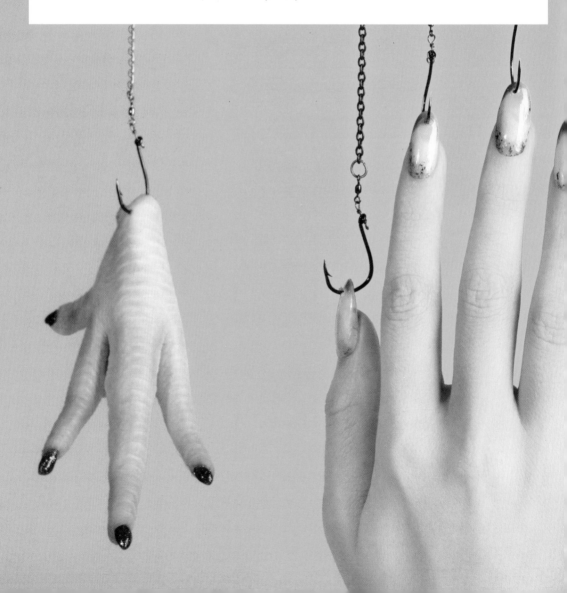

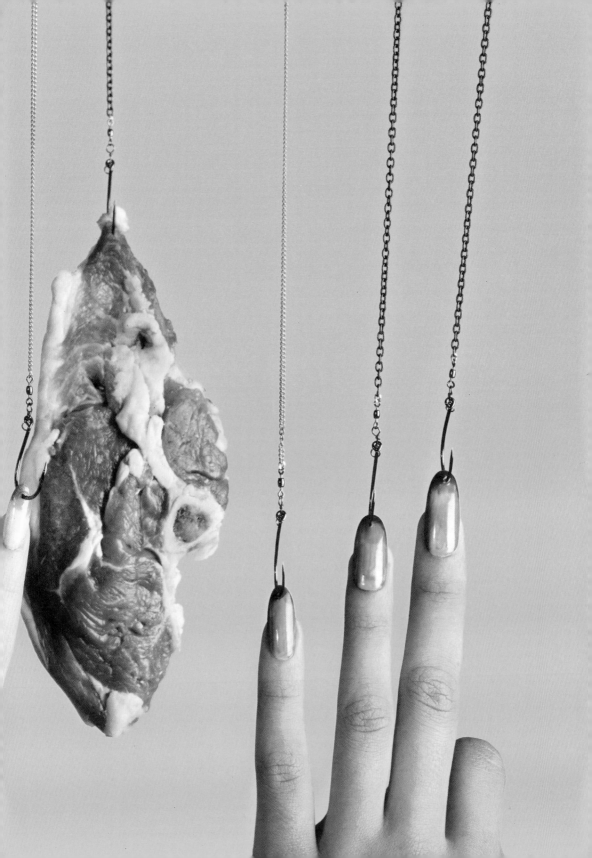

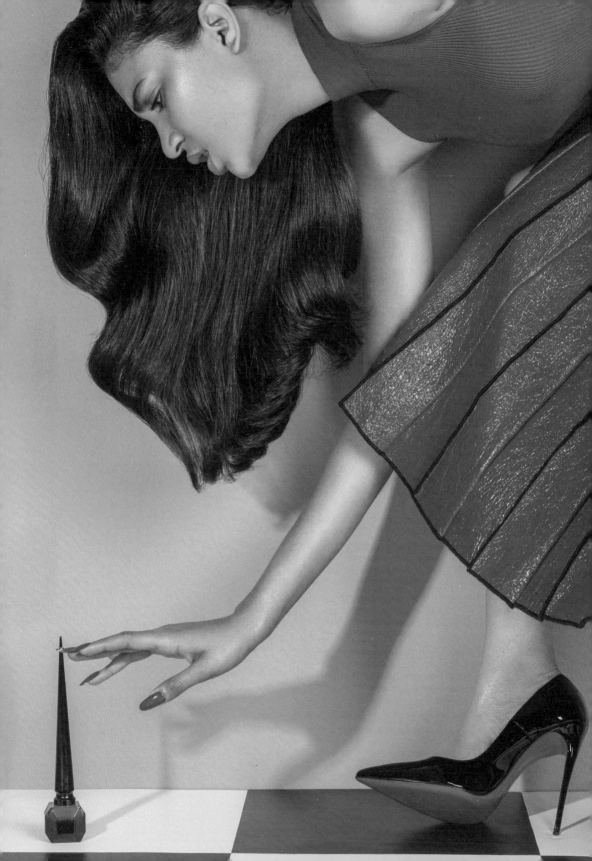

PHOTOGRAPHY BY

Aleksandra Kingo

——

'Ouch!'

PUBLISHED IN

Hunger magazine

——

AUTUMN/WINTER 2015

Here, an incredibly glamorous woman trips in her shiny Christian Louboutin heels and spears her nail on the shoe designer's very own nail polish bottle. The entire scenario exists only because we can make it happen in a single image – fashion stories don't need to make sense! Such stories enable us to test the boundaries of creativity and imagination. The complicated business of making each of the elements work perfectly is why we always work in teams of specialists. Each of us has to come together with our very best efforts to make the unbelievable seem possible. The team at Christian Louboutin loved this story so much that I went on to work with them on shows. It was a natural synergy, not least because Christian first created his famous red soles by painting them with his assistant's nail varnish!

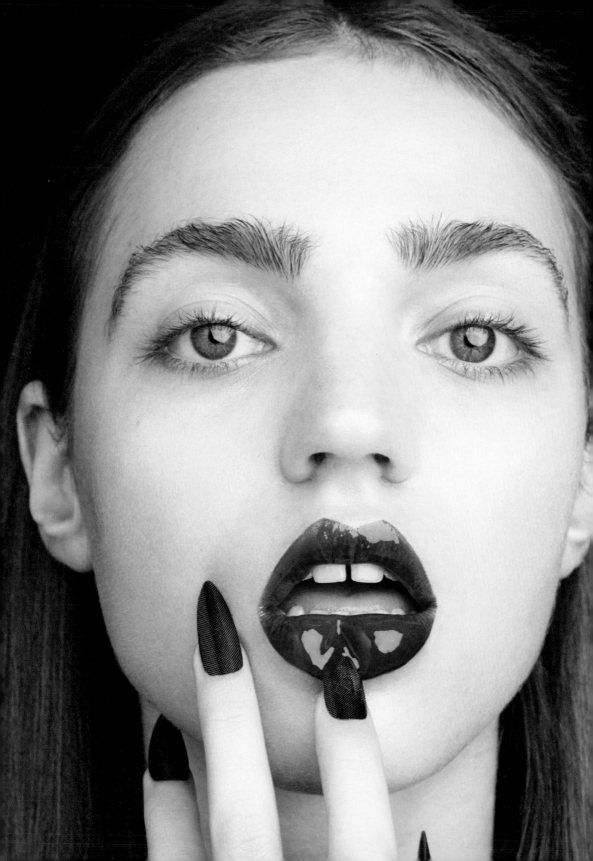

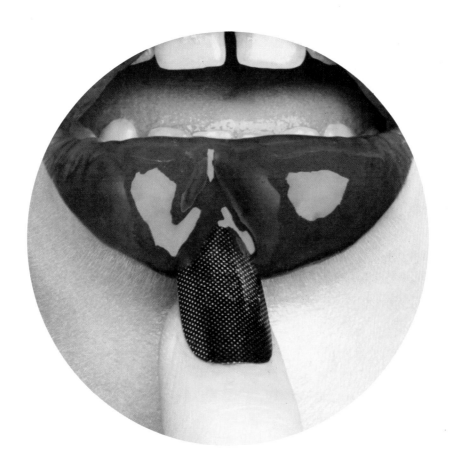

PHOTOGRAPHY BY

Aleksandra Kingo

———

'Ouch!'

PUBLISHED IN

Hunger magazine

———

AUTUMN/WINTER 2015

Here, spear-like nails are created using shaping and Minx stickers with a two-tone car paint finish. We can't be sure if the liquid oozing down her nail is lip gloss or blood. Ouch! There is a long history of nails being made to appear dangerous or aggressive, with sharpened stiletto shapes used to give the impression of weapons. This story was the perfect place to use shape, which is an important part of the idea's narrative and allows the image to make sense.

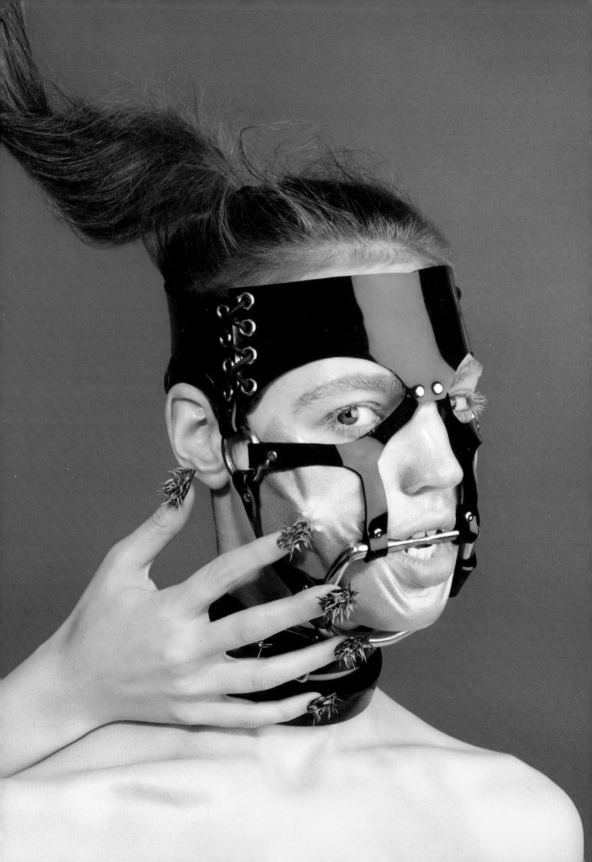

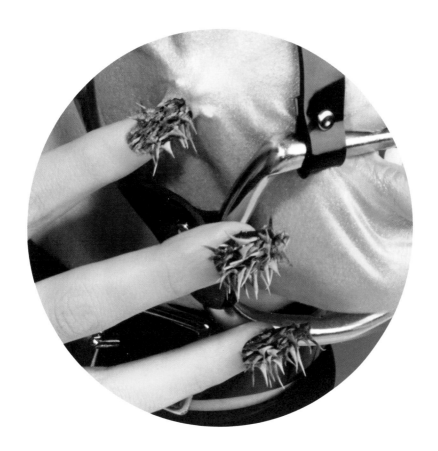

PHOTOGRAPHY BY
Aleksandra Kingo

——

'Ouch!'
PUBLISHED IN
Hunger magazine

——

AUTUMN/WINTER 2015

This image was the final and most extreme picture created in the 'Ouch!' series. The nails are studded with real thorns and used to look as if they are lifting the skin from the model's face. The theme is S & M, but thankfully no pain was inflicted on the model. As ever, it takes a lot of smoke-and-mirror ingenuity to produce the most extreme pictures. The effect here was created by the makeup artist Andrew Gallimore, who cleverly used a form of plastic skin. It's a shocker, but that's the point.

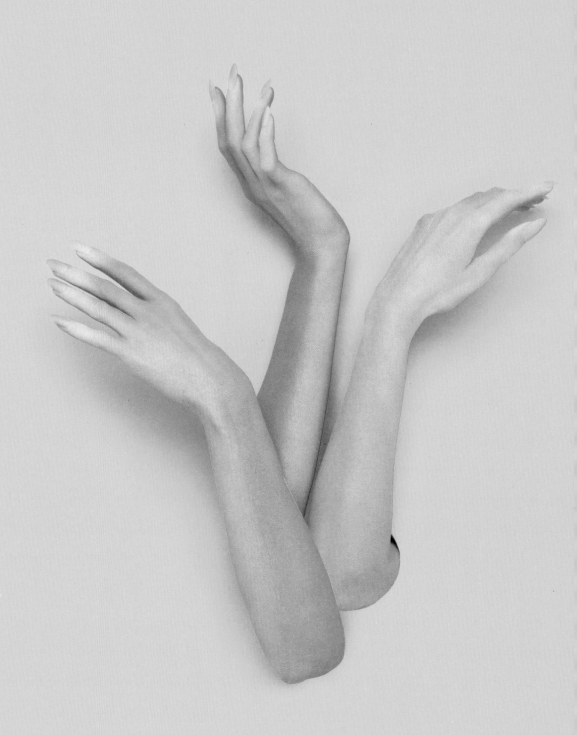

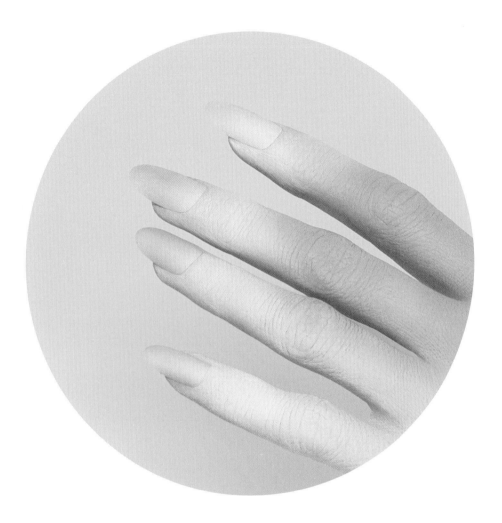

PHOTOGRAPHY BY
Barbara Donninelli

——

'Pastel Puzzle'
PUBLISHED IN
Vogue Me, China

——

JUNE 2016

It might be surprising to hear, but I'm not a pink person at all. It's a key colour for the beauty industry, however, and was the focus of this story, along with other strong pastels. On this occasion, a makeup artist provided the colour washes on the model's body to match the nail colours I was creating. It isn't always clear where makeup ends and nail work begins, but hand decoration usually falls into my remit. Like so much about session work, it involves a bit of a discussion and usually depends on the client's brief.

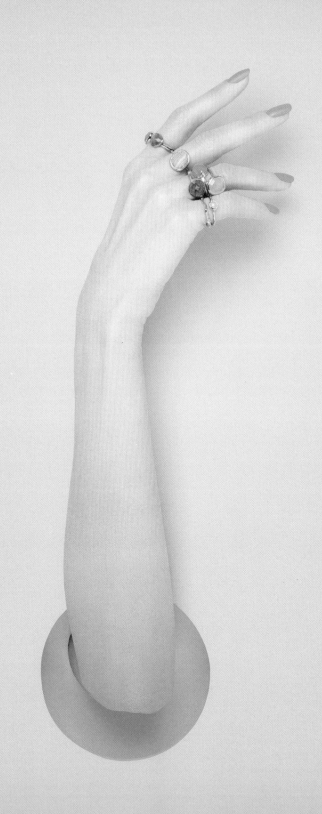

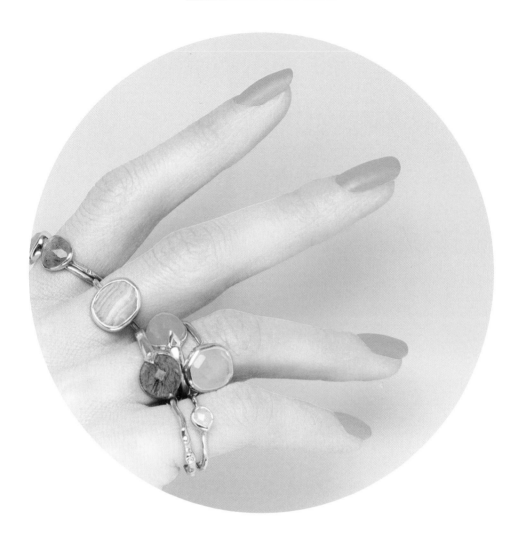

PHOTOGRAPHY BY
Barbara Donninelli

——

'Pastel Puzzle'
PUBLISHED IN
Vogue Me, China

——

JUNE 2016

In the making of photographs, abstract schemes are sometimes a very good way to present a smaller detail such as nails. Throughout this story, the limbs are disembodied to place the focus on specific areas. Here the arm is painted to make it look as though it is emerging from the background. The colours are deliciously unusual, as are the hues in the jewellery. They make sense of the conceptual approach and give the picture its piquancy.

PHOTOGRAPHY BY

Barbara Donninelli

——

'Pastel Puzzle'

PUBLISHED IN

Vogue Me, China

——

JUNE 2016

Sometimes the trick of the ſtrongeſt image is about getting a sequence of colours to work their magic. The order in which the elements of a picture are placed can, however, be a surprisingly difficult detail to get right. Here the pole acts as an anchor for the composition, but the placement of the hands took some time to perfect, especially because the colours themselves are so unexpected.

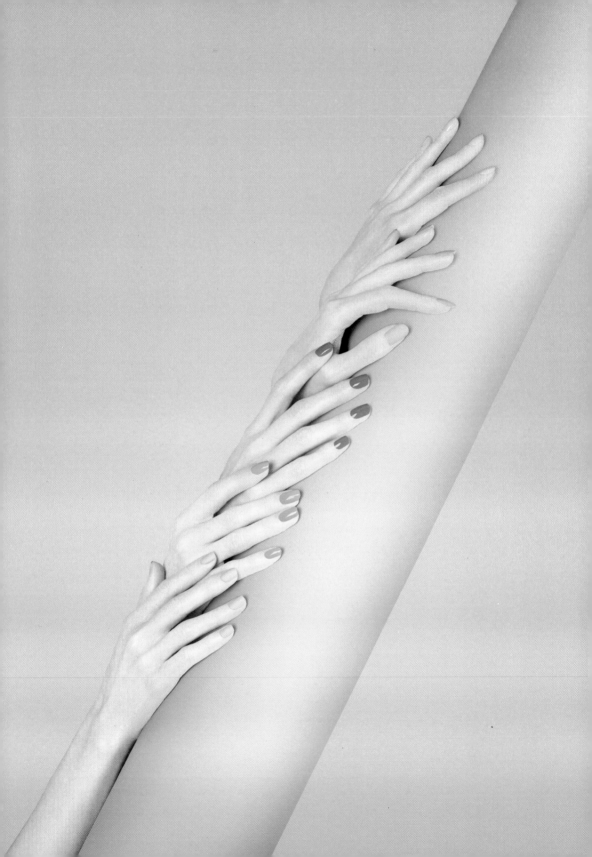

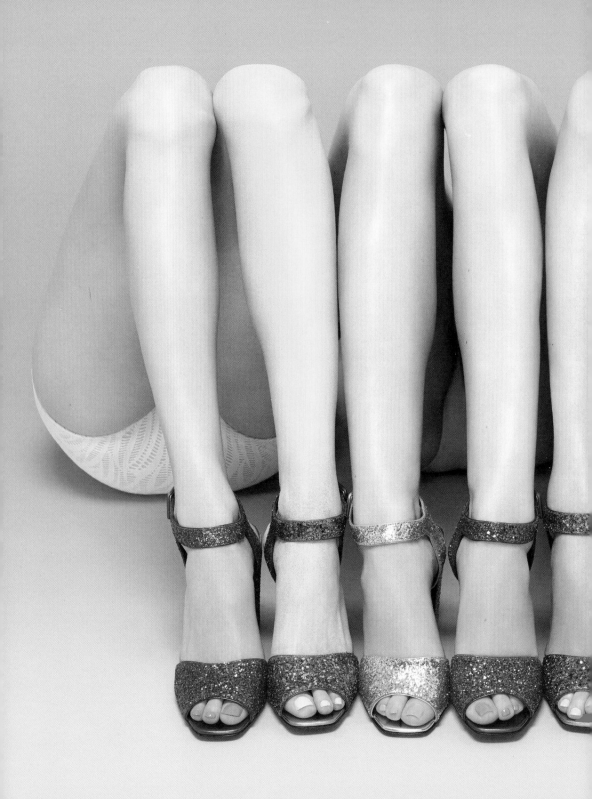

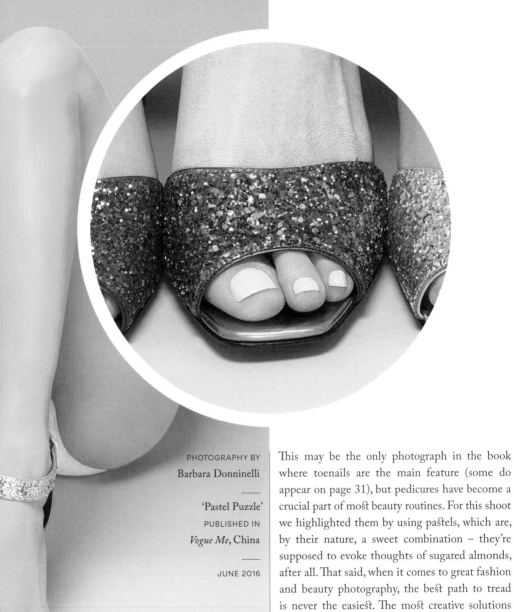

PHOTOGRAPHY BY
Barbara Donninelli

———

'Pastel Puzzle'
PUBLISHED IN
Vogue Me, China

———

JUNE 2016

This may be the only photograph in the book where toenails are the main feature (some do appear on page 31), but pedicures have become a crucial part of most beauty routines. For this shoot we highlighted them by using pastels, which are, by their nature, a sweet combination – they're supposed to evoke thoughts of sugared almonds, after all. That said, when it comes to great fashion and beauty photography, the best path to tread is never the easiest. The most creative solutions always rely on us taking the alternative approach. So, rather than taking the obvious route, we used a combination of stronger colours to make the nail varnish pop here. The unexpected line-up of legs manages to present normally pretty colours in a unique and surreal way.

PHOTOGRAPHY BY

Sølve Sundsbø

———

'Absolutely Fabulous'

PUBLISHED IN

V magazine, V102

———

14 JULY 2016

Backstage at a shoot, I can usually be found sitting on a low stool next to my subject, entirely zoned out while I work away at their nails. I really do go into my own world. There are times when I suddenly snap out of it and look up the arm I'm working on, only to see an incredibly famous head at the top of it. That was definitely the case for this shoot. Joanna Lumley and Jennifer Saunders were, as you'd hope them to be, a hilarious and very warm double act. It was another one of my pinch-me moments. Creating nails for portraits is always a matter of working with the sitter's preferences rather than dressing a character. These two couldn't have made the job any easier.

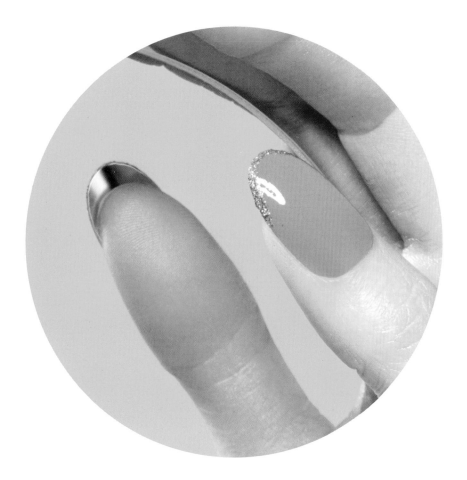

PHOTOGRAPHY BY
Barbara Donninelli

——

'Playtime for Nails'
PUBLISHED IN
Vogue Japan

——

JULY 2016

This dramatic image is featured on the fourth edition of my book, *The Complete Nail Technician*. For me, using reflections in this shoot was about highlighting the backs of nails. Even when they're beautifully painted, nails can look slightly grubby. No matter how brilliant they appear in their naked form from the front, structurally they are uneven and semi-opaque, so colour doesn't travel through them well. With longer nails, it's possible to rectify this by painting the backs of the nails. More than that, it can be an area featuring actual decoration and shouldn't be overlooked.

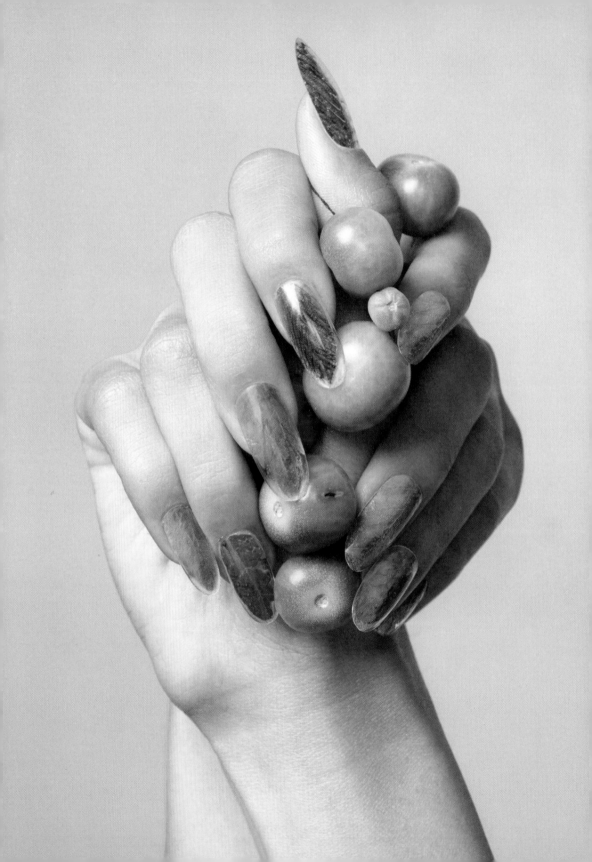

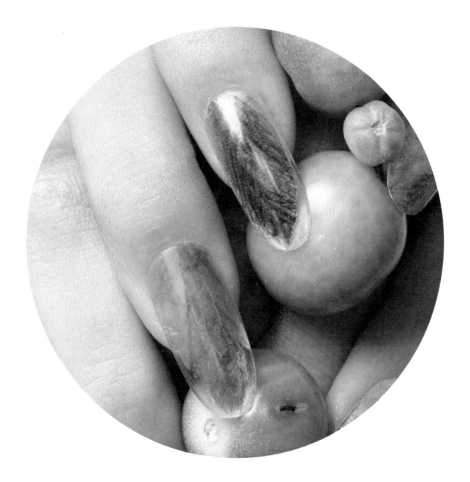

PHOTOGRAPHY BY

Michael Baumgarten

——

'Green Power'

PUBLISHED IN

Vogue China

——

OCTOBER 2016

Editorial nails are sometimes there to inspire, rather than to offer a creatable technique. An idea that looks marvellous in a photograph may not work in the real world, where women (or men) may actually have to pick something up or, god forbid, make a cup of coffee. These nails are a case in point. Caught behind the clear tips are real leaves, freshly gathered for this story. I spent a good deal of time getting them to stick successfully to the nails without damaging their perfect, fragile surfaces. An image may appear effortless and calm – but that isn't always the case!

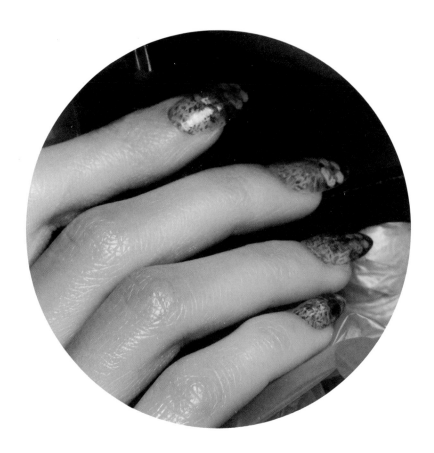

PHOTOGRAPHY BY
Sølve Sundsbø

——

'Mind & Soul'
PUBLISHED IN
Italian *Vogue*

——

NOVEMBER 2016

This shoot was the first time I used pressed flowers within nails. The makeup artist Val Garland had suggested that I try to recreate a *memento mori* – historical mourning jewellery that featured the hair of a loved one. It was a great idea, but impossible to achieve well. I opted instead for dried flowers, encapsulating that delicate, mysterious mood in a different way. I don't keep many sets of nails, but I did keep these because they were so effective. I used the idea very differently for Preen's Autumn/Winter 2017 catwalk show, and *Elle* magazine called them the prettiest nails at London Fashion Week.

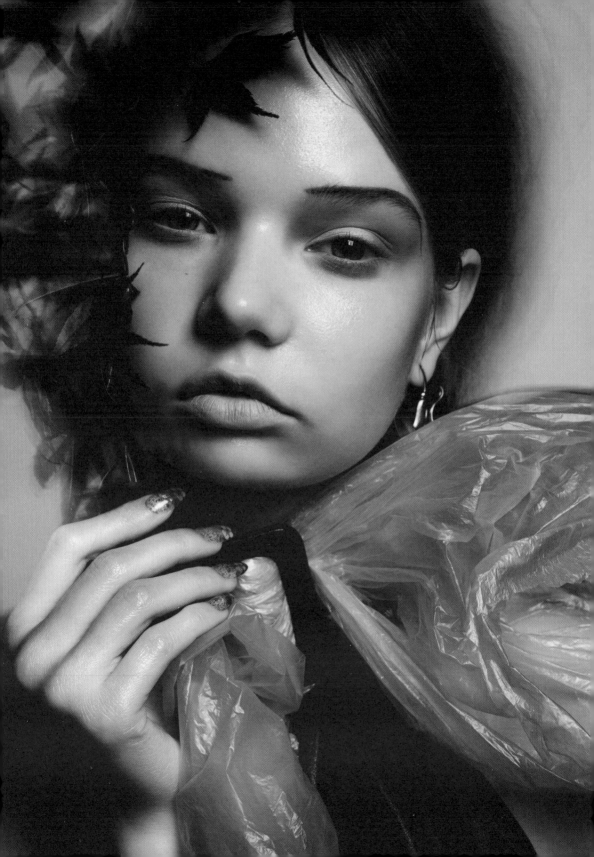

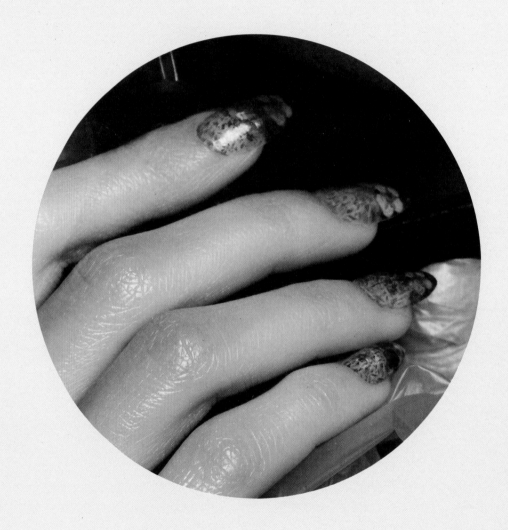

How to use flowers to create a pretty and punchy look

The brief I had for this shoot was Victoriana. I imagined the art of flower pressing in books and images of flowers under a domed glass. Tiny dried flowers are available online or in craft shops – but if the flower is too big, simply trim it with small scissors.

1. Lay out the flowers and petals along with some tweezers.

2. Take a set of clear tips and match the flowers and petals to the size of each nail.

3. Paint the inside of each clear tip with a clear top coat and immediately place the flowers and petals onto the wet polish.

4. When you're happy with the placement, trim any excess flowers and petals using small scissors.

5. Once all the flowers are in place, seal with another layer of clear polish.

6. Using special double-sided tape designed for applying false tips, place them on the nails and press. The bond won't be strong enough for long-term use, but it is a pretty effect for a single event.

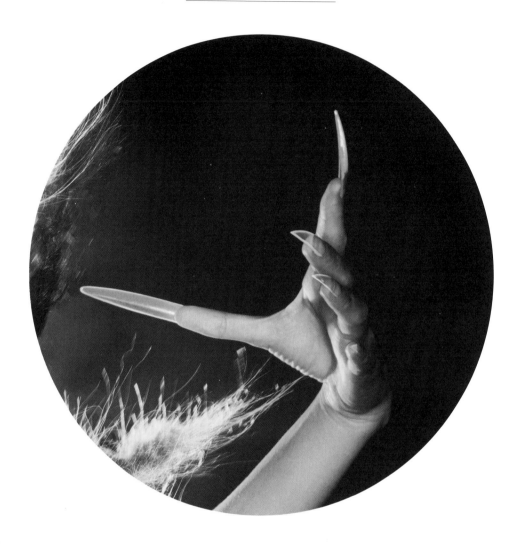

PHOTOGRAPHY BY

Sølve Sundsbø

———

'Super Creeps'

PUBLISHED IN

AnOther Magazine

———

SPRING/SUMMER 2017

Some of the stories I've helped to create over the years have been out of this world. Fashion pictures enable us to create fantastical ideas that would never work as a real-life option. No more so than with this story, where the nails are no longer a small detail but take on a far bigger role for the Medusa-like creature we've created. Her nails have become talons to match her wild hair. She's a terrifying yet compelling character, and one we all loved working together to create.

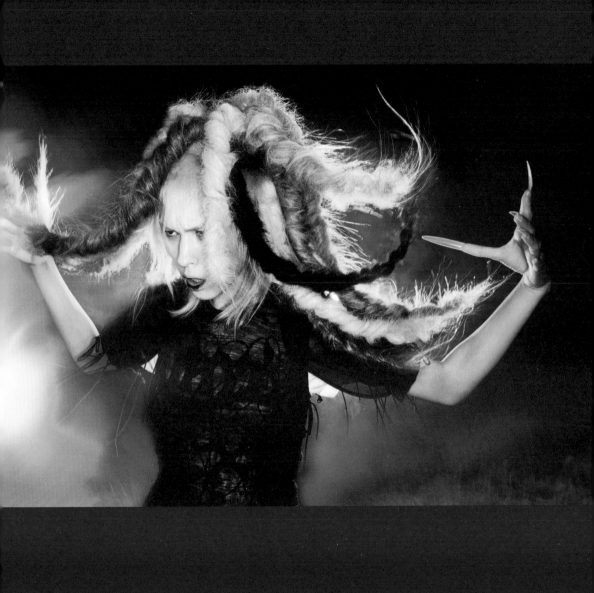

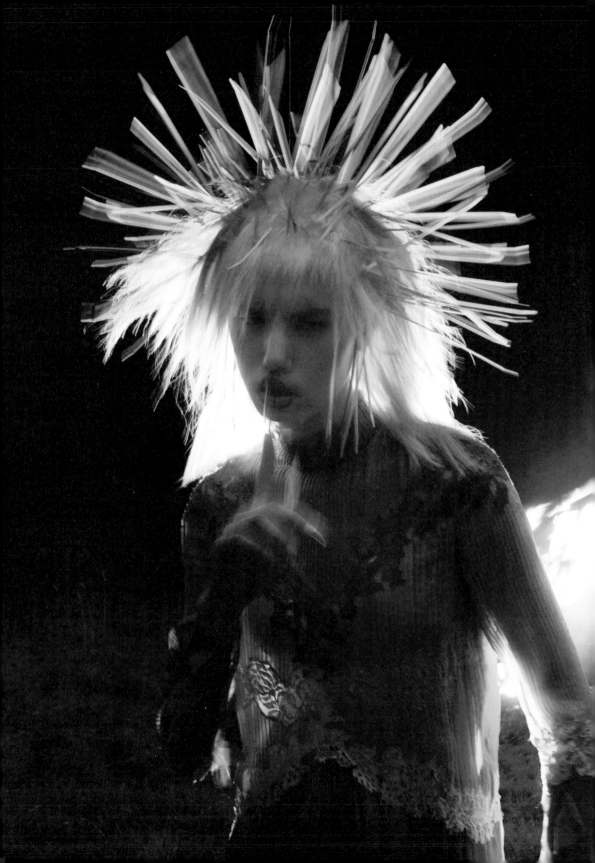

PHOTOGRAPHY BY

Sølve Sundsbø

———

'Super Creeps'

PUBLISHED IN

AnOther Magazine

———

SPRING/SUMMER 2017

This image is special to me partly because it's an example of creative generosity within a team. The stylist, Katie Shillingford, was happy for me to create outrageous nails for a couple of pictures at the end of the shoot, and I created long, spiky, clear nails with neon edges to them. The hair artist, Eugene Souleiman, was so inspired by them that he designed this amazing look to match them. Eugene, who is well known for his highly creative and well-executed hair, used neon cable ties to achieve this extraordinary effect.

Show Nails

Show Nails

Fashion shows and live events combine the adrenaline rush of an extreme sport with the need for our fastest and most artistic work. There's nothing quite like the buzz backstage when the huge beauty and styling teams are working at full stretch. It always amazes me how serene and perfect the models appear on the other side of the catwalk, because the reality behind the scenery is highly organized chaos. The results, though, have to be perfect. I'm booked to provide the finesse and to ensure that each and every nail is as good as it can be.

When I'm designing nail ideas for a show, I always provide as many options as possible. This gives a designer the widest choice of ideas. I've also learned that when it comes to shows, the nails can be as creative as the designer wants them to be. Sometimes they will be after a super-natural look, sometimes a supernatural one, but it's always best to be prepared for ideas to go either way. If creativity is required, there are few limits in terms of structure or texture because the nails are on the models' hands for only a couple of hours. They can be crazy, impractical or fabulous.

My first show, in 1997, combined all three. Alexander McQueen was into his second season at Givenchy in Paris. At the time, it was virtually unknown for a designer to have a nail team – but that was about to change. Sharon Dowsett and Val Garland were leading the two makeup teams for the Autumn/ Winter Couture show, *Eclect Dissect*. This was the second couture show for Lee (his first name and the one used by his friends and

colleagues). It was clear that it would also make a big impression. I had worked with Sharon on shoots with Nick Knight, and it was she who suggested to the Givenchy team that I create some nails for the show.

I had *no* clue about what to expect. I tentatively asked what they might want and was told there would be 50 models – although I wouldn't have to do the nails for all of them. Lee, I was told, would send me some ideas.

They came to me by fax. (This was the era before emails.) Lee had sketched very long, spiral silver nails, to be worn by Debra Shaw, one of the models. I had no idea how to make them: nothing like them had been attempted before. All I had to go on was my creativity and an awful lot of experimentation. I was able to make what were effectively plastic nails for salon clients, using acrylic and combining a liquid and a powder. So I played with this, along with the foil containers from Chinese takeaways. It took some time to work out how to make spirals of different widths to fit the different-sized nails on the models' fingers. Suffice to say, it involved a lot of trial and error.

BELOW: Briefing sketch for the *Eclect Dissect* collection for Givenchy (Autumn/Winter 1997, Haute Couture)

I made four curly nails before setting off for Paris. I wanted to make sure they were exactly what Lee wanted before I made the other six. To help, I took just one person, my salon business partner, Kay Dodd. *(Just one person? What was I thinking? I now have a team of nine or ten technicians for that number of models.)* We arrived fresh from our first Eurostar journey just three days before the show, and with a lot of preparation to do.

I remember being overawed by Givenchy's atelier, where the seamstresses, or *petites mains*, were crafting exquisite gowns. The stress levels were pretty high, though. Katy England, Lee's long-term stylist and muse, worked with Sharon and myself to come up with an agreed list of nail ideas, and the models who would be wearing them. Thankfully I only needed to concentrate on about a quarter of the models.

One show section had a Maori theme. For it, Naomi Campbell was to wear an amazing pair of shoes, encrusted with

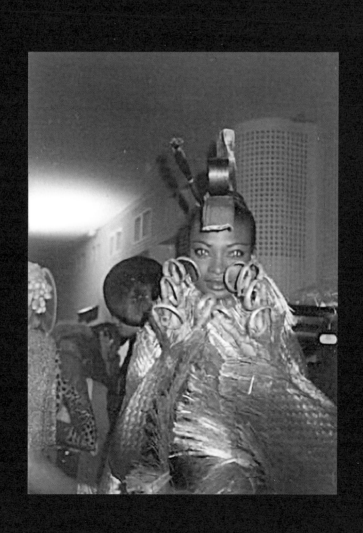

real diamonds. To embellish her feet further, Lee and the team wanted a Maori-style design painted on them, something I was asked to do. To make sure it was spot-on, I had a test model for one of the prep days to help me create and perfect the design. She spent hours sitting on a chair on top of a table wearing the priceless shoes. I painted various designs until I got it right. Polaroids were taken and I was ready to reproduce this on Naomi's feet before the show.

Back in our shared hotel room, Kay and I made the remaining spiral nails, now approved by Lee. We had to turn the bathroom into a lab as we worked through the night with a very volatile liquid and fine white powder! It was a ridiculous environment to work in and wasn't conducive to efficient creativity. At one point, the large pot of white powder was knocked over, sending the dust all over the bathroom. What must the hotel housekeepers have thought?

Despite all this, we got the nails done perfectly and on time. At the show venue, we set about applying and creating nails. I was so fresh to the business at this stage, I just did what I thought would work. We didn't have the time-saving products that exist today; there were no easy 'stick-ons', and Kay and I had to provide long nails. Making long, beautiful nails usually required a long and tricky salon process, but somehow we got there – and even had the audacity to sneak out to watch the show, which was an amazing experience.

There was always something amazing going on with Lee. At the start of 2006, I was called in to do a simple manicure for a top-secret project. Unfortunately, I was working, so I sent my assistant – and we were both sworn to secrecy. Not many weeks later, I was in Paris for the Autumn/Winter 2006 shows, including Alexander McQueen's *Widows of Culloden* collection. The show nails were very simple and clean, so I had the opportunity go to the back of the massive square amphitheatre and watch the show.

In the middle of it was a huge glass pyramid and when it was time for the finale, a spot of light appeared inside it and grew. I could hear gasps of wonder around me, followed by comments such as: 'It's a woman!'

The image grew in size until it was revealed to be Kate Moss. To the sound of thunderous applause, the holographic Kate spun as if in mid-air until she and her ethereal dress began to dissolve. The spectacle ended in a clash of stars that disappeared into the

LEFT: Debra Shaw wearing the spiral nails backstage at the *Eclect Dissect* collection for Givenchy (Autumn/Winter 1997, Haute Couture)

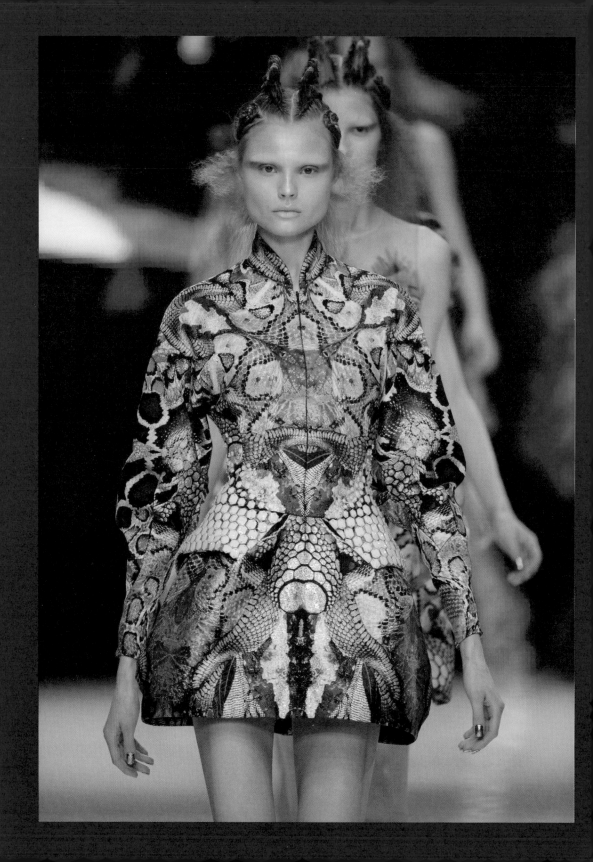

ether. To have been a small part of that moment made the team and I incredibly proud.

This amazing creation, by the music and film director Baillie Walsh and Alexander McQueen, was based on a Victorian illusion called Pepper's Ghost. It was recreated for the exhibition *Savage Beauty*, (at the Metropolitan Museum of Art and the V&A), where it was one of the last exhibits of a very emotional walk-through demonstrating the genius of the man.

Another important show I worked on for him was his Spring/Summer 2010 show, *Plato's Atlantis*. It is now regarded as a masterpiece for its creative vision, and sadly it would turn out to be his last. In preparation, I met with Lee and was told the extraordinary backstory attached to the show and collection. His concept was based on a telling of evolution in reverse. He imagined the creatures of the air and earth evolving back into the sea.

I suggested we could use the work of a new nail company, Minx, based in San Diego. The team there was able to create a first: nail decorations that could be printed to order. We were sent artwork for many of the fabrics Lee was using, and Janice Jordan at Minx created 41 different metallic designs using small details from each one.

LEFT: *Plato's Atlantis*, Alexander McQueen (Spring/Summer 2010)

BELOW: Raquel Zimmermann, behind the scenes during the creation of the film for *Plato's Atlantis* by Nick Knight for Alexander McQueen, 2009

Dawn Lynch-Goodwin, Janice's business partner, came to the UK with the precious samples. Along with a couple of my show team, we set about making the nails. Lee wanted them to 'grow' as the show progressed and the models' characters became more extreme. We made more than 1,000 nails so that Lee and his stylist, who hadn't seen them, had as many options as possible.

Needless to say, it was a very complex show. The hair, by Guido Palau, included some incredibly complicated styles that used braiding, and 'wings' that grew in the same way as the nails as the show progressed. Equally, Peter Philips designed the makeup to start relatively simply and evolve into recontoured faces using prosthetics.

The backdrop to *Plato's Atlantis* was a film made by Nick Knight, whose website SHOWstudio would also be live-streaming the show. It featured the model Raquel

Zimmermann, who was filmed naked and covered with many, many writhing snakes. I created the natural-looking nails for the film (see pages 88–89) and spent a fascinating day watching the snakes and Raquel's interaction with them. In a draughty warehouse in the hinterlands of Park Royal in London, she lay in a large sand tray and was carefully decorated with multicoloured snakes by their animal handlers. She wasn't scared of them, but there were a few uncomfortable moments: at one point, she had to ask the handler to move the snakes because one was trying to slither where no snake ever should!

There were magical moments, too. Raquel had been given 'big hair' for the shoot and, for some reason, lots of little white snakes had retreated into it. There was a sudden bang in the studio and all the little snakes rushed from her hair at the same time. It was an amazing Medusa moment and Lee literally jumped for joy and excitement.

During the show, my team and I were backstage next to the final lineup. We were frantically watching for lost nails and telling the models off for fiddling with their nails while they were waiting to go on! We were also fortunate enough to watch the motivational talk Lee gave to the models. He explained to them about their tribe – and insisted that they should help each other if one fell from their towering shoes. Being close to these fabulous 'creatures' was emotional, and once they were on stage projecting their unworldly auras they were completely captivating.

Plato's Atlantis closed with another surprise: the world premiere of Lady Gaga's 'Bad Romance' blasted from speakers. A few minutes earlier, Gaga had tweeted about the moment and the rush to watch the streamed show broke the internet! The originality and power of *Plato's Atlantis* blew everyone away and memories of it still give me goosebumps.

Another Minx collaboration that created a new way of seeing nails was for Charlie Le Mindu, the avant-garde designer and hairdresser. He loved what I'd been doing with crazy nails and also liked what could be done with Minx. His idea was to have nails that represented hair and to use the nails themselves to decorate the clothes and accessories. I sent Janice in San Diego references and she responded with samples of different colours and ways of representing hair through nails.

We all discussed what would be needed – both for the collection and for the models' actual nails. Charlie then announced how many nails would be needed for his team to make the collection:

RIGHT: Rossy de Palma,
Charlie le Mindu
(Spring/Summer 2012)

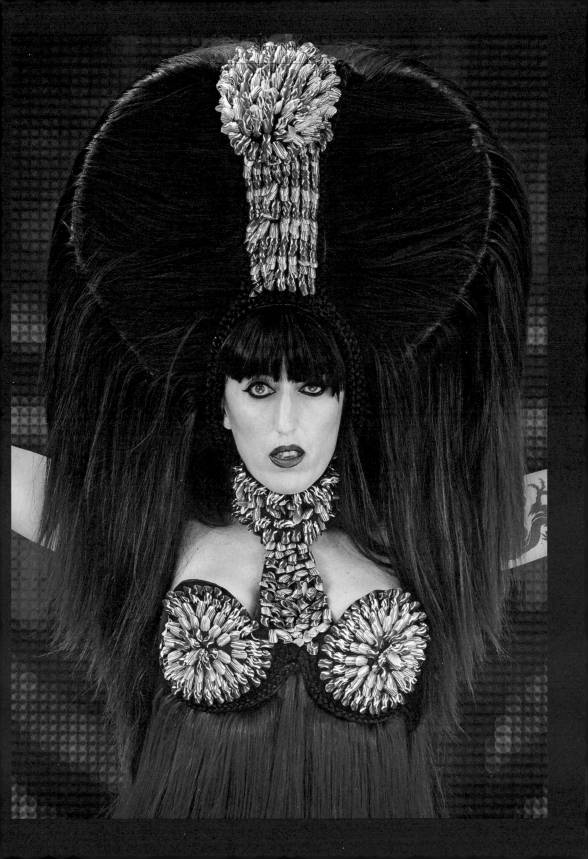

ABOVE: Charlie le Mindu
(Spring/Summer 2012)

30,000! Oh, and to sew them on, the ones being used for the garments each needed a little hole in them. Minx agreed to take on this huge challenge.

When my team and I arrived in Paris, we made the nails for the models to wear, as well as a special set for the actress Rossy de Palma, who was going to appear in the show. The collection comprised dresses, body suits, accessories and even a bra, each with hundreds of nails sewn onto them. The show opened with a dancer from Le Crazy Horse Saloon, the iconic Parisian cabaret club, wearing nothing but a headpiece, my nails and a vajazzle. It closed with Rossy wearing towering shoes and a massive headdress and bra made from Minx's nails (see page 201). We had a last-minute panic when I realized her nails had been left on the table in our apartment. One of the team jumped in a taxi to collect them – with little time to spare!

As well as my catwalk moments, I've had lots of career highlights creating nails for other events. High on that list is the closing ceremony for the 2012 Summer Olympics in London. A few weeks before the event Nick Knight shot a selection of British models, dressed by British designers, for a *Vogue* story. The models then reassembled in the same outfits, for the closing ceremony. In the lineup was Kate Moss (wearing Alexander McQueen), Naomi Campbell (Alexander McQueen), Stella Tennant (Christopher Kane), Karen Elson (Burberry), Lily Donaldson (Vivienne Westwood), Lily Cole (Erdem), Jourdan Dunn (Jonathan Saunders and Stephen Jones), Georgia May Jagger (Victoria Beckham) and David Gandy (Paul Smith).

On the day of the ceremony itself, my small nail crew and I met the rest of the backstage team in central London. Security was high, and we were all to be taken to the Olympic site by a coach. It was time for lunch by the time we got there and Sam McKnight (hair), Val Garland (makeup) and Lucinda Chambers (stylist) all went to the green room where the artists performing at the ceremony congregated. We are all used to working with celebrities, but the room was wall-to-wall with British legends:

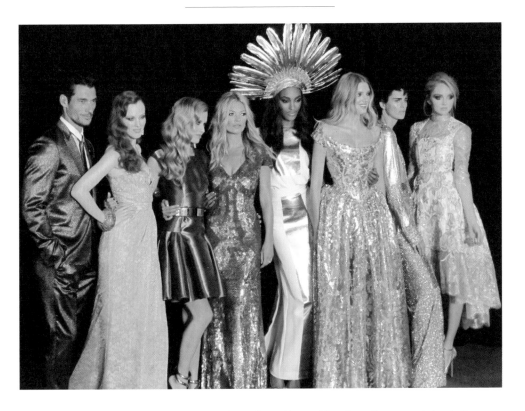

the Pet Shop Boys, Brian May from Queen and Annie Lennox. Then in walked the Spice Girls, and between us we knew all five, so it was lots of fun.

Once the work with the models was completed, we were able to watch the rehearsal. Before long I realized that one of my assistants was missing – I found her playing Super Mario with David Gandy on a game console set up for the VIPs. Later I lost my other assistant and found him too playing with David – ping-pong this time! I watched the rehearsal with Gareth Pugh, who was there to dress the Pet Shop Boys, and his partner (and now husband) Carson McColl. We weren't able to see the actual show in the arena, but huge TV screens were set up for us backstage. Afterwards we went outside onto the roof to watch the spectacular closing fireworks. It was a magical, wonderful memory to keep forever.

Fashion Rocks

London, 15 October 2003

To date, this was probably the largest job of my career in terms of size. Fashion Rocks is a series of live collaborations between fashion and music to raise funds for charitable causes. The first Fashion Rocks event presented the work of 17 designers, including Alexander McQueen, alongside musicians including Beyoncé, Duran Duran and Grace Jones. As well as manicuring the artists and presenters, I was in charge of creating nails for 180 models. With the help of 18 nail specialists, we ensured that every model had a different nail idea, even when some were walking for multiple designers. We managed it, but it goes down as an exhilarating challenge.

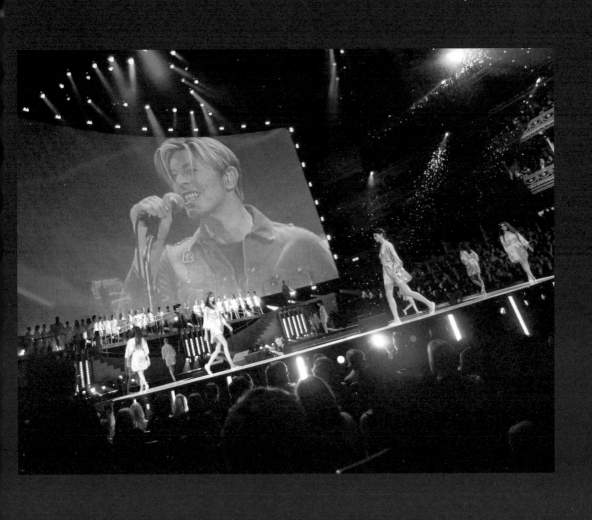

Louis Vuitton

Autumn/Winter 2012

One of my favourite aspects of working for the catwalk is that we sometimes get to see spectacular shows. High on that list are the shows created by Marc Jacobs for Louis Vuitton. I worked on them in Paris for many seasons, and each one was jaw-dropping – none more so, perhaps, than the season he conjured a model of a full-sized steam train complete with Pullman carriage.

Call time (when the team has to assemble) was 3 a.m. Shockingly early, but normal for such a production. What cheered us up was the sight of a massive train standing in the middle of the set. We had no idea what was going to happen, but my goodness, were we in for a surprise when we watched the rehearsal!

First came a rumble that shook the venue, then the sound of a train whistle and a whoosh of steam from behind two huge doors. Then … the doors opened to reveal the train, all lights steam and noise. The girls were helped from the train by a train guard and escorted along the 'platform' by a porter carrying an array of Louis Vuitton luggage. What a show!

Best of all, the train was disassembled and put on a boat to China – and a few months later I journeyed to Shanghai to repeat the experience.

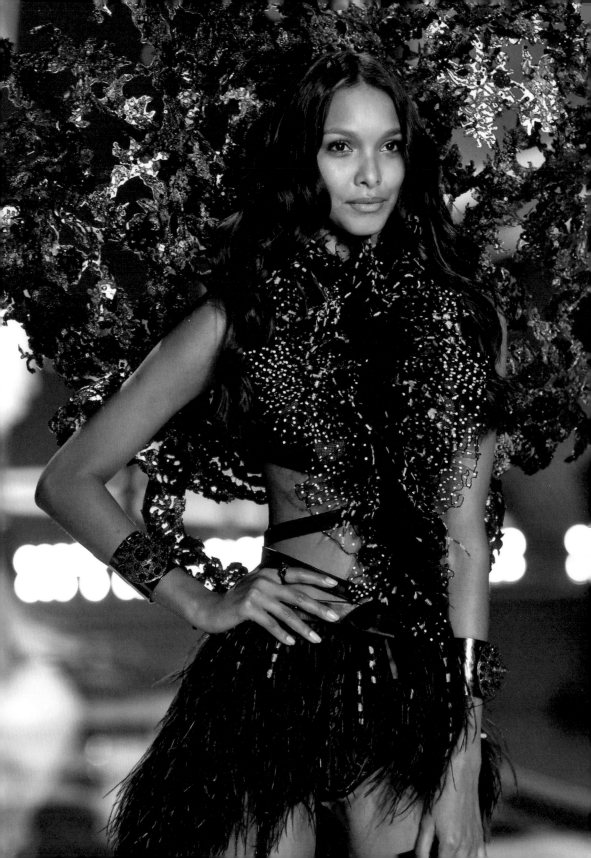

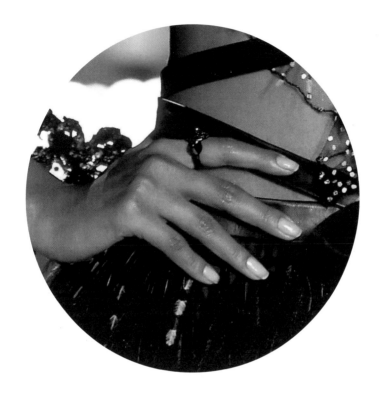

Victoria's Secret

London, 2014

The VS extravaganza arrived in London along with 'Angels' Alessandra Ambrosio and Adriana Lima, as well as Taylor Swift, Hozier and Ed Sheeran, who were to perform. The show itself was split into six themes: Gilded Angels, Exotic Traveller, Fairy Tale, Dream Girl, University of Pink and Angel Ball. There was as much going on behind the scenes as in front of them! Reporters and film crews crowded the luxurious pink backstage area, where we dispensed natural nails and excellent foot massages. My team were goggle-eyed and beyond thrilled to have found themselves on Cloud VS for one night.

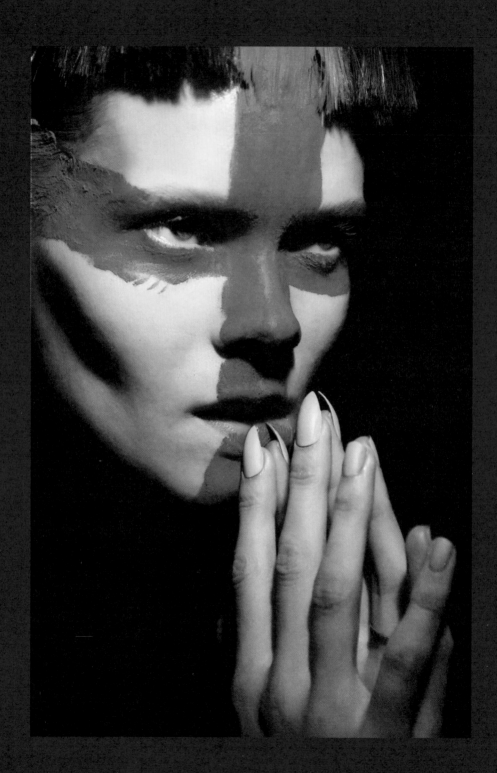

Gareth Pugh

Autumn/Winter 2016

Sometimes nails can tell a very complex story. For Gareth's Autumn/Winter 2016 show they were a part of a very powerful narrative created around an existential female battle. Gareth always produces strong warrior heroines and this one was one of his most striking. Three of the models' nails were cut short, as though broken in battle, and two of them, the forefinger and middle finger, were left long and pointed – these were her 'weapons'. Each nail was painted matte nude to reflect her warrior status rather than being given a vampy gloss. Each one also had 'dirt' beneath it to suggest the grime of battle – we achieved this with a brown eye pencil.

Vivienne Westwood

Autumn/Winter 2017

With most fashion houses, a show job begins with a beauty test where the designer gets together with the hair, makeup and nails team to work out the look for a show. For this collection Vivienne said to me: 'Ooh Marian, I've got something for you …' and she produced two red gift bags – one metallic and one covered in glitter. This show was all about recycling and upcycling, themes close to Vivienne's heart. She had also mentioned rectangles, so I started the nail process by cutting oblongs from the bags and applying them to nails. She loved the idea.

That was just one of the concepts I created for the collection. I always create lots of different nail options for Vivienne, usually 20 fingers with different ideas on each. (Vivienne has been known to look at this eclectic mix and decide that the hotchpotch is absolutely right for her rather than a single idea.) The nails for this particular show were inspired by unrefined hand puppets made using household materials by the artist Paul Klee for his son, so they included finger puppets made from the tips of vinyl gloves and secured with raffia twine.

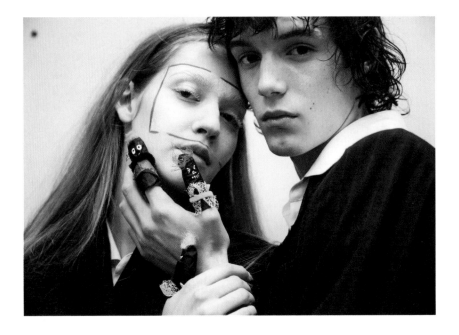

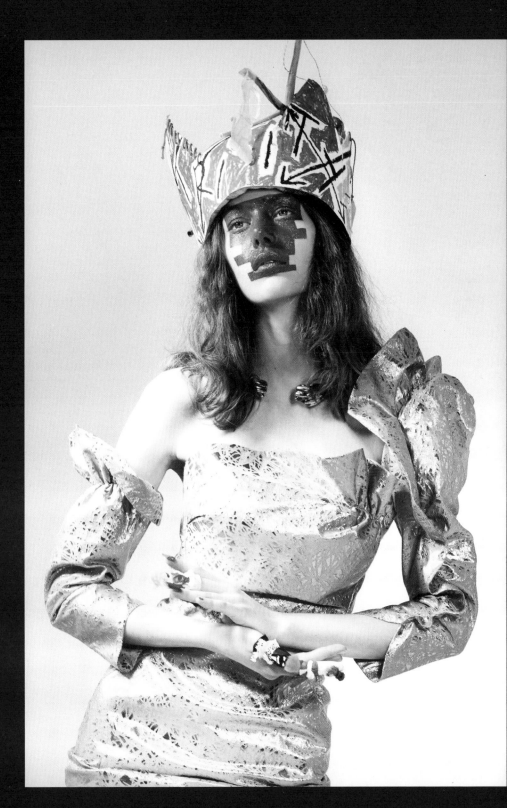

Pucci

Autumn/Winter 2017

Fashion houses work in many different ways to put together a fashion show. For this Pucci collection, I worked with the nail company CND to develop, and then create, the ideas that made it onto the catwalk. The process began with a briefing at Pucci headquarters, including their team, myself and Jan Arnold, the co-founder of CND. We were presented with the idea of short nails decorated with the company's iconic prints. Because the issue of scale must always be considered for nails (it's a very small area to cover!), we came up with two sets of designs: hand-painted and prints of the fabric designs.

Once the scheme was agreed, we created the nails overnight – very last minute, but we generally have only a day or so to work our wonders. Occasionally I'll get a mood board beforehand, but I travel with my extensive kit so that I can be responsive to the designers and create my ideas there and then, so they can see them in situ. Fashion shows are always creatively fluid and everyone involved has to be prepared for surprises!

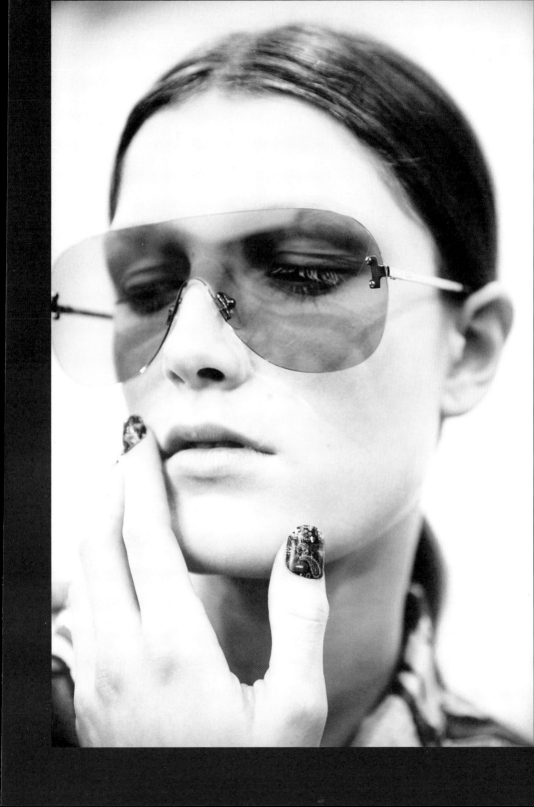

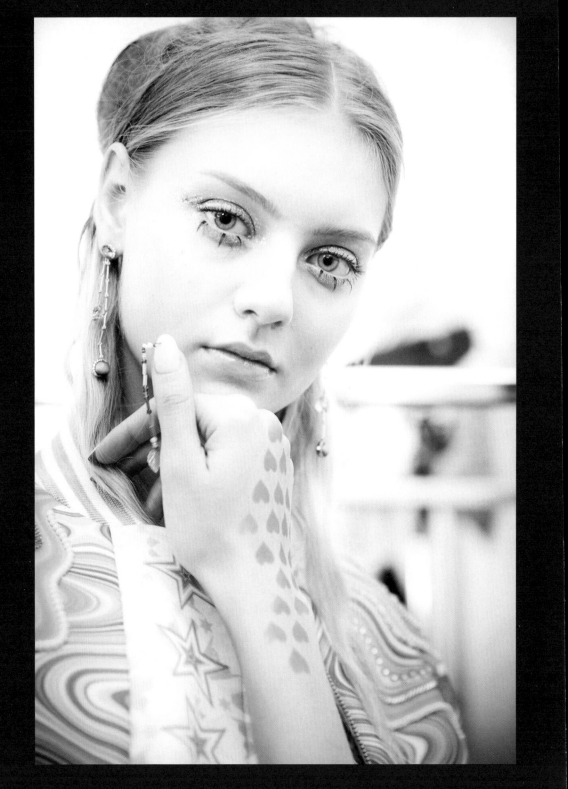

Manish Arora

Spring/Summer 2018

I have worked with Manish for many years and we've developed a very effective way of working. Before each collection, I turn up at his studio and he arranges for me to have access to all his embellishments and trimmings. This gives me a good idea of where the collection is going, and creates a platform for my ideas. I then sit on the floor and spend quite a lot of time saying, 'What do you think of this?'

Sometimes the embellishments make it onto the nails, as they did here. This particular collection included lots of references to dream-catchers, so we managed to recreate the idea by piercing the ends of the nails and threading them with string of beads. We always make 15–20 nails for each model and a normal cast includes 20 models. These nails had a real craft to them, so the whole scheme took a long time to create. We certainly had our work cut out for us, but that attention to detail always ensures that the nails look their very best.

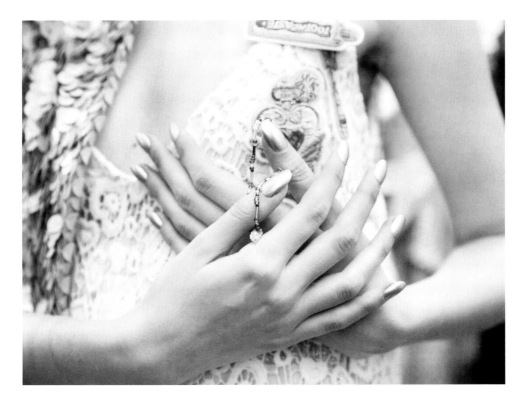

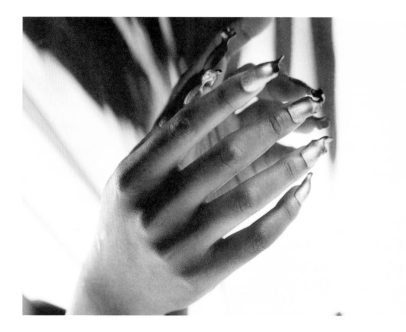

Gareth Pugh
Spring/Summer 2018

This presentation was in the form of a film rather than a show. It's a very different way of working and on this occasion also included an unusual form of collaboration with the nail company CND and other nail creatives. The process produced some very interesting ideas. It began with Gareth sending me lots of references about his approach and fabrics, and after this we spoke on the phone and crystallized our initial thoughts.

At that point, I worked with a nail artist from CND to create a webinar presented to six nail artists. We invited them to come up with some designs based on our original thoughts and on Gareth's mood board and references. It's a process that produces exquisite nails, because the work is prepared well in advance of the shoot and allows the creatives more time to perfect it.

The artists came up with ideas and took pictures of their work. I edited these with Jan Arnold, co-founder of CND, and we then sent the designs to Gareth for him to make the ultimate choice. Because there were only six models, we were able to change the nails during the filming, which meant that we could get lots of nail ideas into this collection.

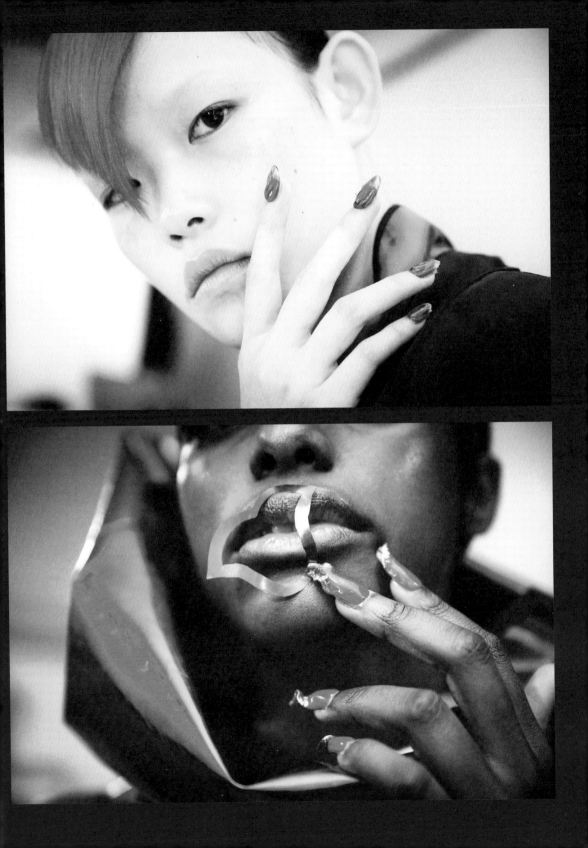

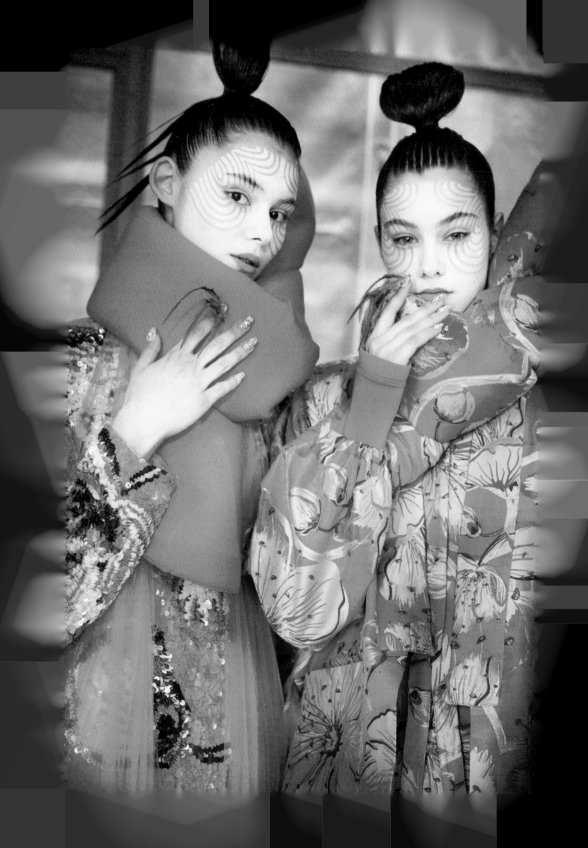

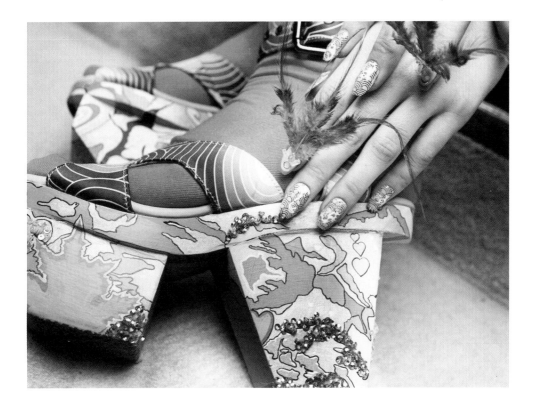

Manish Arora

Autumn/Winter 2018

For this collection, we chose the same collaborative process we used for Gareth Pugh's S/S18 film (see pages 218–19). Manish sent me lots of references and we then worked with an international team of nail artists across the Internet. We also involved the crystal company Swarovski, for which both Manish and I work quite a lot. Manish had just opened three rooms in the spectacular museum Swarovski Crystal Worlds, so it felt like a natural fit.

The combination of influences came together nicely. On this occasion we took lots of physical examples of the nail options for Manish to choose from, and ultimately he chose one design to be used for all the models. We then had a day and a night to put them all together. Each nail was hand-painted with a koi carp and decorated with Swarovski crystal 'bubbles'. Thankfully I always bring together a nail factory with lots of artists wherever I do shows, so we had a big team to create them. They were beauuutiful!

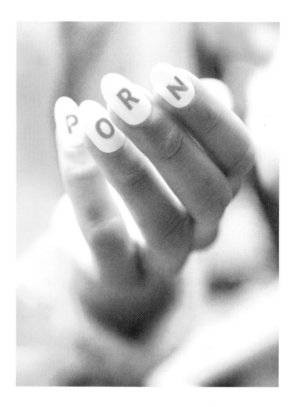

Andreas Kronthaler
for Vivienne Westwood

Autumn/Winter 2018

Whenever I work on a Westwood collection, there is a very set pattern of how the show elements come together. I'm never briefed beforehand and the team is very visual, so each time I arrive at the Westwood headquarters in Paris and meet up with hair artist Sam McKnight and makeup artist Val Garland, we never know what we're going to see! Whatever the theme of the show, we'll all have a discussion and come up with ideas relating to our own areas.

On this occasion the brief was clear, and CND was on hand as a sponsor to help me create them. Firstly, I needed to provide nails with words printed on them. 'SEX' and 'PORN' were two words used and the task for me was to make the graphics clear and strong – even on the toenails. Another idea the team wanted me to create were sets of nails decorated with long hair. This concept was more tricky, so I took on the challenge myself rather than delegating it – something I always do if the idea has a new complication I haven't previously mastered.

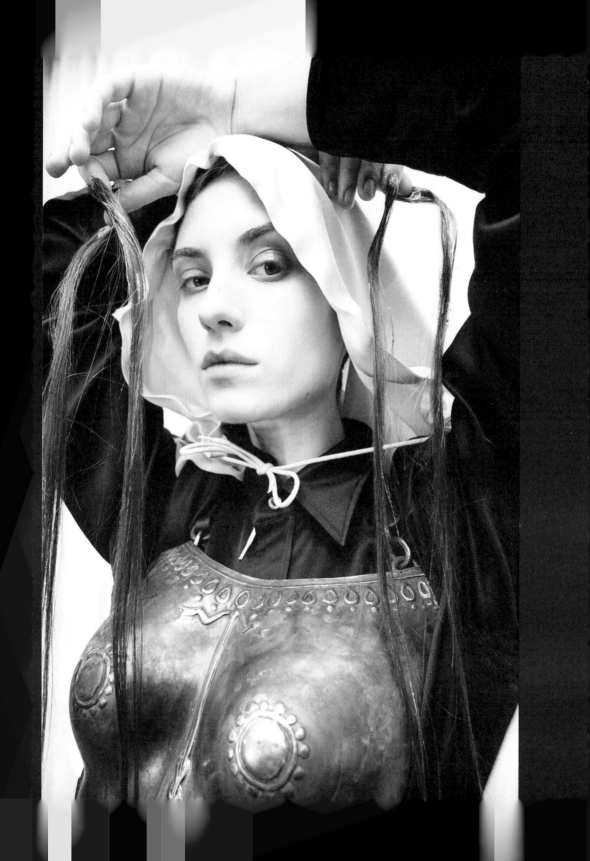

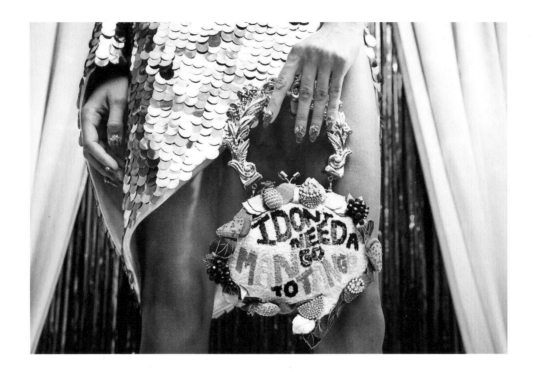

Sophia Webster

Autumn/Winter 2018

My collaborations with CND have produced some very interesting work. For this collection, Sophia was working with the legendary stylist Patti Wilson to create a presentation at the Café Royal's Pompadour ballroom in London. It was transformed into a scene inspired by Baz Luhrmann's film *Strictly Ballroom*, using lashings of tinsel and disco balls. The models were posed around the room as a static performance – a format that works very well for showing off nails, because the viewer can get a much closer look than is usually possible on the catwalk.

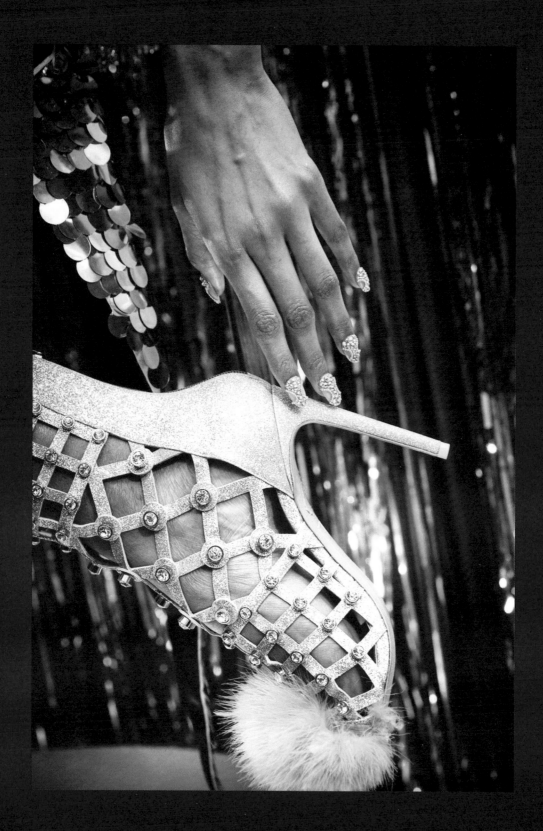

Nail Files

Introduction

I'm often asked by budding nail technicians how they can make a career for themselves through salons, photographic and show work. Nails can certainly offer a skilled person an exciting and lucrative job, but it's crucial to acquire the foundation skills.

In most countries there is no regulation when it comes to nails, so there is no standard path to follow. It is also impossible to know whether those things you have learned apply themselves to any standard. So I always say to anyone thinking about going into nails that they should do their research and find the best teacher possible. A college or course might have the full curriculum, but if the teacher isn't engaging you, or doesn't have skills that have been thoroughly tested in the real world, you won't be getting the best start. Skill and experience are everything and at the end of the day it's the teacher who will make the experience valuable to you.

I always recommend that anyone starting out should go to a variety of salons to see how a number of other technicians work. A good way to judge a person's skill is their ability to do great natural nails. Extreme nails can mask shortcomings, whereas the simplest finish requires a deft touch. Is their work beautiful, and is the salon hygienic? These are two of the most important questions to ask.

Skills are only half the equation, though. The most creative nails reflect ideas that are as exciting as the technique is exquisite. This aspect of nails is much harder to teach, because it comes from within. Most creative jobs will arrive with a brief. This is the starting point for a nail artist to begin their imaginative journey, one that will hopefully lead to the very best results.

Some artists work better from a visual cue. Others, including myself, find words more inspiring. For the story 'Ouch!' (see pages 162–69), I was simply given that single word as a starting point. From it I was to create ideas that would form a 17-page photo shoot. It was all I needed, though, because I found it such an interesting concept. I turned up at the first production meeting with far too many ideas.

Even if a creative mind is more inspired by words, it's extremely important that everyone opens their eyes and minds to what's around them. Very often a good nail concept will be repeated again and again because nail artists are limiting their research to the work of other nail artists, often via social media. I make a point never to look at the work of other nail artists. What has been seen cannot be unseen and I'm extremely wary of recreating an idea that has already been realized.

Instead I will spend my time looking at anything from a peeled Mediterranean wall, a pavement, a lake or even nightclub lighting – inspiration for textures, colours and pattern is everywhere. I have also used the artwork in comics, because their artists use amazing and unique palettes.

Another aspect of my creative practice is to save surprising bits and bobs in case my thoughts lead me in their direction. In my office I have a collection of boxes, all carefully labelled, containing broken glass, quartz, sand, silver flake, thorns, brass pins, wire beads, shells, graphite, hole punches (in different shapes), an embosser, a glue gun, fabrics, tattoos and stencils, and more. The fact is, they do get used – some crop up on the pages of this book. My tip is that if you see something and think: 'Ooh, you never know' – keep it!

What keeps me on my toes is striving to create unique work. That's the hardest thing of all, because at times I feel as though there is nothing new in the world. Even so, the ideas emerge, sometimes when I'm sleeping or when I'm driving. They can seem impossible at first – but with a bit of skill, ingenuity and patience, I usually find a way to make them happen!

A Short History of Nails

To understand how nails came to be a focus for adornment, we can follow a timeline back to the Bronze Age, although it's believed that nail art predates this time. Archaeological discoveries of wall paintings and artefacts show that some early cultures paid attention to their fingernails and toenails, often including beautiful and intricate decoration.

World mythologies give nails symbolic importance. In Greek mythology, Eros cut Aphrodite's nails while she was sleeping and scattered them on the beaches of the earth. The Fates then gathered them up and turned them into the semi-precious stone onyx, the Greek word for 'fingernail'. Norse mythology includes Naglfar, a ship that ferries the spirits of dead warriors and which is made from nails of the deceased.

By 3300 BCE, it is clear that Indians were decorating their nails with henna, the temporary herbal dye still used today for temporary tattoos and hair colour. By 3000 BCE, the Chinese were using beeswax, egg whites and vegetable dyes to colour nails. In both places, nail decoration was always associated with higher social classes. There is even evidence that execution was the penalty for less elevated women found to be adorning their nails.

In the ancient city of Babylon, pure gold nails were discovered in tombs dating from around 2300 BCE. Gold manicure tools have been found in some royal tombs. Men of the time also wore coloured nails, although it's believed that gold nails were more relevant to men than to women.

Egyptian queens, in particular, were trend makers of their times. Nefertiti (1370–1330 BCE) wore a ruby red colour, possibly created using blood, which was very popular. Cleopatra (60–30 BCE) favoured a brighter crimson. Egyptologists have determined that nail colours signified social classes, with paler colours and green designated to the lower classes and red and black reserved for the highest.

By 600 BCE, fancy embellishments started to appear. In China, precious stones and complex cloisonné designs created with metalwork and inlays were produced for the noble classes.

The modern world, and its accompanying fashions, saw a creeping democratization of nail care and decoration, although it always relied on a privileged, smooth-skinned hand. Eighteenth-century French society paid plenty of attention to beautiful nails, either buffed to a shine or with a little delicate colour.

However, manicures only truly became popular in the 20th century thanks to the emergence of Technicolor in the film industry of the 1930s and 1940s. Film stars of the day wore lipstick and matching nails – almost always red – creating in their wake a global trend that remains with us today.

The development of nail enhancements (plastic tips and forms) emerged from American dentistry. One of the early proponents was Dr Stuart Nordstrom, a dentist and the chemist for Creative Nail Design – now known as CND and owned by Revlon. It was these enhancements that gave nail technicians the broadest creative opportunities in terms of both shape and decoration.

By the late 1990s, the teaching of Nail Services, as it is now known, emerged as an area of beauty practice in its own right. Before this time, manicures had been taught as a part of hairdressing qualifications, since professional manicurists worked alongside hairdressing. The Health and Beauty Therapy Training Board (HBTTB), the training authority for beauty services at the time, decided to bring manicure and pedicure skills within its training remit. This not only helped to establish the business we know today, when nail bars and standalone salons feature in every city; it also paved the way for nails to become a creative focus in fashion and beyond.

Tool Kit

My tool kit is vast and has grown along with my career. I decided at the start that if I wanted to be a specialist I needed to have every possible product and piece of equipment. I wanted to be sure that every request I received, or any off-the-wall idea I had, could always be accomplished in the minimum amount of time.

Over the years, there have been many configurations of my kit, but I've now found what works for me, so it has stayed the same for some time.

Every job in my nail world is about efficiency and speed rather than pampering. The only time this is not the case is when a celebrity has arrived at a shoot, and hair and makeup are not quite ready with their briefing decisions.

I'm in the fortunate position that many brands send me their new products and innovations, but it is only the genuine efficient and effective products that win their place in my kit.

There are three parts to my work tool kit:

1. Core

This one goes with me to every shoot and every show. It is a mix of the products and tools that I need for every job. It is a very edited and curated collection, and it can change as new and better products come along. A knowledge of the many different types of nails and their problems, plus an understanding of the different products they require, is essential. Products in similar categories do different things, so I am always prepared to provide 'something for everything'.

My kit bag is one that I designed alongside my manufacturer of choice, Roo Beauty. Relatively small, it fits over the handle of a suitcase or trolley, and I always have it in leather.

This core kit contains all my basics:

1. Hand cleanser
Hygiene! CND Cool Blue is my favourite.

2. Polish remover
My basic choice is cosmetic-grade acetone in a lockable pump. Any remover with additives will not be quick enough and will leave a film on the nail, which leaves it unsuitable for repainting.

3. Nail cleanser
Removes grease or oils – and has many other uses. CND Scrub Fresh is my first choice, because it can deal with every type of contaminant.

4. Cuticle remover
I have a few products for this. An alkaline dead skin remover (with a tiny water spray to remove residue) and several nail oils: CND Solar Oil; Famous Names Dadi' Oil; Mavala Mavapen Nail Cuticle Oil.

5. Cotton pads and buds
Always a few, from simple cotton pads to plastic-backed (HandsDown pads) and lint-free (Soft Landings) and buds (MyKitCo.™)

6. Files and buffers
Many for every nail type and job. Usually single-use in a pack.

7. Tools
Several cuticle tools; nippers; tweezers, straight and curved; scissors, straight and curved; brushes for using pigments or applying nail art; nail and tip clippers.

8. Nail pencil
An old-fashioned product that I have always used to very good effect.

9. Polish base coats
A variety, depending on the nail condition.

10. Polish top coats
A bigger variety: glossy, matte, quick-drying, and some with a colour enhancer to make colours pop.

11. UV gel polish remover wraps
Lots of models turn up at shoots and shows wearing a UV gel polish. I always have Magis Gel Foil Wraps and acetone for this challenge!

12. Polish dry
My favoured product is Beauty Narcotix The Ultimate Fix. A spray for using between layers, it has no oil, so it is perfect for correcting smudges.

13. Nail adhesives
Vital to fix broken nails and – on the very odd occasion – to apply false nails, but always with a Minx Coat to avoid damage to the natural nail.

14. Toupée tape
My very quick, temporary method of applying false tips.

15. Wax strips
… I even have little strips of depilatory wax for hairy toes!

2. Polishes and pigments

This is where it gets silly! I have thousands of polishes and pigments and they are all arranged into brands and colours. Keeping them in check calls for several storage methods – mostly the ones I designed for Roo Beauty. Why so many? I've always believed that being a specialist means being able to do whatever is needed at the drop of a hat. There's no such thing as a simple red, after all, because there are hundreds of shades. I try to have them all – and if I don't, I carry empty bottles so I can mix the exact shade myself. Sometimes, taking a whole brand of polishes is appropriate; at other times I need a wide variety of specific shades.

3. Everything else

I maintain a huge collection of pigments and effects. This means I'm ready to create any colour or effect needed. I also have hundreds of Minx nail wraps in many designs, including some created exclusively for me.

I can't possibly list everything that falls into this section because I'm a committed collector. These items comprise my creative jewellery box and help me to produce unique work. Wherever I go, I'm always seeing things that I think might be useful, and when I make something very unusual, I source materials and squirrel them away in case I need them later. These include sand, grit, feathers, fabric, embossing tools, air brushes (with compressor and paints), broken glass, thorns, silicone for moulds, liquid rubber, beads, jewellery findings and, of course, lots of Swarovski crystals!

Address Book

Like any creative practitioner, I have developed relationships over the years with suppliers and manufacturers. Some have produced unique products for me; others simply make or sell the very best examples of the must-haves that I cannot do without. This list includes most of my go-to suppliers. Note that some sell only to professionals.

Blue Streak Crystals

www.bluestreakcrystals.co.uk (professional and consumer)

Crystal wholesaler and authorized Swarovski supplier.

Chanel

www.chanel.com (consumer)

Polish range.

Christian Louboutin

www.christianlouboutin.com (consumer)

Polish range.

CND

www.cnd.com (professional)

Nail products and services.

Dashing Diva

www.dashingdiva.com (professional)

Stick-on, press-on and pre-glued nail tips.

Elegant Touch

www.eleganttouch.com (consumer)

Press-on and stick-on nail tips.

Hobbycraft

Hobbycraft.co.uk (professional and consumer)

An Aladdin's cave of crafting supplies and ideas.

Kure Bazaar

www.kurebazaar.com (consumer)

Beautiful polish range, great for nudes.

Lecenté

www.Lecente.com (professional)

Creative nail art supplies, glitters and powders.

Magis Supplies

www.magissupplies.com (professional)

Removal wraps.

Minx Nails

www.minxnails.com (professional)

Manufacturer of creative wraps and accessories.

Pink Candy

www.pink-candy.co.uk (professional and consumer)

Wide range of specialist nails, including fetish.

Roo Beauty

www.roobeauty.com (professional and consumer)

The best storage, cases and trollies.

Salon Services

www.salon-services.com (professional)

Supplier of professional salon products.

Sisley Paris

www.sisley-paris.com (consumer)

Hand care.

Slixir

www.slixir.com (professional)

Creator of an innovative hand cream for skin and nails and polish wearers.

Swarovski Professional

Swarovski-professional.com (professional and consumer)

Specialist site supplying crystals to industry professionals.

Sweet Squared

www.sweetsquared.com (professional)

UK distributor of CND™, Shellac™, Vinylux (a pro retail line of polish), files and buffers and enhancement products, Lecenté (pigments and glitters), Minx, :YOURS (stamping plates), Mundo (hygiene), Microplane and Swarovski crystals.

Beauty Narcotix

www.beautynarcotix.com (professional and consumer)

Creator of The Ultimate Fix, a super-efficient nail drying spray.

This Works

www.thisworks.com (consumer)

Skin care for hands and feet.

Yours Cosmetics

www.yourscosmetics.com (professional)

Creative stamps, polishes and stampers for nail art.

Glossary

A

ACETONE: a solvent commonly used to remove tips and as a nail varnish remover.

ACRYLIC: a plastic used throughout the nail industry for its light weight and staying power. Acrylic mimics the flexibility and strength of natural nails.

C

COATING: any covering applied to the surface of the nail.

CUTICLE: a thin layer of skin that is constantly being shed from the eponychium, which adheres to the nail plate.

CURING: the process of polymerization.

D

DISTAL EDGE: refers to the part of a structure that is furthest from the centre of the body.

E

EFFLEURAGE: a stroking technique used in massage.

EPIDERMIS: the uppermost layer of skin attached to the bottom of the nail plate.

EPONYCHIUM: the skin fold and seal at the base of the nail plate.

EXTREME NAILS: unusually long nails or those that are formed into unnatural shapes.

F

FOILING: a technique that uses the application of sheet material to create a seamless finish.

FORM: a foundation placed under the free edge of the nail, onto which the nail technician can create an acrylic nail and extend it beyond the finger.

FREE EDGE: the part of the nail plate that extends beyond the end of the finger.

FRENCH MANICURE: a classic painting technique that uses white to colour the free edge of the nail and a natural colour on the nail bed.

FURROWS: longitudinal lines on a nail plate.

G

GEL: gels are used to create hard surface coatings and are normally cured by exposure to ultraviolet light.

H

HYPONYCHIUM: the distal edge of the nail bed; a seal between the nail plate and the nail bed.

K

KERATINIZED: the description of a skin or nail cell that has lost its contents and transformed into the protein keratin.

L

L&P: liquid and powder, also known as acrylic.

LATERAL NAIL FOLD: the soft tissue on either side of the nail plate.

LUNULA: the half moon at the base of the nail where keratinization is incomplete.

M

MATRIX: area beneath the proximal nail fold where the keratinization of skin cells takes place to form the nail plate.

MARBLING: a nail art technique that mixes two or more colours together.

N

NAIL BED: the skin on which the nail plate rests.

NAIL DECAL: a decorative transfer created for use in nail art.

NAIL PLATE: the hard keratin layers that sit on the nail bed.

NAIL STICKERS: decals specifically created to cover the whole nail or motifs created for areas of the nail.

P

PRE-TAILOR: to shape a plastic tip prior to application to ensure the correct fit.

PIGMENTS: colours used in the creation of cosmetic effects; these need to be specifically approved as an ingredient.

POLISH SECURES: nail art accessories adhered using nail polish.

S

SCULPTURED NAILS: artificial nails created by building the nail onto the natural nail and extending it using a form.

SMILE LINE: the curved line created naturally by the hyponychium, or by a coloured artificial overlay, or by nail polish.

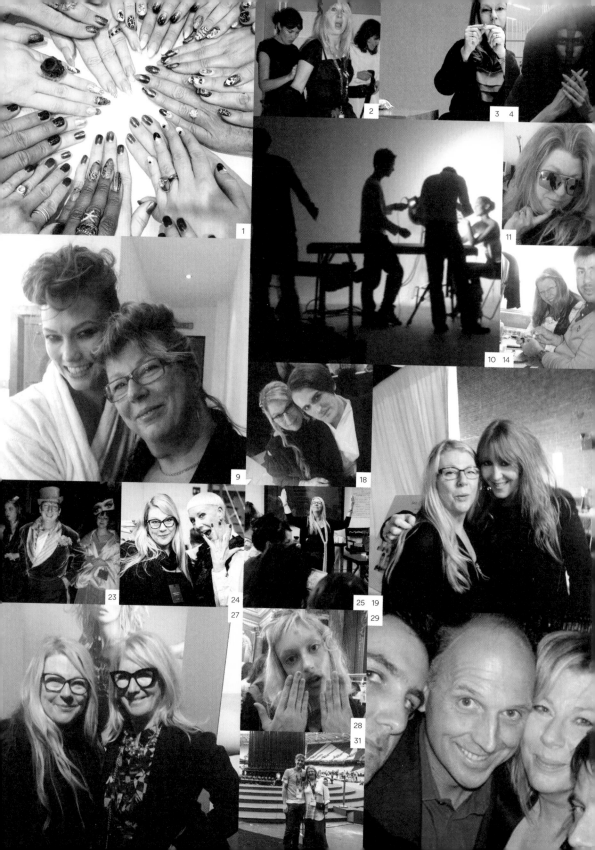

PICTURE CREDITS

The author and publisher would like to thank the following individuals and organizations for permission to reproduce images in this book. In all cases; every effort has been made to credit the copyright holders and contributors; but should there be any omissions or errors the publisher would be pleased to insert the appropriate acknowledgment in any subsequent edition of this book.

Captions for previous page:

1. CND's inaugural VIP Brand Summit, New York City, 2016.

2. Val Garland, Kate Phelan and Bella Freud at the Bal Masqué for the Möet & Chandon Fashion Tribute to Nick Knight, 2006.

3. Me during an interview conducted by Alexander Fury for SHOWstudio, 2010.

4. Backstage at Gareth Pugh, Autumn/Winter 2016.

5. Gisele with pierced nails for Dior 2009.

6. My team at Maiyet in Paris, sponsored by Kure Bazaar: David Barton, Adam Slee, Lyndsay Mackintosh, Hollie Wakeham.

7. CND Design Lab Team, Hello Kitty x Ryan Lo, 2017: Kelly Melanitou, Roxanne Valinoti, Veronica Atkinson.

8. My Paris Fashion Week Team at the end of a very long season:

Delphine Aissi, Silene Tonello, Adam Slee, Kelly Shenton, David Barton, Becca Gray, Jennie Nippard, 2015.

9. Me and Karlie Kloss backstage.

10. Nick Knight shooting an image which is on the cover of the second edition of my textbook: *The Complete Nail Technician*.

11. When you work with a fabulous hair artist (Sam McKnight) who insists on playing around!

12. Somewhere backstage: Rachel Fury, Kristine Toce, Becca Gray, Nic Hills, Charlie Jepso, 2017.

13. Me and my husband at The Event by Sweet Squared, 2016.

14. Me with my first assistant at the time, Adam Slee, on the train to Paris making nails for Gareth Pugh's fashion show.

15. Me with Winnie Huang, CND Brand Ambassador, at Ryan Lo's London show, 2017.

16. Stella McCartney's Paris

fashion show, March 2018: Delphine Aissi, Teresa Warman, Rachel Fury, Nic Hills, Becca Gray, Amy Oldale.

17. Me at the Hair by Sam McKnight exhibition, Somerset House, 2016.

18. Me and Gareth Pugh at The Fashion Awards, 2016.

19. Me and Charlotte Tilbury at the Victoria Beckham fashion show in New York City.

20. Me, Sam McKnight and Val Garland at the Hair by Sam McKnight exhibition, 2016.

21. Me and Kay Dodd in our salon in 1988 and 30 years later in 2018.

22. Me and George Alsford.

23. Stephen Jones at the Bal Masqué.

24. Me and Jan Arnold, CND co-founder and Style Director, 2017.

25. Me describing my experience at the launch of 'Transformations' for MAC in Lake Como in 2014.

26. CND Team holding CND Vinylux, backstage at Vivienne Westwood, 2017. Rachel Furr, Nic Hills, Antonia Catalano, Becca Gray, Charlie Jepson, Anita Puluczkai. Front: Jennie Nippard.

27. Me and Val Garland at Hair by Sam McKnight exhibition, 2016.

28. Backstage at Vivienne Westwood.

29. Me and Sam McKnight.

30. John Galliano, Nick Knight, Val Garland, Sam McKnight, Raica Oliveira, Stephen Jones and Veronica, backstage at a Dior shoot.

31. Me and David Barton at the closing ceremony of London 2012 Summer Olympics.

32. Me and Sam McKnight.

33. Me and Gareth Pugh at a Selfridges event, 2018.

34. Nails for *V* magazine's Kendall Jenner Couture Shoot, 2016, Photograph by Chris Sutton.